IN THE EYE OF DESERT STORM

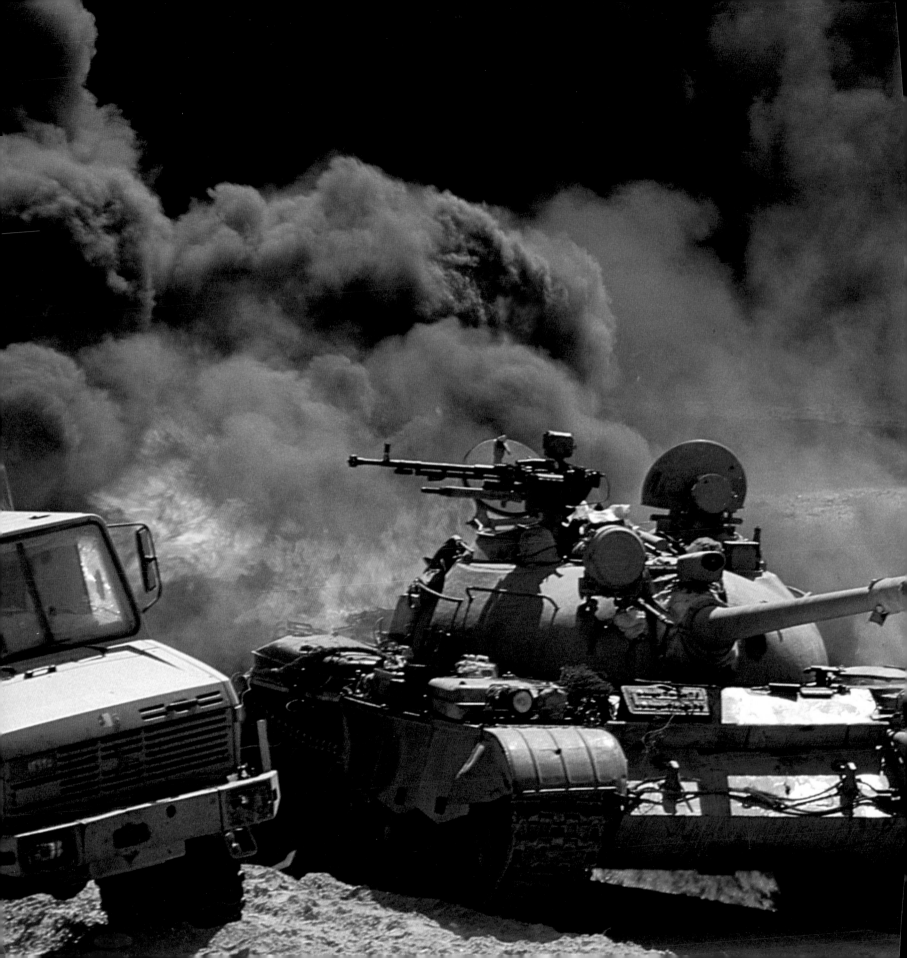

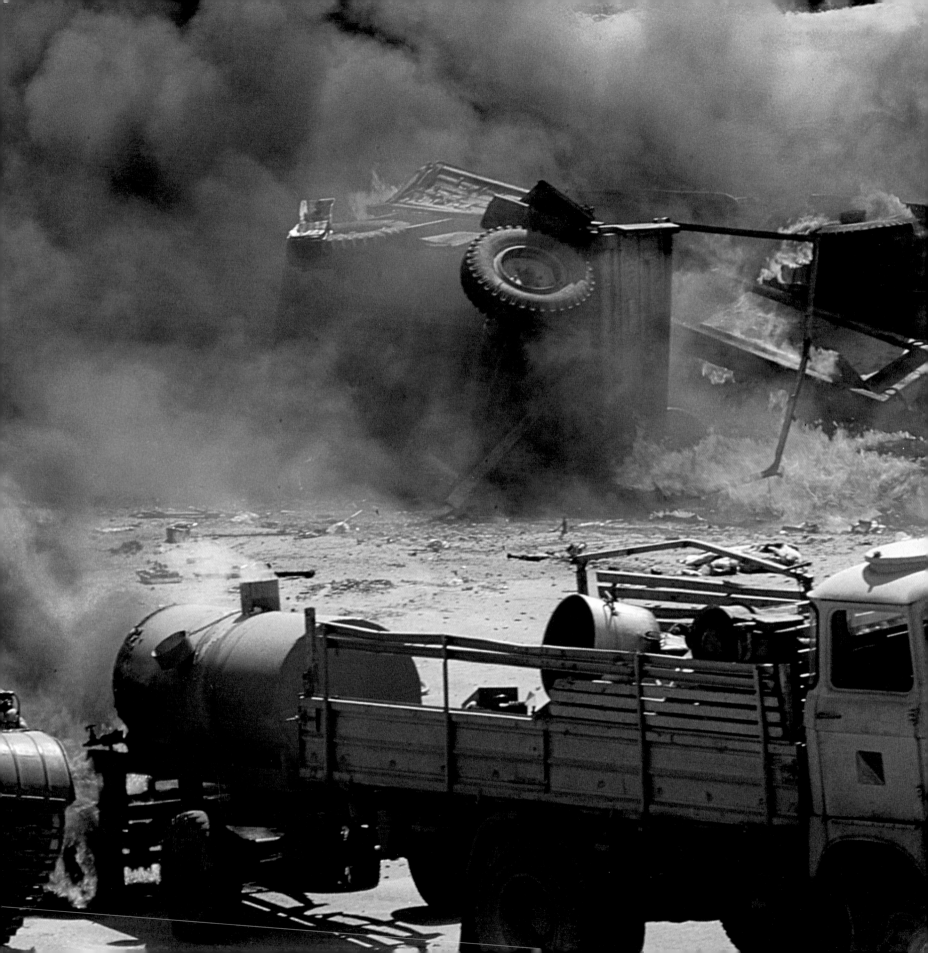

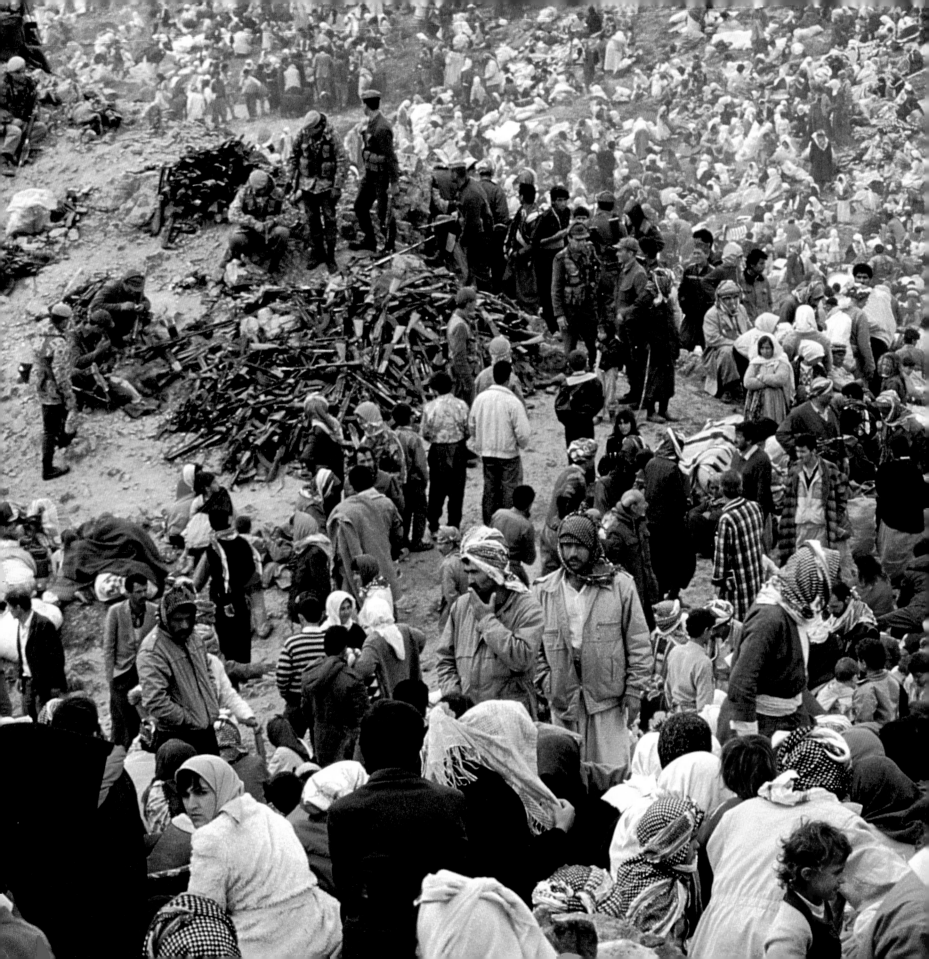

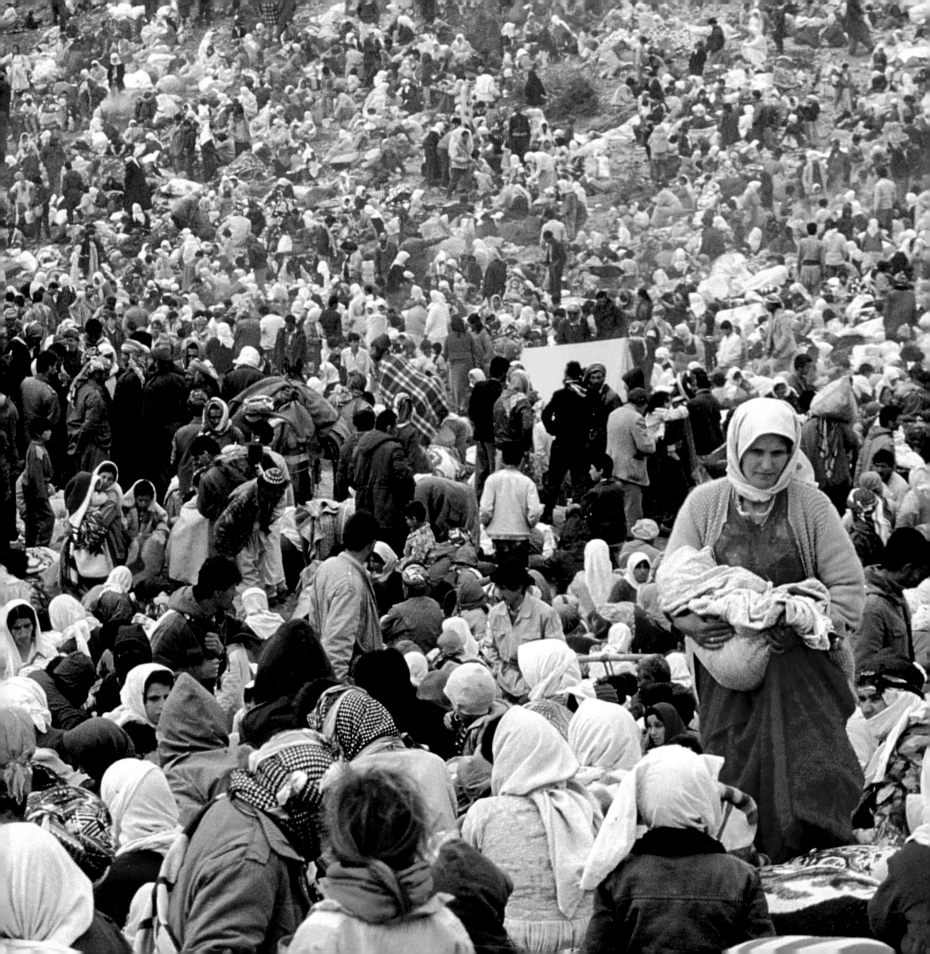

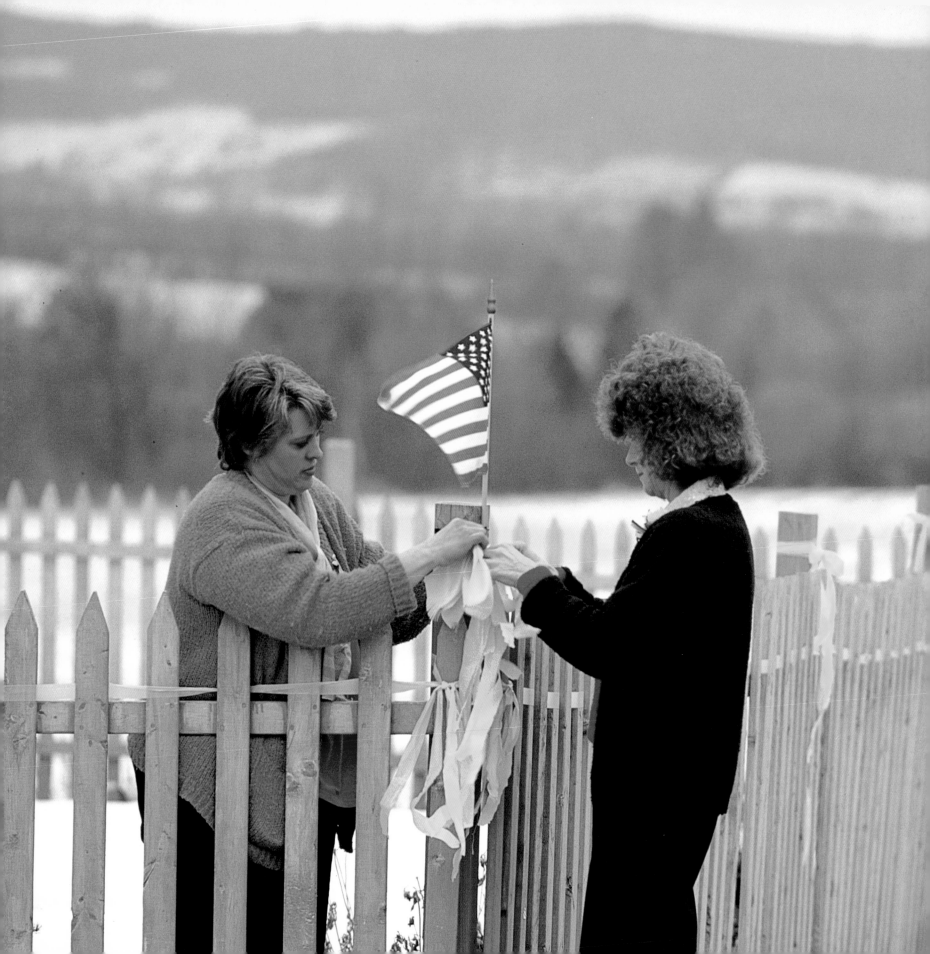

IN THE EYE OF
DESERT STORM

PHOTOGRAPHERS OF THE GULF WAR

INTRODUCTION BY C. D. B. BRYAN

IMAGES AND TEXT BY SYGMA PHOTOGRAPHERS

HARRY N. ABRAMS, INC., PUBLISHERS

NEW YORK

in association with

THE PROFESSIONAL PHOTOGRAPHY DIVISION OF

EASTMAN KODAK COMPANY

PAGES 2–3

The end of the war came quickly for thousands of Iraqi soldiers retreating from Kuwait City. As allied forces neared the capital, Iraqis stole every vehicle in sight and fled with all the loot they could pack, forming a frantic convoy toward Iraq. But allied air power put a grisly end to the traffic jam that stretched for miles. Along the road from al Jahrah to Basra, now known as the Highway of Death. Outside Kuwait City. 2 March 1991. *(Thierry Orban)*

PAGES 4–5

Iraqi caught by allied air power on the Highway of Death. Al Jahrah, Kuwait. 1 March 1991. *(Jacques Langevin)*

PAGES 6–7

During the war President Bush encouraged Iraqi citizens to overthrow Saddam Hussein, but when Iraqi Kurds rebelled at the end of the war they found themselves without support. "Climbing the mountains that separate Iraq from Turkey, hundreds of thousands of Kurds fled Iraqi bombing and threats to persecute them," reports Patrick Robert. "I had spent several days with the Kurds during this calamity, and we were all afraid of Saddam Hussein's army catching up with us." Kurdistan at the Iraqi-Turkish border. 30 March 1991. *(Patrick Robert)*

PAGE 8

"The goal that Barbara Kone and Sandy Clary set was to put up a yellow ribbon at every house in their small town," recalls Joe McNally. "It took their minds off worrying about family and friends serving in the Gulf. But their activity was also born of a determination that these war veterans would not get the same sort of treatment as the Vietnam War vets." Caroline, New York. February 1991. *(Joe McNally)*

PAGE 14

General H. Norman Schwarzkopf became a national hero for leading the allied forces in the Gulf War. The four-star general directed one of the biggest, fastest military deployments in U.S. history and skillfully unleashed its forces to liberate Kuwait while keeping allied casualties to a minimum. Riyadh, Saudi Arabia. 10 February 1991. *(Thierry Orban)*

PAGE 15

"Saddam Hussein is a master at manipulating the press," says one veteran Sygma photographer. "He summons you to Baghdad, puts you in a hotel, and there you wait. The knock at your door comes at any hour. If it suits him, then you'll hear Hussein deliver a speech at 4 A.M., and the next morning, you're out of there." Baghdad, Iraq. *(Jacques Pavlovsky)*

PAGE 18

"The first image of this assembly of U.S. and Saudi troops reminded me of summer camp," says Jean-Louis Atlan. "A sea of shiny, clean soldiers anticipating President Bush's Thanksgiving visit. Women were very much a part of this war effort, and were particularly visible among the Western forces." Dhahran, Saudi Arabia. 22 November 1990. *(Jean-Louis Atlan)*

PAGE 19

"This tank driver was the son of an English military man," recalls Thierry Orban, who spent ten days with the 1st Cavalry Regiment of the French Foreign Legion. "From a very young age, it had been his dream to join the Foreign Legion as a way to travel and embrace a military career. I thought he had the perfect mug for a Legionnaire." Hafar al Batin, Saudi Arabia. 12 October 1990 *(Thierry Orban)*

PAGE 22

Captain David Ray Smith, U.S. 82nd Airborne Division, twice made the cover of LIFE magazine in the same short war. It began with this photograph, taken in Dhahran, Saudi Arabia. Smith quickly became an icon of the broadly supported war, as Americans found renewed respect for the military. Upon his return one month later Smith was again on the cover, this time with his wife, Jamie. Dhahran, Saudi Arabia. November 1990. *(Jacques Langevin)*

PAGE 23

"No expression, no emotion, no sense of humor," says Thierry Orban of General Colin Powell, Chairman of the U.S. Joint Chiefs of Staff. "This was a very serious man in charge of winning a war, and with Schwarzkopf and half a million troops, he did so." Riyadh, Saudi Arabia. 10 February 1991. *(Thierry Orban)*

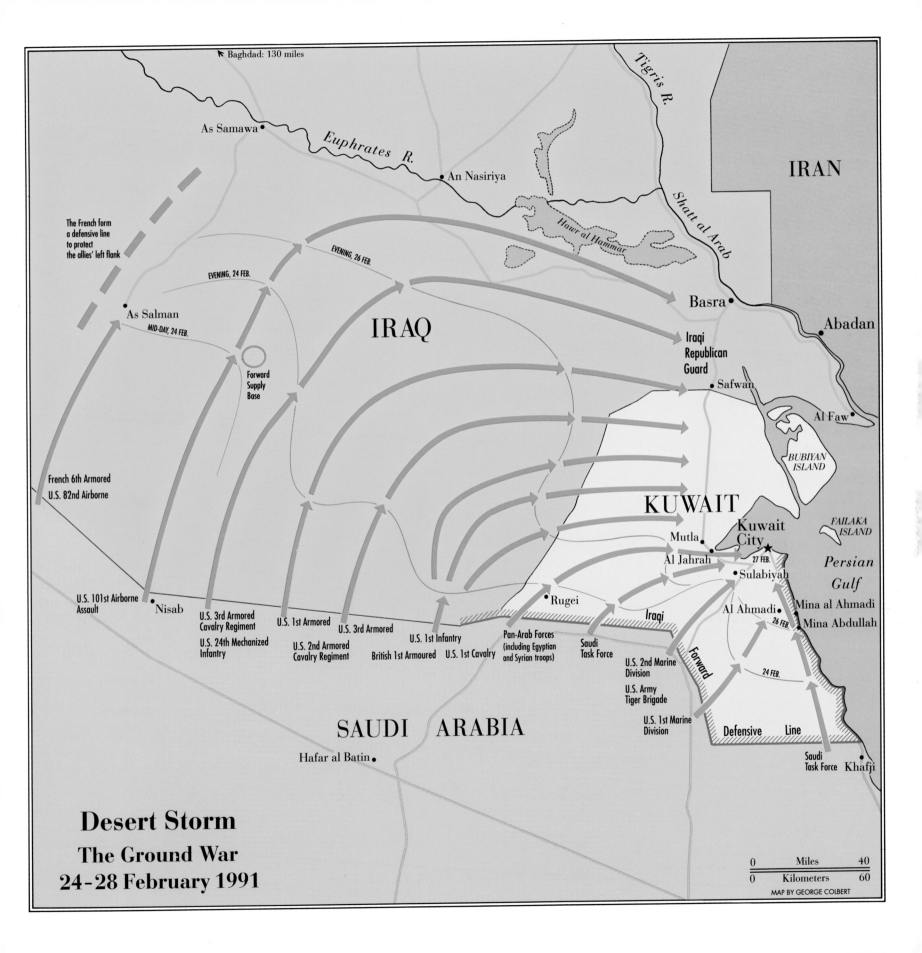

Baghdad: 130 miles

Tigris R.

As Samawa

Euphrates R.

An Nasiriya

IRAN

Shatt al Arab

Hawr al Hammar

Basra

The French form
a defensive line
to protect
the allies' left flank

EVENING, 26 FEB.

EVENING, 24 FEB.

IRAQ

Iraqi
Republican
Guard

Abadan

As Salman

MID-DAY, 24 FEB.

Forward
Supply
Base

Safwan

Al Faw

French 6th Armored
U.S. 82nd Airborne

BUBIYAN
ISLAND

KUWAIT

FAILAKA
ISLAND

Mutla

Kuwait
City

27 FEB.

Persian
Gulf

Al Jahrah

U.S. 101st Airborne
Assault

Nisab

U.S. 3rd Armored
Cavalry Regiment

U.S. 24th Mechanized
Infantry

U.S. 1st Armored

U.S. 2nd Armored
Cavalry Regiment

U.S. 3rd Armored

British 1st Armoured

U.S. 1st Infantry

U.S. 1st Cavalry

Rugei

Pan-Arab Forces
(including Egyptian
and Syrian troops)

Iraqi

Saudi
Task Force

Sulabiyah

Al Ahmadi

Mina al Ahmadi

Mina Abdullah

26 FEB.

U.S. 2nd Marine
Division

U.S. Army
Tiger Brigade

U.S. 1st Marine
Division

Forward

24 FEB.

Defensive Line

SAUDI ARABIA

Hafar al Batin

Saudi
Task Force

Khafji

Desert Storm

The Ground War
24–28 February 1991

| 0 | Miles | 40 |
| 0 | Kilometers | 60 |

MAP BY GEORGE COLBERT

INTRODUCTION

C. D. B. BRYAN

Almost thirty years ago, I helped write the narrative for a Swedish antiwar documentary film. The footage, showing the devastation we had wrought upon our planet and ourselves from the outbreak of the First World War through the early 1960s, was horrific — especially the images of Hiroshima and its hideously burned radiation victims being treated in understaffed and underequipped Japanese hospitals. Still, THE NEW YORK TIMES film critic wrote, "It doesn't take an hour to tell us that war is bad." He was right, of course.

Now the Gulf War is over. It was a stunning victory, yes; but the devastation there was horrifying, too. And before we get too bloated with pride about the technological efficiency with which it was waged and the swiftness with which it was won, and before we raise a generation of armchair "Top Guns" who think wars are easy and fun, it might be wise to take a long, close look at the photographs in this book and recall the Vietnam-era slogan of Another Mother for Peace: "War is not healthy for children and other living things." Because the mothers, too, were right, of course.

■

"SHOWING WAR'S IRRATIONALITY AND HORROR," WROTE WILLIAM JAMES IN 1910, "IS OF NO EFFECT UPON men. The horror makes for fascination. War is a strong life, a life *in extremis.*" Four years later, World War I commenced; and at its end, nine million lay dead and twenty-one million more were wounded. I wonder what James would have thought of Desert Storm commander General H. Norman Schwarzkopf, who said in a WASHINGTON POST interview three weeks before the ground war began in Kuwait, "Every waking and sleeping moment, my nightmare is that I will give an order that will cause countless numbers of human beings to lose their lives. I don't want my troops to die. I don't want my troops to be maimed. It's an intensely personal, emotional thing for me."

I have known the general since he was a young lieutenant colonel recently back from his second tour in Vietnam. That was twenty years ago. I remember Schwarzkopf telling me then, "War is a profanity. It really is! It's terrifying. Nobody is more antiwar than an intelligent person who's been to war."

And yet, there are those who, even though they don't have to, keep going back to wars again and again like, well, moths to the flame. They are the war photographers, veterans like Jacques Langevin, the Sygma agency correspondent whose riveting coverage of the April 1989 massacre in Beijing's Tiananmen Square may be surpassed here by his images of Kuwait's "Highway of Death" (pages 4–5, 122–24).

These are the photographs that cry out — this is what happened *here! Now!* The best photographs do that. And the best war photographs — despite the tragic repetition of their themes — have the ability to appall us anew.

■

IT IS DIFFICULT TO PREDICT WHAT WILL BECOME THE ICONS OF THE GULF WAR. WE WERE SO INUNDATED with images from Operation Desert Storm. How raptly we sat in front of our TVs watching — both in anguish and in excitement — the preparations, the massive airlifts of equipment, the unloading of cargo ships, the fighter-bombers roaring aloft from golden Saudi airfields and gray carrier flight decks, the heavy, tracked armored vehicles grinding through the ocher, wind-whipped desert sands. And how avidly we tuned in the briefings with their mesmerizing videos of laser- and TV-guided bombs falling on the Iraqi capital, their scenes of tracers and antiaircraft fire eerily illuminating Baghdad's nighttime sky and of Patriot missiles streaking up to intercept incoming Scuds over Tel Aviv — all "LIVE!"

The strange, Nintendo-like character of the television war was enhanced in part by the sanctuary from which we watched it and in part by the peculiar nomenclature of its high-tech sophistication: Stealth fighters, cruise missiles, AWACS, Wild Weasels, Raven electronic countermeasure aircraft, satellite imagery, infrared or night vision optics, and "smart bombs" — an oxymoron that takes the breath away.

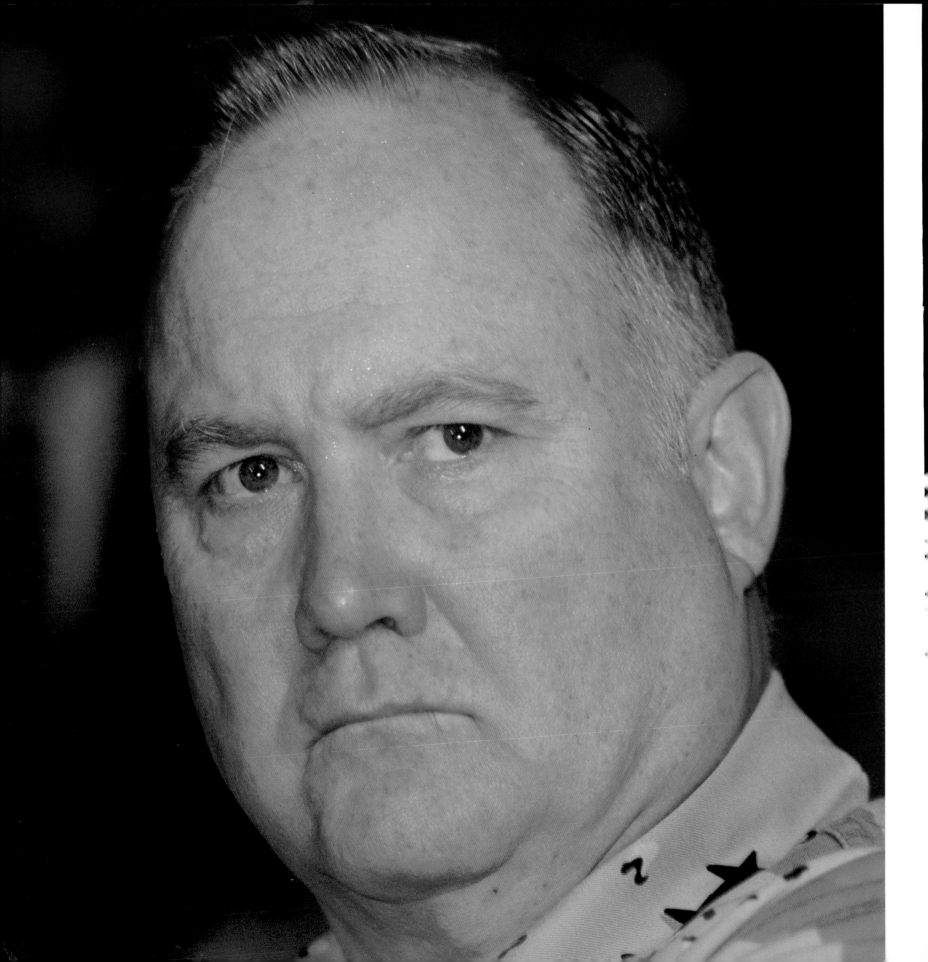

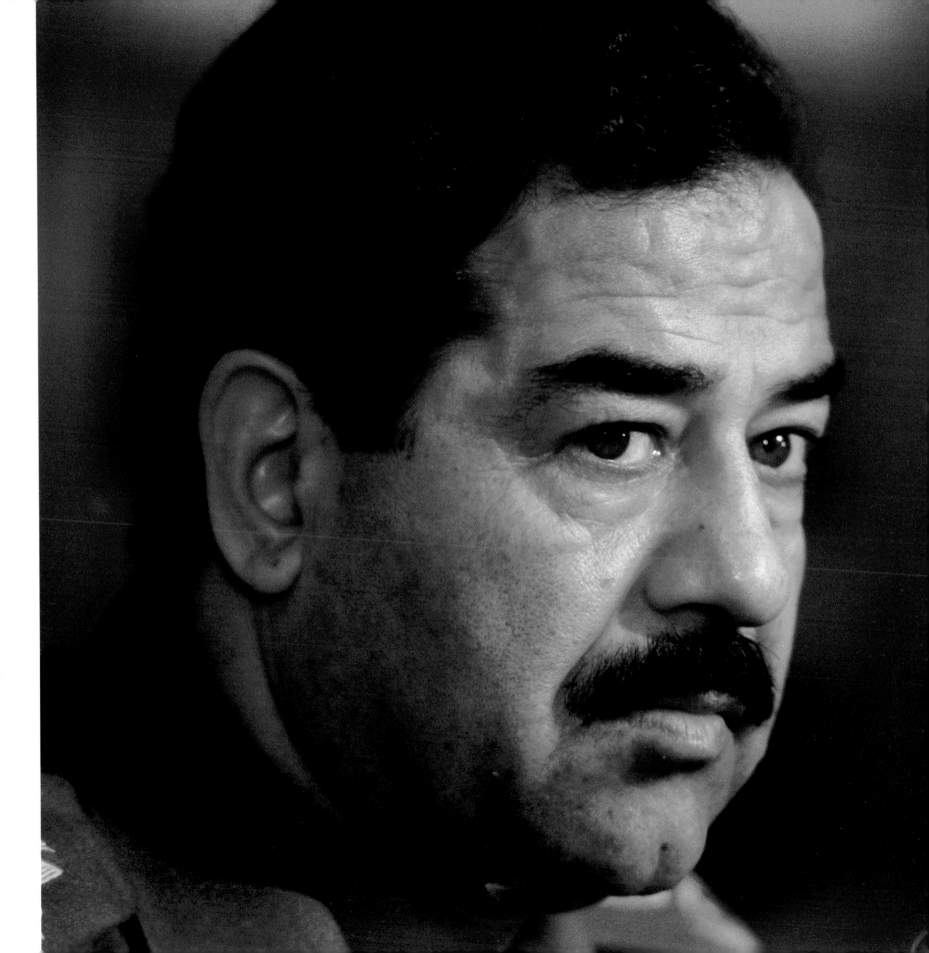

Not until the ground war began did the images on television become less star-wars and more earth-wars: seabirds choking and drowning in the oil-clogged Gulf; skies darkened at noon by the billowing black smoke from hundreds of ignited Kuwaiti wellheads; and then the pathetic parade of shell-shocked Iraqi forces rushing to give themselves up. So eager were they to quit the fight that according to one account they surrendered to journalists in a rented car, to an Army engineer whose bulldozer had become trapped in the sand, and even to a small, airborne reconnaissance drone — a robot.

Still, as the seasoned NEW YORK TIMES reporter Malcolm W. Browne wrote, in its early stages it was a war that "seemed to smell more of grease paint than of death." This was because despite all its television coverage, Operation Desert Storm, for those of us not directly involved in it, remained somehow choreographed, distant, antiseptic, diminished in savagery by both the frustratingly narrow restrictions placed by the U.S. Department of Defense on journalists attempting to cover the war, and by the very familiarity and comfort of the living rooms and bedrooms from which we viewed it.

■

A PHOTOGRAPH IS DIFFERENT FROM A TELEVISION IMAGE. IT IS more intimate, more immediate. It depicts only the face of that actual instant the shutter is tripped. The photographer selects what to show us, forces us to slow down, to study what he wants us to see. Uninterrupted by a news-caster's droning narrative, we are left to make of the image what we want. An isolated fragment of time is frozen and the manner in which the photographer selects that fragment and chooses his framing, distance, detail, and exposure is what suffuses that image with meaning. It is not surprising that today every event is accompanied by the insistent *yes-LOOK!*, *Yes-LOOK!*, *Yes-LOOK!* of still cameras' motor drives. In the best photographs there is that sense of the *now!*

Even though television provides instant access to tragedy, even though an assassination or exploding space shuttle can be replayed endlessly, it is the still photograph that focuses and crystallizes our grief and rage. Somehow — and I can't begin to understand how this happens — the single photograph of that awful moment demands an exhalation of breath. It releases, in a way that the motion pictures or video images rarely do, the linchpin of our emotions and makes what we already know to be true, not just true but, for the first time, *real.*

The photographs in this book have that sense of the real. They were taken by twenty-four veteran photographers of Sygma Photo News Inc., the international agency founded in 1973. Between them, these photographers have garnered every major award in the field of photojournalism and their combat experiences span every war since Vietnam.

In the Gulf, Sygma photographers worked outside the news pool set up by the U.S. Department of Defense to

cover the war. Only the Associated Press, Reuters, TIME, NEWSWEEK, and U.S. NEWS & WORLD REPORT were members of the Department of Defense still photography pool. Sygma photographers were not included for two reasons: the five members of the pool refused to include them (or any other organizations), and even had they been invited to join the pool, they would have refused to abide by the ground rules for the still photographers covering Operations Desert Shield and Desert Storm. The rules were set forth in a two-page, single-spaced operational plan issued by the United States Department of Defense Joint Information Bureau (JIB/DOD) in Dhahran, Saudi Arabia, in January of 1991. JIB/DOD required that "all pool photographs are to be taken on color negative (C-41) film," rather than the slide film that photographers prefer for its superior quality for both picture-taking and reproduction. JIB/DOD ordered that all still photographs made in JIB combat groups were to be available to all JIB/DOD combat group members; that no pool photographer could sell an exclusive photograph on his own; and that all photographs were to be developed, transmitted, and shipped by a five-member editorial team made up of one member each from the Associated Press, Reuters, TIME, NEWSWEEK, and U.S. NEWS & WORLD REPORT.

Typical of the language of the JIB/DOD operational plan is this excerpt:

> All pool editing will be done by the pool editorial team....
> Pool material will be available only in negative form.

Usage of the film for transmission shall be on a priority-need basis. Priority needs shall be determined by the pool coordinators. Pool members are responsible for their own distribution and distribution equipment. Pool film is not to be removed from the pool editing area and must remain with the pool.

Even members of the pool were unhappy. In an article datelined Dhahran, 11 February, not quite two weeks before the ground war was launched, the distinguished NEW YORK TIMES reporter R. W. Apple, Jr., wrote:

> The imposition of a rigid press pool system in the Persian Gulf War, with fewer than 100 reporters authorized to talk to half a million American servicemen and women, has led to the detention of correspondents and angry protests to military authorities.
>
> More than two dozen reporters and photographers have been held for up to eight hours by the United States or Saudi military for trying to cover the war on their own, without military escorts. Dozens of others have managed, often with the help of rented four-wheel-drive vehicles, to cut across the desert or otherwise avoid detection by military policemen.
>
> Without access to American troop units, correspondents are unable to verify statements made at press briefings in Riyadh, the Saudi capital. They cannot fully describe the ground fighting, which soon may intensify. They are also unable to convey the emotions, thoughts, and morale of the front-line soldiers and their officers — often the essence of war correspondence.

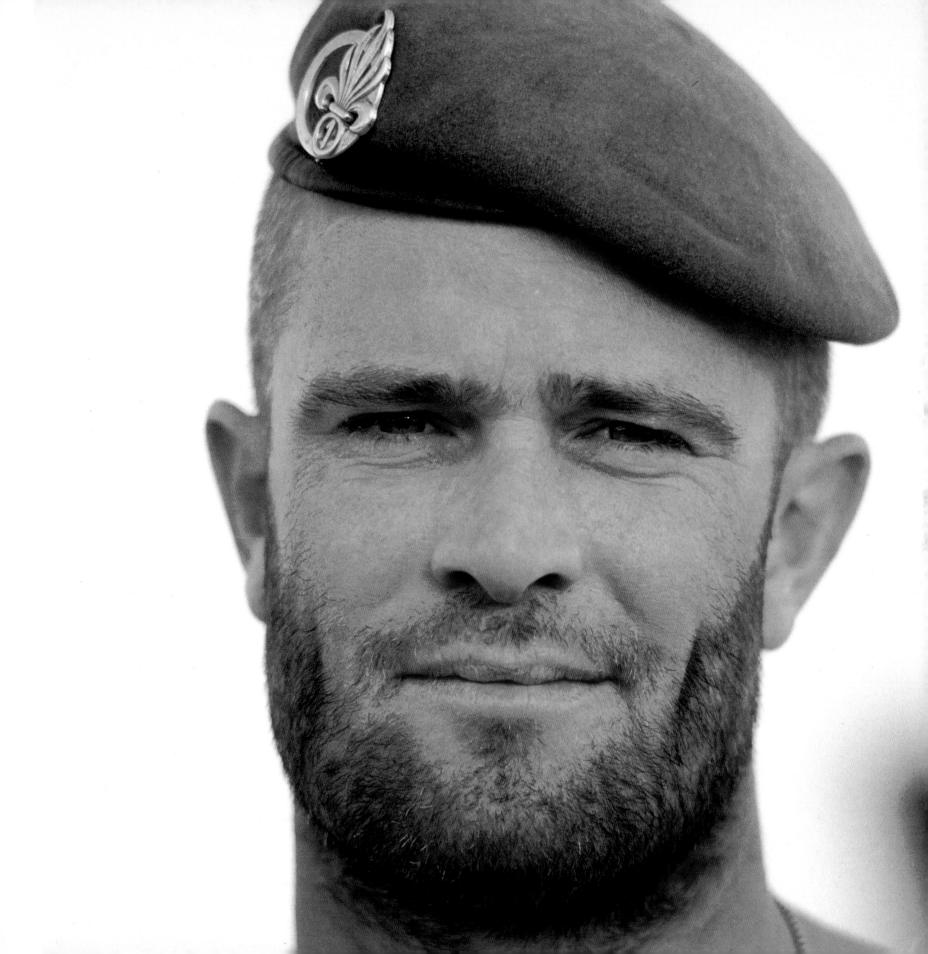

Apple reported that among those apprehended and detained by the American and Saudi military were three NEW YORK TIMES correspondents, two A.P. reporters, a six-member team from the British Broadcasting Corporation, and several French free-lance photographers. Two Sygma photographers were among them.

Of the more than one thousand journalists accredited by the Saudi Ministry of Information to cover the war, only 126 were in the DOD pool. "But even that figure is misleading," Apple complained. "Many of those are...[TV] camera operators and technicians. Several...have done little but sit around hotels in Dhahran and Riyadh, while others have visited only airbases far behind the lines or ships in the Persian Gulf." What really offended Apple to the core, however, was that "some pool spots are occupied by reporters working for publications such as MIRABELLA, the monthly women's magazine, and STARS AND STRIPES, an authorized military newspaper."

It is no wonder Sygma photographers would have nothing to do with the pool. As Sygma's president Eliane Laffont said, "The photographers were losing their freedom. When you are told what to do, where and how to do it, and what to do with your material after it is done, in essence you are working for the Pentagon. And the Sygma photographers did not want to do that."

How did they get around the restrictions? "Well, you know," said Laffont, "they just took their own cars and drove into the desert."

THE MOMENT IRAQ INVADED KUWAIT ON 2 AUGUST 1990, Sygma mobilized its worldwide network of photographers and dispatched them to the countries affected by the emerging conflict in the Gulf: the United States, Europe, Saudi Arabia, Israel, Jordan, Kuwait, and Iraq. Working unilaterally and with neither the restrictions nor the protection of the DOD pool, the Sygma photographers captured images that will remain part of the visual history of this war: the emotional departure of the American troops; their arrival in Saudi Arabia; young Saudis enlisting; American, British, and French troops settling into the region: how they lived, trained, relaxed, and fought in that stark desert moonscape.

Sygma photographers documented the air war with its sculpturally elegant weaponry and the savage ground war with its terrible toll. They photographed the destruction of Kuwait City, the capture of Iraqi prisoners, the unearthly light of the burning oil fields, a Patriot launch over Tel Aviv, the hideous images of the Iraqi deaths on the highway from Baghdad, and the tragic ecological consequences of flooding the Gulf with oil.

Sygma photographers were present with the U.S. Special Forces to document the initial stages of Kuwait City's liberation. To be there, they had had to locate and link up with the Special Forces on their own. They lived with them, traveled with them, shared their rations and their risks. Although by not being part of the DOD pool Sygma photographers were able to avoid the pool's

restrictions, it also required that they give up protection offered pool members by the military. The results, though, are photographs unlike any that came out of the pool: intimate moments of the real war — its hazards, its triumphs, and its sorrows. Sygma photographers were present, too, to capture the Kuwaitis' jubilation, the joyful homecoming of the U.S. troops to their families, and the war's somber legacy: the burial of the dead, and the mournful plight of the Kurds fleeing the continued savagery of Saddam Hussein.

■

THE RESTRICTIONS PLACED ON PHOTOJOURNALISTS' FREEDOM to tell their stories during the Gulf War have antecedents older than America's recent incursions into Panama and Grenada. One can look as far back as the 1850s and 1860s, to the Crimean War and, later, the U.S. Civil War, and find how photographers then, as now, were hindered in trying to show the reality of war.

In the Crimea, Roger Fenton had to bribe generals with portraits of themselves in order to be able to drive his van full of equipment and seven hundred unsensitized glass-plate negatives to the front lines. The closest he came to photographing the bare facts of the war was a single, bleak image of a barren rutted road littered with spent cannonballs between two hills: *Into the Valley of the Shadow of Death, Crimea*, 1854.

During the Civil War, photographers could make their way onto battlefields only after the fighting had ended. There, on truce days agreed to by both sides so the casualties could be buried, photographers such as Mathew Brady, Timothy O'Sullivan, and Alexander Gardner would roam the shattered woods and the trampled pastures, their noses covered with handkerchiefs against the terrible stench, in order to document the dead. For the most part, nineteenth-century war photographers were observers both after the fact and from afar. Censorship and their cumbersome equipment and slow film condemned them to shooting tableaux, portraits, or battlefields empty but for corpses. The vast majority of their images fail to engage our emotions. We are less touched by the photographs of Antietam, for example, than by the knowledge that on that spot, 26,000 men were slaughtered in one day. How much more moving is Thierry Orban's photograph (page 88) of a single dead Iraqi soldier lying like a piece of litter tossed to the roadside by the French armored personnel carrier halted in the background.

The photographer was not even permitted near the battlefields in World War I. Caught taking pictures, a cameraman could face court-martial or death. At the outbreak of the war, only two photographers were allowed to cover the Western front; they were both army officers. Their photographs were not for publication, but for record. The taking and releasing of photographs was controlled by the governments. Images of that war's hideous carnage did not even see the light of publication until

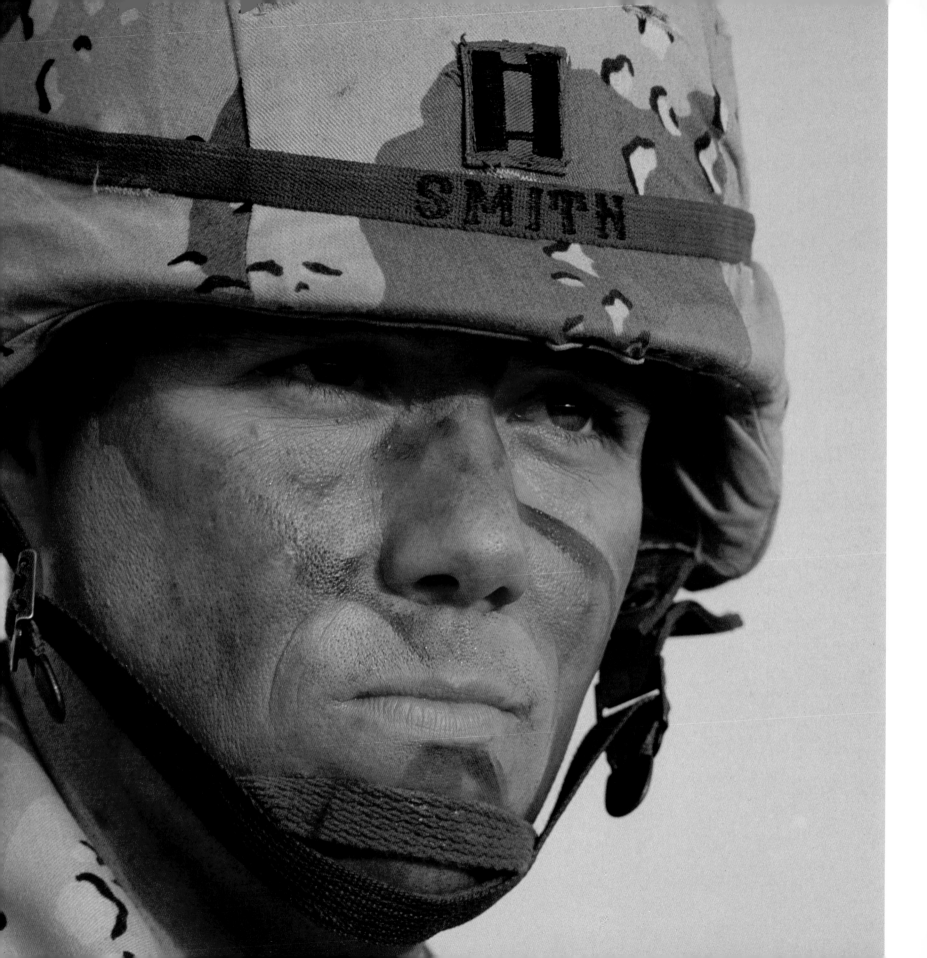

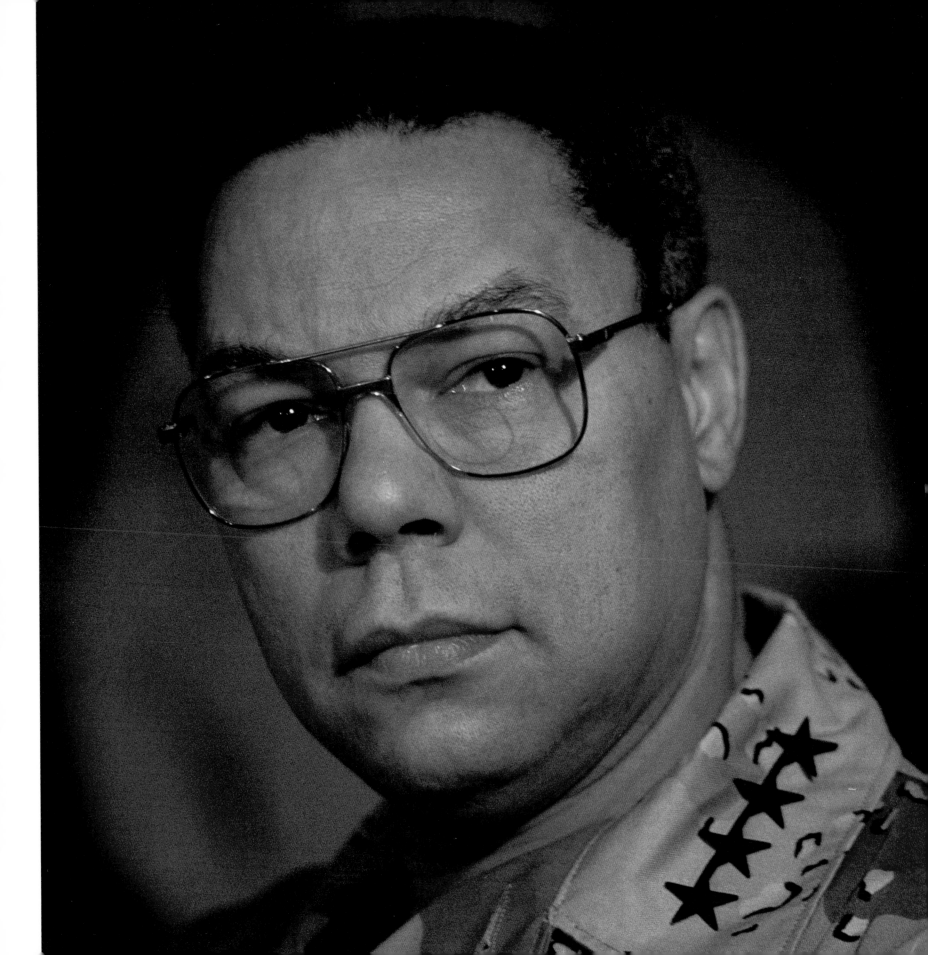

after the armistice had been signed; and by then, the impact of such photographs had been dissipated by relief that the war had ended. Still, some powerful images survive, among them an unknown German photographer's 1917 picture of an injured German infantryman helping his more seriously wounded comrade up the steep slope of their trench. It is a photograph that speaks to us still: the air so thick with fog or smoke that little light pierces the gloom; the bleeding men fragile, desperate. That photograph, like Patrick Durand's image (page 95) of a score or more Iraqi prisoners fording a shallow body of water to give themselves up, smoke-shrouded high tension towers in the background, is a photograph of utter defeat.

On the eve of Mussolini's attack upon Ethiopia in 1935, Alfred Eisenstaedt took a picture that conveyed that war with a symbol: a single closeup of the cracked and calloused bare feet of one of Emperor Haile Selassie's soldiers. Look now at Thierry Orban's photograph (page 93) of a group of Iraqi soldiers lying belly-down surrendering to French Foreign Legionnaires. The Iraqi second from the right is barefooted, too. There are disturbing parallels to be drawn.

Perhaps the most famous war photograph of all time was taken by Robert Capa the year following Eisenstaedt's. Capa's 1936 photograph of a Loyalist soldier during the Spanish Civil war, arms outflung, falling at the instant he is killed by machine-gun fire, is considered the most dramatic action photograph ever taken. That last word is key.

Photographs, unlike paintings or films, are *taken*, not made. The best of them capture what the photographer Henri Cartier-Bresson called "the decisive moment" — decisive not simply because of the exterior event taking place (in Capa's case, the Spanish Civil War), but because the photographer released his shutter at the exact instant when the earth, sky, light, soldier, war, and death merged to form a *picture*. The moment before would have been too soon; the moment after, too late.

Even in World War II, only heavily censored photographs were released for publication — and only well after the battles depicted were over. Despite this, many were so powerful they have remained as icons of that war. Consider Margaret Bourke-White's image of prisoners at Buchenwald of 1945: through the sharp linear steel of a barbed wire fence, we see the soft eyes and haunted faces of the concentration camp prisoners staring back. It is the eyes in Bourke-White's photograph that capture us. Look now at Thierry Orban's photograph (page 91) of an Iraqi soldier holding up some surrender leaflets dropped by American planes. His eyes, too, still contain all the fearful horror of his war.

Orban's photograph reminds me of the pictures taken by perhaps the most famous photographer to emerge from the Korean War: David Douglas Duncan. It was said of Duncan that "he could capture the war in a single face." His 1950 series of photographs of hollow-eyed

Marines at Changjin Reservoir is unforgettable.

From the Korean War on, photographers like Duncan commonly became an intimate part of a combat unit. He lived with them, shared their rations, their suffering, their terror. As a result, there emerged from that conflict a new type of war photography: personal, disturbing, horrifying glimpses into the day-to-day lives of strong men *in extremis*, a precursor of what we now see in this book.

Then came the Vietnam War.

■

"WAR PHOTOGRAPHERS ARE AMONG THAT SPECIAL BREED attracted to war," the photographer and historian Jorge Lewinski wrote in THE CAMERA AT WAR. "They have something [of] the nature of mercenaries — the whores of war — but in a more positive sense. They may not be prepared to kill and maim for the sheer excitement and adventure, but is the camera not a substitute for a gun? We do not have to look any further for the incentives in a war photographer. On the one hand, he is able to experience the supreme stimulation and intensity of the war adventure, with its attendant dangers; on the other hand, he has the opportunity to perform a seemingly noble deed — to fight the evil and outrage of war by depicting its horrors in his photographs. Who could ask for more?"

■

WELL, THEY COULD ASK FOR FAME AND MONEY. AND MANY of those who went to Vietnam to shoot not people but pictures got both.

Photo- and print journalists in Vietnam experienced a freedom of reporting never before enjoyed and a complete lack of censorship. "Vietnam," the journalist Michael Herr wrote in DESPATCHES, "is what we had instead of happy childhoods." Photographers were actually encouraged to go out into the battles with the men. Accommodations were provided, transportation and information backup services were all paid for by the Army, which wanted the press to look at what was happening and to report favorably on what they saw. To the military's dismay, the photographers reported their own truth.

"More convincingly than any other kind of picture, a photograph evokes the tangible presence of reality," wrote John Szarkowski, Director of Photography at the Museum of Modern Art. "Its most fundamental use and its broadest acceptance has been as a substitute for the subject itself — a simpler, more permanent, more clearly visible version of the plain fact."

Szarkowski was not referring specifically to war photography when he wrote this, but his understanding of the role photography plays in distilling fact holds especially true when measured against the unmistakably pungent reality of the photography that emerged from Vietnam.

Vietnam inspired the repetition of by-now-classic scenes: the pain and indignity of terrified civilians and weeping children, the machines of war and the battles with their wounded, dead, and captured. We had seen

versions of all of these in one form or another in the photography of previous wars. But what we weren't prepared for was the photographer's overt shock at what was happening before his very eyes — at horrors not shown us before. For the first time, images of the suffering *we* were causing far outnumbered those of American heroics.

Although David Douglas Duncan's Vietnam reality differed little from what he saw in Korea — brave Marines, this time at Khe Sanh — a new generation of photographers viewed Vietnam more ambivalently. What they focused upon was the anguish of its people: Malcolm Brown showed a flame-engulfed Buddhist monk self-immolated in Saigon in 1963; and ten years later there was Huynh Cong "Nick" Ut's Pulitzer Prize-winning photograph of little Phan Thi Kim, naked, having torn off her napalm-burning clothes, running, screaming toward us. Don McCullin photographed a fallen North Vietnamese soldier, his personal effects scattered by plundering South Vietnamese: just beyond the reach of the soldier's arm is his wallet, spilling letters from home and photographs of his parents, wife, and children. These are images that will not leave one's mind.

Tim Page's NAM and Philip Jones Griffiths's VIETNAM INC., both books of photographs published after the war, shared a vision of Vietnam's lush beauty and its killing heat. But whereas Griffiths focused on the civilian casualties of armed combat and the misguided programs to "win hearts and minds," Page was seemingly most touched by the GIs — the ghetto blacks and white midwestern farmboys who, one moment, had been hanging out in their particular islands of America and, the next, found themselves forced into a world of ambushes, mine fields, booby traps, and firefights.

In 1969, Page was severely wounded in Vietnam when a man in front of him stepped on a land mine and a two-inch blade of shrapnel was driven through Page's forehead. Several months later, recovering in London, Page received a letter from a British publisher asking him to write a book that once and for all would "take the glamour out of war." According to Michael Herr, Page couldn't get over it. He quoted Page in DESPATCHES as saying, "Take the glamour out of war! I mean how the bloody hell can you do *that?*…It's like trying to take the glamour out of sex, the glamour out of the Rolling Stones! Ohhh, what a laugh!"

■

ONE MIGHT FIND "GLAMOUR" IN JACQUES LANGEVIN'S PHOTO-graph of the U.S. 82nd Airborne's handsome Captain Smith (page 22), which ended up on the cover of LIFE. There might even be "glamour" in the macho display of helicopters, tanks, and aircraft in the remote wastes of the desert. But there is no glamour to be found in Langevin's pictures of the "Highway of Death." His photograph (pages 4–5) of the charred remnants of what had been an Iraqi soldier, his wrecked body nearly indistinguishable from the wreckage of the burned vehicle in which he had

been trying to escape, is truly horrible. This is the image that will stay with me the longest from the Gulf War.

The photographs Sygma presents in this book are so different from those we saw in Vietnam. The Indochina landscape was green, lush, wet; the Gulf landscape brown, desolate, dry. The juxtaposition of the soldiers and their equipment in the desert is astonishing. I look at Derek Hudson's photograph (pages 78–79) of a British division of armored vehicles in the desert, their taillights glowing in the hazy dusk, and it is as though this war were fought on an alien planet.

I look at Patrick Durand's photograph (page 136) of a no-longer-graceful cormorant half-sinking into the oil-fouled Persian Gulf and I find incomprehensible the arrogance of a man who would wage war against his own planet. I look at Stephane Compoint's photograph (pages 134–35) of an abandoned Iraqi tank sitting in the pool of oil left from the destruction of the Kuwaiti wells by the retreating Iraqi army, the oil fires burning in the background, and I see yet more evidence of Saddam Hussein's madness. And, too, I wonder at Compoint's photograph (pages 130–31) of a Kuwaiti standing before an oil fire,

his red and white *kuffiyah* so startlingly colorful against the blackened sky. It is shocking to find beauty in images of such destruction.

Most of all, I look at the sorrow and the dignity of the faces of the family photographed by Jean-Louis Atlan (page 154) at Arlington National Cemetery in Virginia as their son is laid to rest, and I brood. *Yes*, it was a great victory. *Yes*, it helped this nation, in the President's words, "kick the Vietnam syndrome once and for all." *Yes*, we stopped the armed aggression of Saddam Hussein against Iraq's neighbors. And *yes*, we have restored the Emir of Kuwait to power — whether the Kuwaitis want him or not. But as I look at Patrick Durand's photograph of plump, sporty Kuwaitis in their convertible (page 110), I cannot make myself care for them one iota as much as I care for that one boy lying in Arlington now.

And, finally, I cannot look at the "Highway of Death" with its incinerated remains of human beings and truckloads of looted jewelry, televisions, dishwashers, and soccer balls, and feel anything but disgust.

As General Schwarzkopf said, "War is a profanity." It really is!

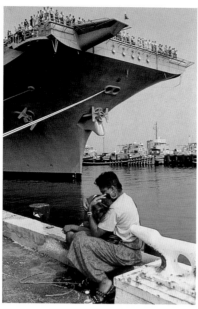

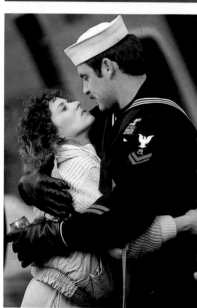

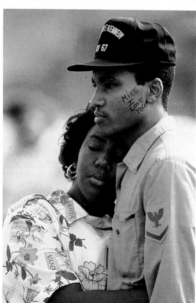

LEAVING HOME

"Ignoring the press and other sailors walking by, they kissed and cried as if they were alone in their own home and not on a cold, rain-swept dock," recalls Les Stone. "For what could be the last time this couple saw each other, they kissed as if they were the only two people left on earth." Norfolk, Virginia. 28 December 1990. *(Les Stone)*

Farewells as the USS *Theodore Roosevelt* sails from Norfolk, Virginia, for the Persian Gulf. 28 December 1990. *(Les Stone)*

Less than two weeks after Iraq invades Kuwait, the aircraft carrier USS *John F. Kennedy* departs from Norfolk, Virginia. 15 August 1990. *(Denis Finley)*

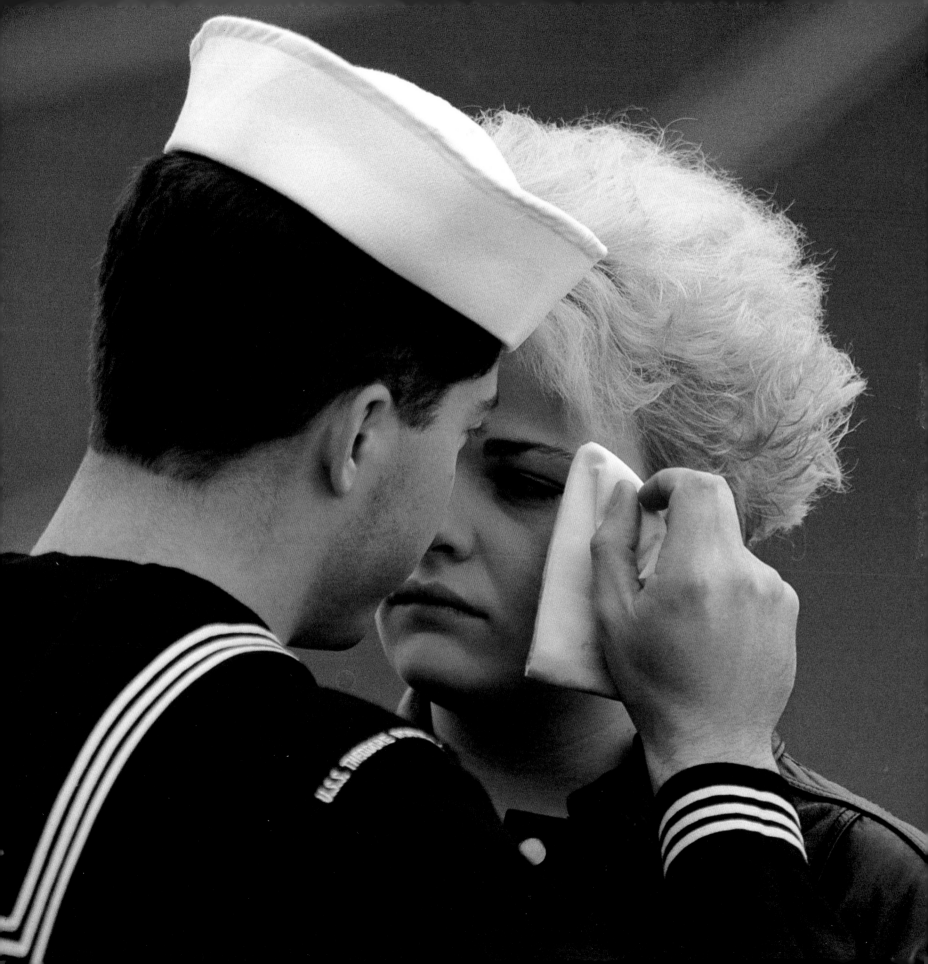

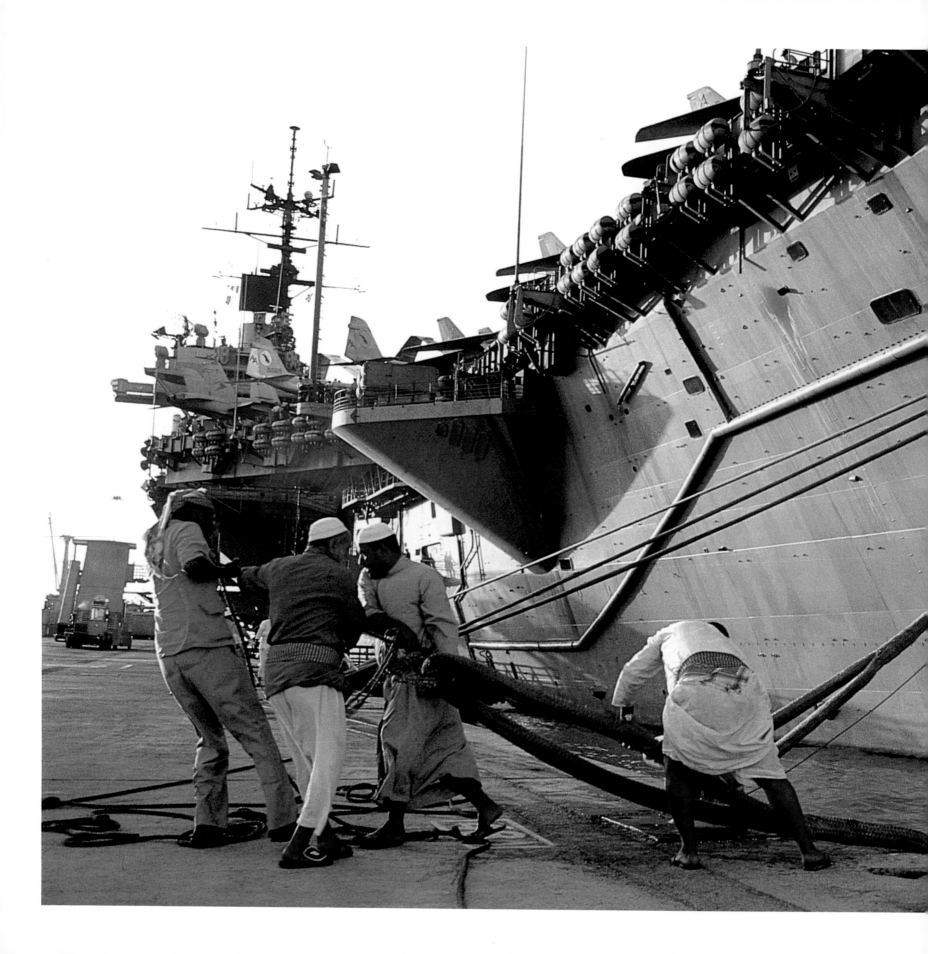

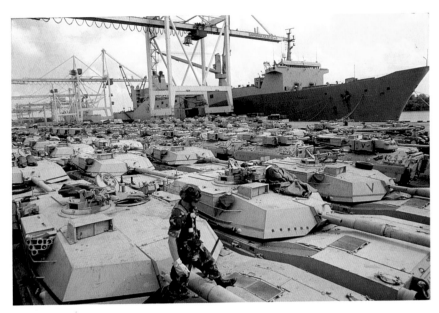

MIDEAST EXPRESS

LEFT

"I happened to be there when the USS *Saratoga* docked in Jidda, Saudi Arabia, for a brief stay. The clash of the two cultures brought together in this strange war struck me instantly," notes F. Lee Corkran. "Here was this modern floating city being secured to the dock by local workers using rope that at a distance looked like a thread, but was actually the thickness of a fist. The dockworkers looked as if they'd be better suited tying up a pearl-diving boat than an aircraft carrier. It seemed their efforts against the giant would have no effect, but they did the job." Jidda, Saudi Arabia. 14 February 1991. *(F. Lee Corkran)*

ABOVE

Tanks from the U.S. Infantry's 24th Division depart from Savannah, Georgia, for Saudi Arabia. 14 August 1990. *(Jonas Jordan)*

FIRST IMPRESSIONS

RIGHT

"Incoming troops — the 'cherries' — assembled here before they were bussed out to the forward camps in the desert," says F. Lee Corkran. "The large Bedouin-style tents were canvas shelters from the blistering Arabian sun in a sand-blowing sea of chaos. Jet and cargo planes of all makes passed in front of them on the constantly busy ramp. K-loaders with pallets full of equipment and supplies lumbered back and forth between planes and dock areas. For new troops this was their arrival point into the Gulf. It was also their departure point into an unfamiliar environment and uncertain future." Dhahran, Saudi Arabia. November 1990. *(F. Lee Corkran)*

ABOVE

Troops of the U.S. 7th Corps arrive from Germany. Dhahran, Saudi Arabia. November 1990. *(F. Lee Corkran)*

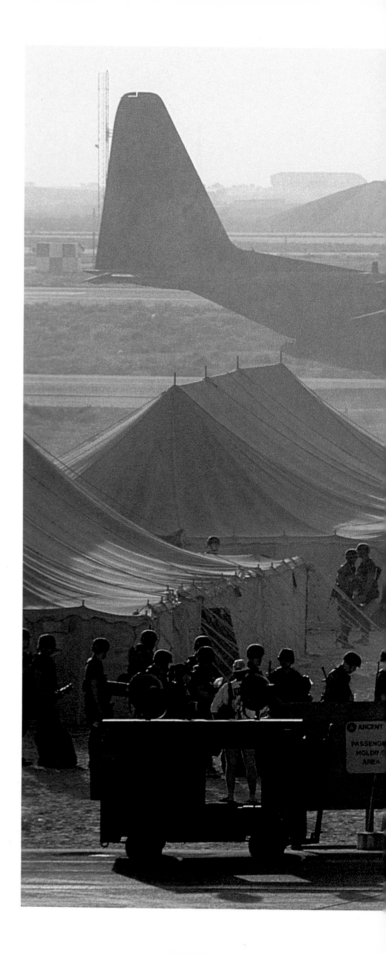

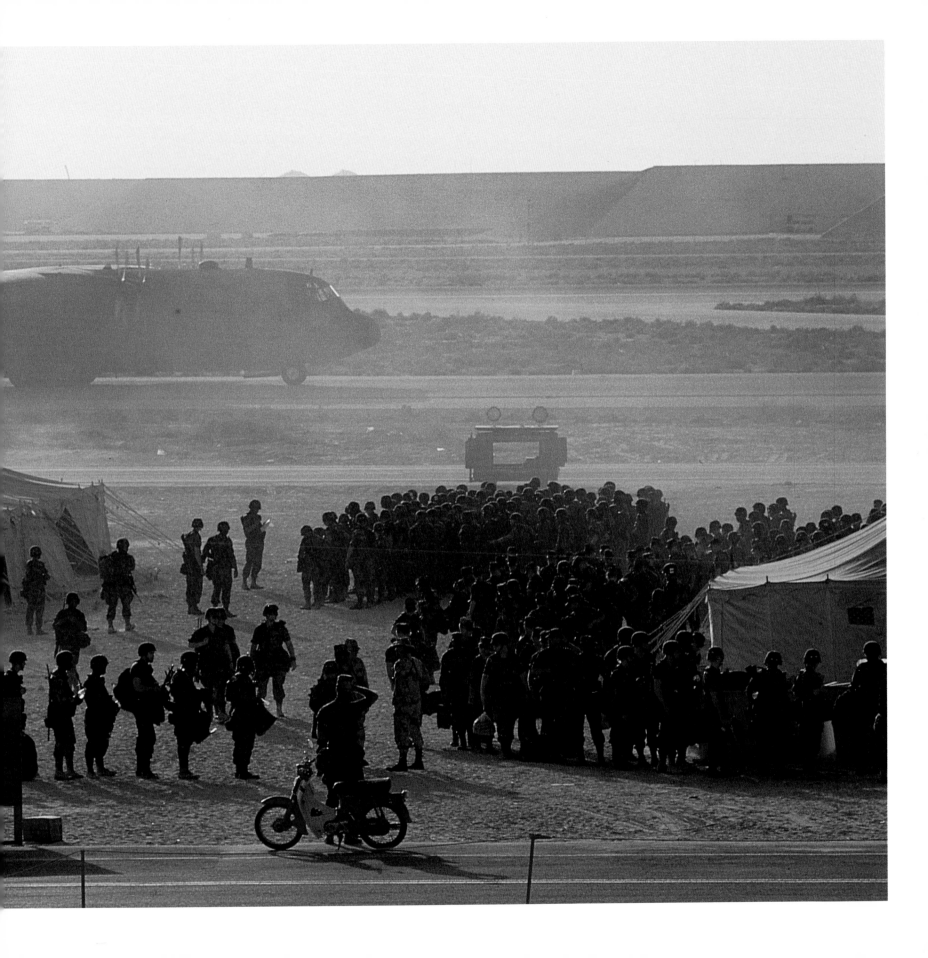

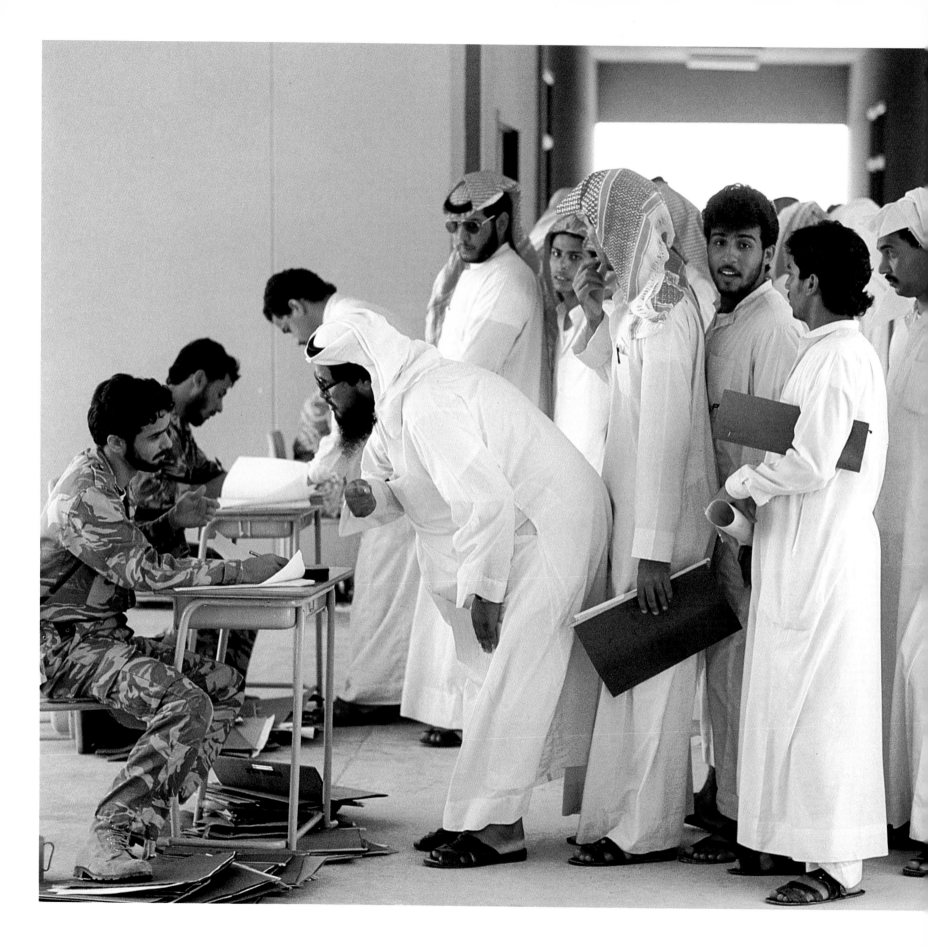

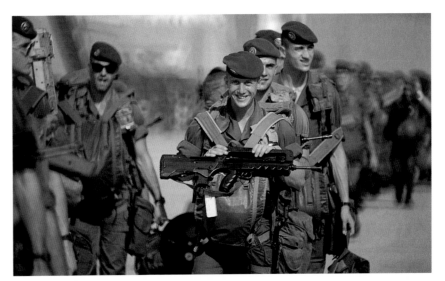

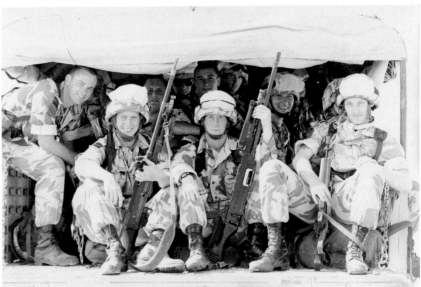

OPERATION DESERT SHIELD

LEFT

"Press was welcomed at the Saudi Army's recruitment centers," reports Jacques Langevin. "The Saudi Ministry of Information had decided to launch a major publicity campaign geared to the media. They were desperate to show the world that Saudis intended to play a vital role in the defense of their homeland against the threat of Saddam Hussein." Dhahran, Saudi Arabia. 28 August 1990. *(Jacques Langevin)*

TOP

"After seven days of seasickness, the arriving French paratroopers expected to find desert, but instead came into an ultramodern port," recalls Thierry Orban. "None of them believed there would be a war." Yanbu, Saudi Arabia. 29 September 1990. *(Thierry Orban)*

ABOVE

British troops of the Coldstream Guards en route to the Kuwaiti northern front. Saudi Arabia. 19 February 1991. *(Derek Hudson)*

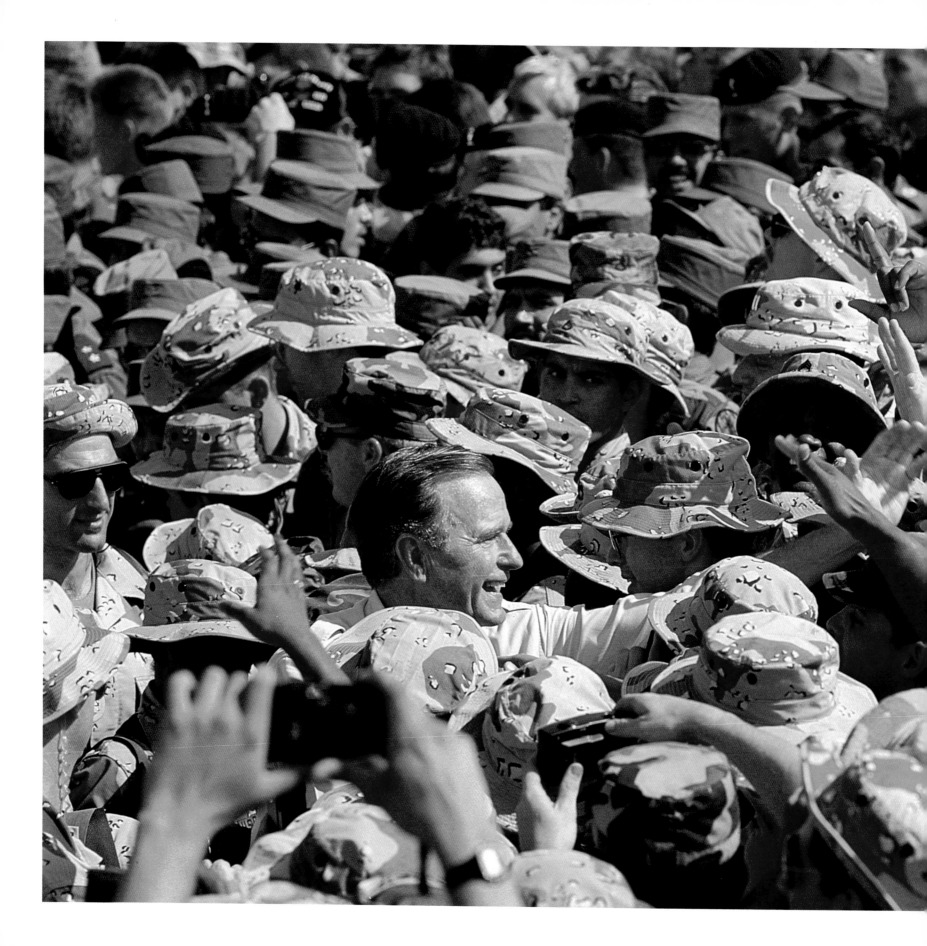

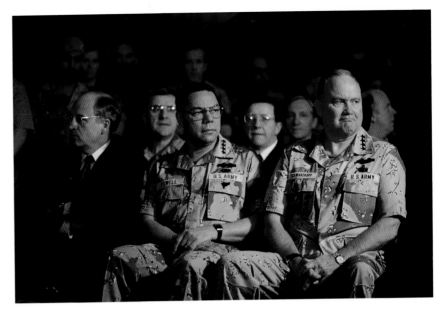

TOP GUNS

LEFT

President George Bush visits American troops during Thanksgiving. Dhahran, Saudi Arabia. 22 November 1990. *(Jean-Louis Atlan)*

ABOVE

"Generals Colin Powell [center] and Norman Schwarzkopf [right] were attending the press conference held by Defense Secretary Dick Cheney [left] at the Riyadh Hyatt," recalls Thierry Orban. "It was a relatively uneventful affair, except Schwarzkopf seemed nervous or in a hurry, and was looking at his two watches so often that I was convinced the ground war would begin any moment. It did begin, but two weeks later." Riyadh, Saudi Arabia. 10 February 1991. *(Thierry Orban)*

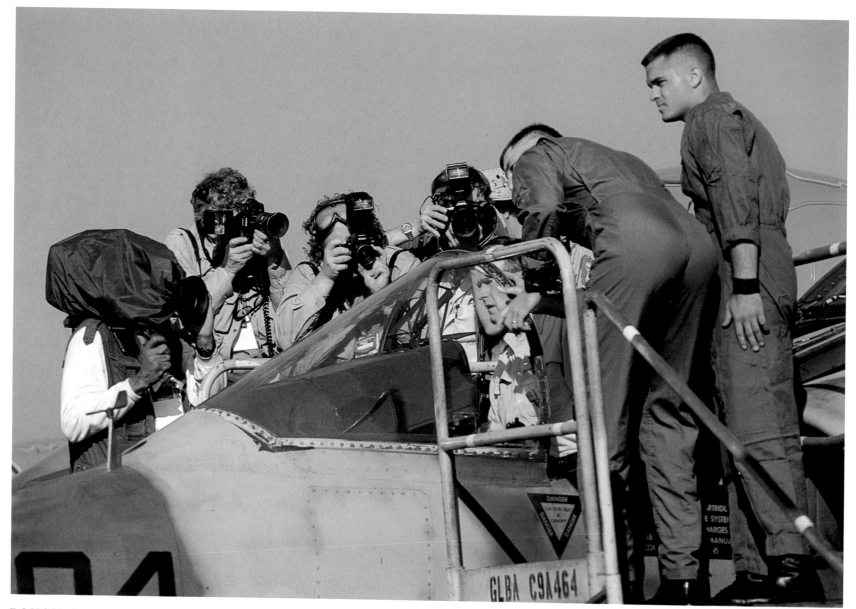

ROUGH AND READY

ABOVE

"President Bush climbed into the cockpit and gave us all a good picture," recalls Jean-Louis Atlan, "but I got the feeling that though the troops were enjoying his visit, they were far more anxious to hear the President say something definite about their mission. Many had been in Saudi Arabia since August and had no idea what was going on. Would they fight a war?" Dhahran, Saudi Arabia. Thanksgiving Day 1990. *(Jean-Louis Atlan)*

OPPOSITE

From the dock in Dhahran, President Bush hails the troops on the deck of the USS *Nassau*. Dhahran, Saudi Arabia. 22 November 1990. *(Jean-Louis Atlan)*

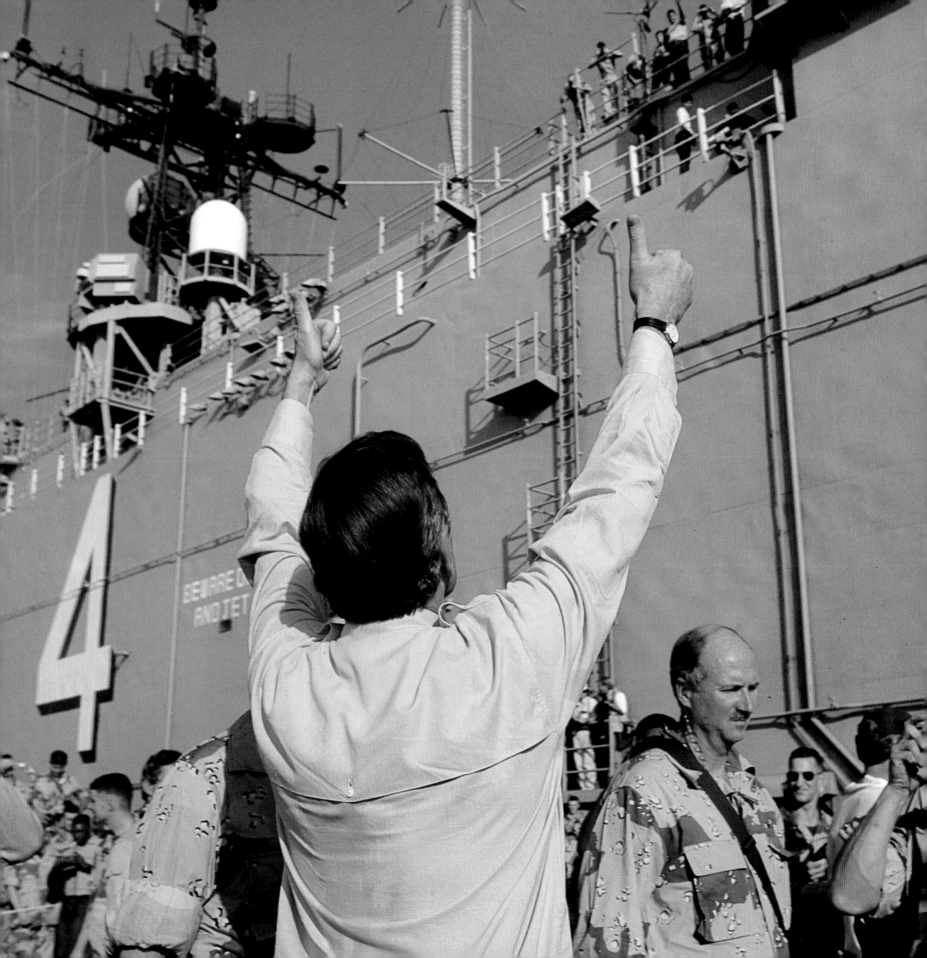

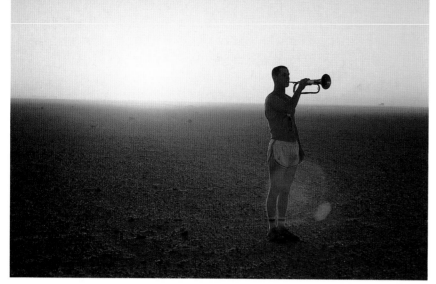

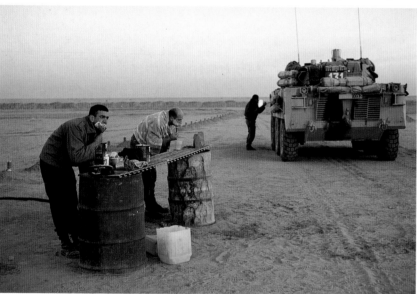

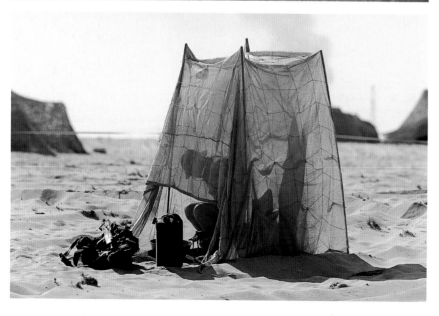

DESERT LIFE

OPPOSITE

By Western standards desert life was primitive. In October the daytime temperature was blistering, and the U.S. Army erected thousands of makeshift wooden showers. "There was a water tank on each roof," Jacques Langevin reports, "and one soldier's chore was constantly to fill the tank. With all the sand, wind, and temperatures over one hundred degrees, showering was the only true luxury." Jubail, Saudi Arabia. October 1990. *(Jacques Langevin)*

TOP

The bugler practices a short distance from camp. 6th Engineering Regiment, French Foreign Legion, northeast Saudi Arabia. December 1990. *(Axel Saxe)*

MIDDLE

Morning washup for the French Foreign Legion. Camp of the 1st Cavalry Regiment, northeast Saudi Arabia. December 1990. *(Axel Saxe)*

BOTTOM

"Our helicopter was lifting off to fly us over a live tank battle exercise of the British 7th Armoured Brigade, when I spotted an odd little camouflage shroud with a rifle and gas mask sitting outside," remembers Derek Hudson. "Silhouetted was some poor guy who was taking advantage of the facility." Abu Hadriya, Saudi Arabia. 7 January 1991. *(Derek Hudson)*

OVERLEAF

At day's end, French Foreign Legionnaires in their battle fatigues jog several miles around their camp. Directly behind them follows a truck ready to dispense NBC (Neurological Biological Chemical) suits in case of a surprise chemical attack. Saudi Arabian desert. December 1990. *(Axel Saxe)*

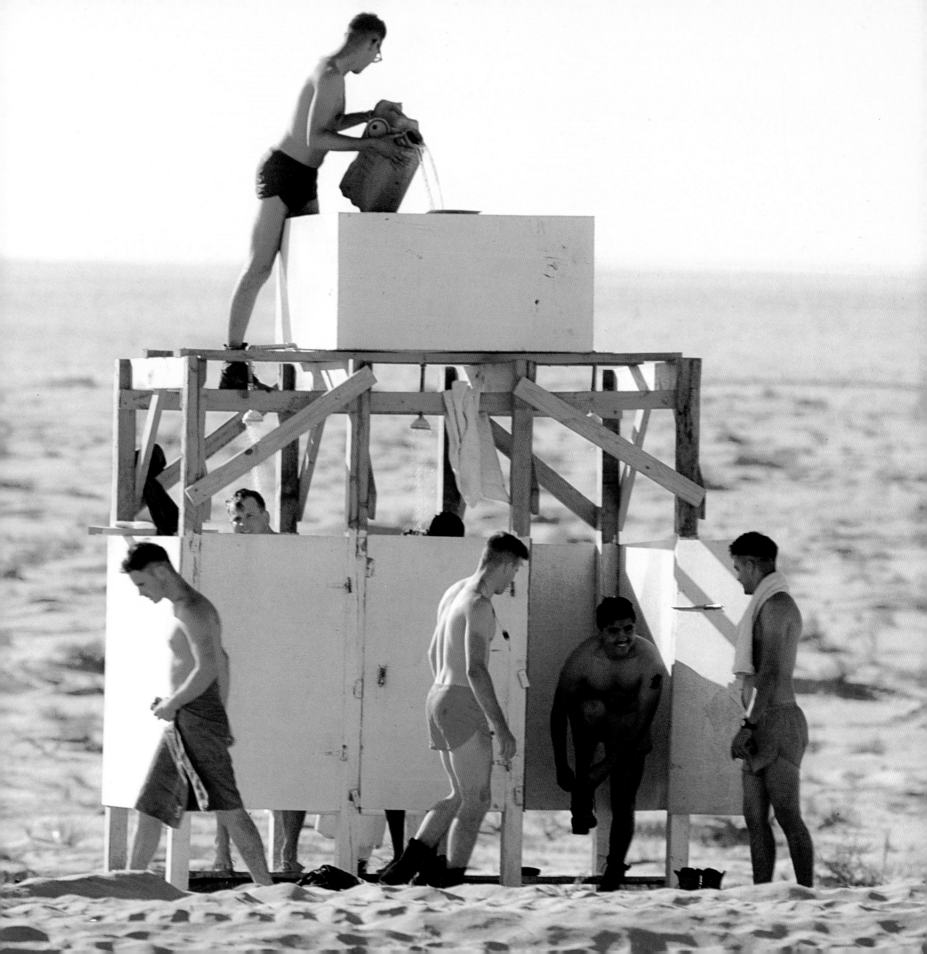

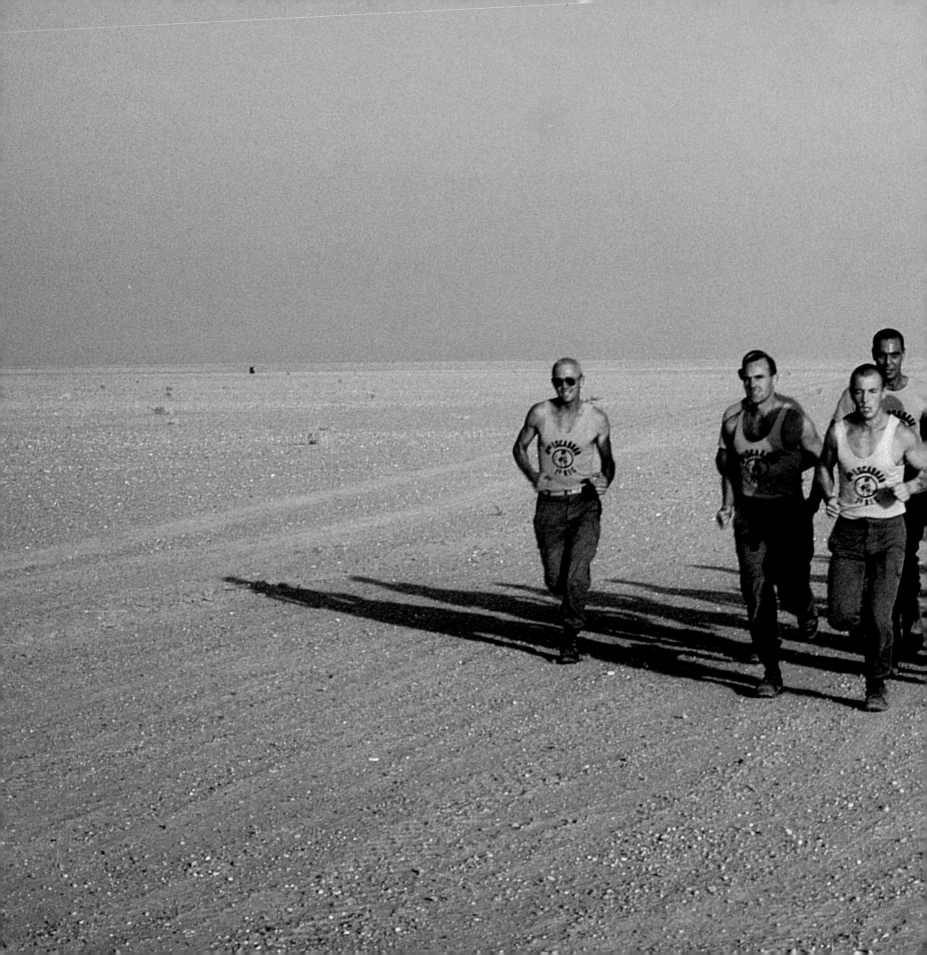

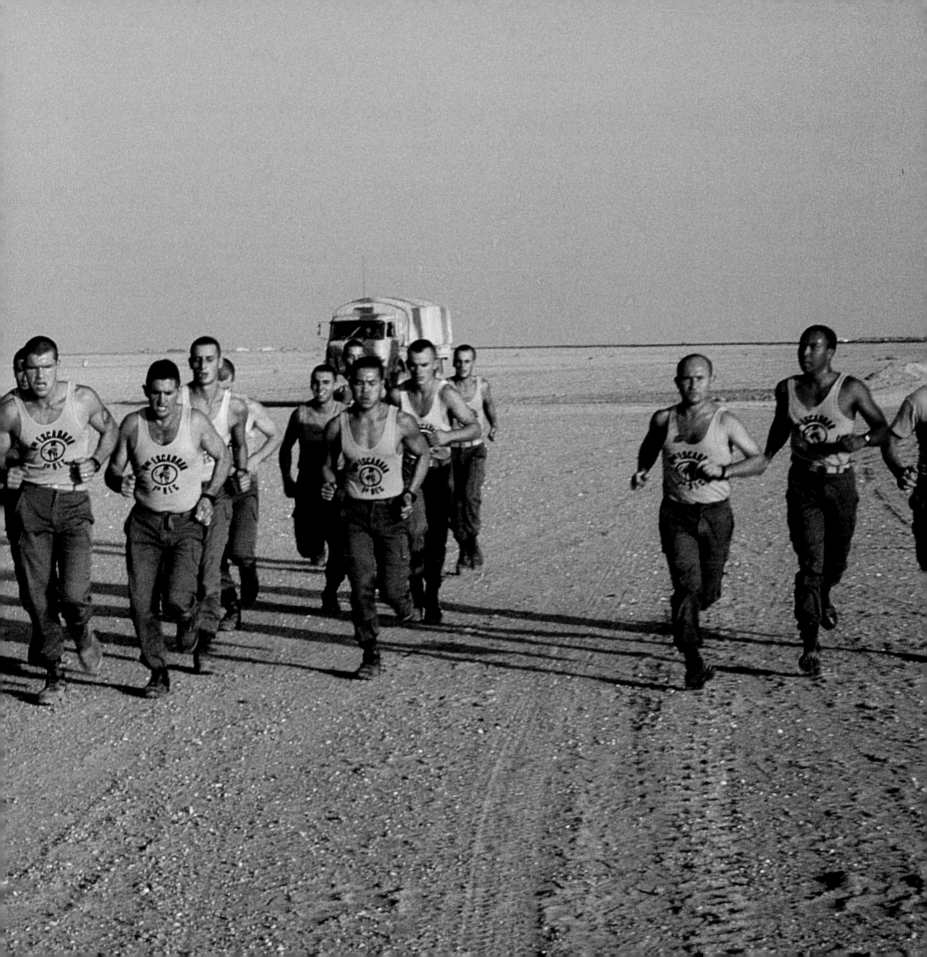

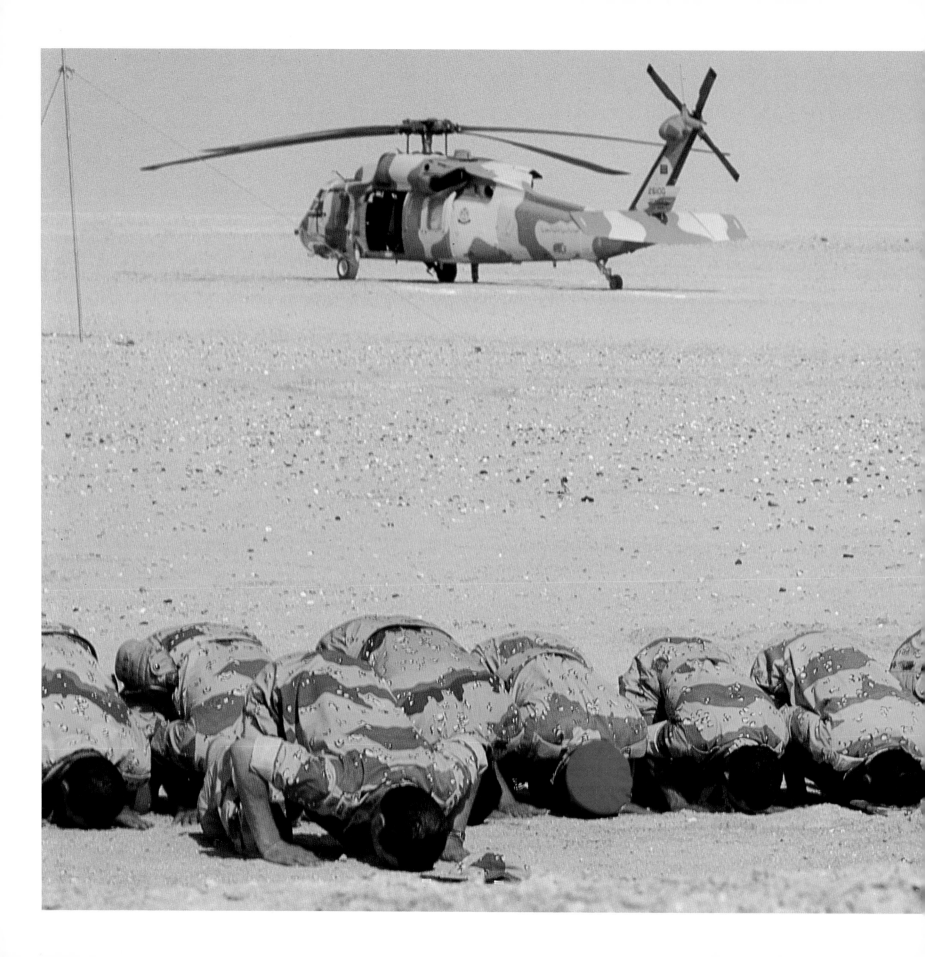

FACING MECCA

LEFT

"Five times a day the Saudi soldiers pray," notes Jacques Langevin. "With the help of water canteens, they purify themselves through the ritual of washing their faces and feet and, in special cases such as a military alert, by pouring water over their boots without removing them." Saudi-Kuwaiti border. 25 August 1990. *(Jacques Langevin)*

ABOVE

Saudis face Mecca for tank-side prayer. Saudi-Kuwaiti border. 25 August 1990. *(Jacques Langevin)*

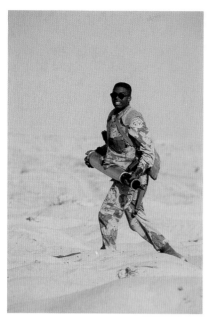

SAND TREK

"It was 110 degrees at noon and the desert was like an inferno," remarks Jacques Langevin. "Nevertheless, the U.S. Marines were training." Saudi Arabia. November 1990. *(Jacques Langevin)*

During a live-ammunition training exercise, a U.S. soldier carries a shell from a truck to a tank, where it will be fired. Saudi Arabia. November 1990. *(Jacques Langevin)*

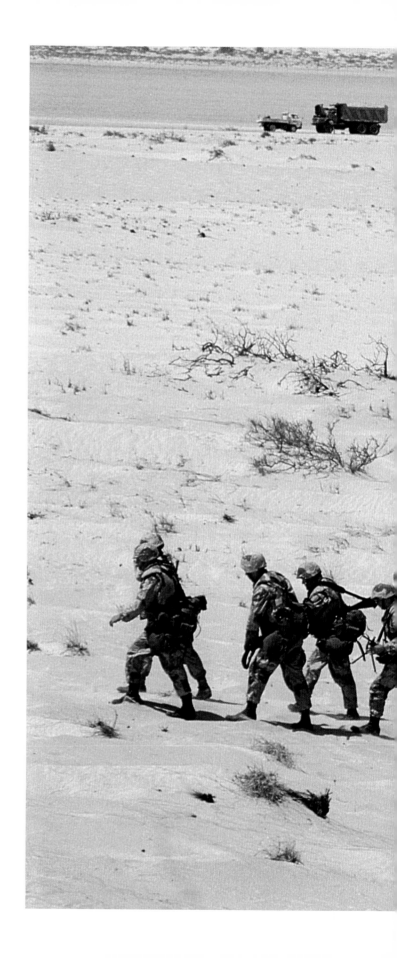

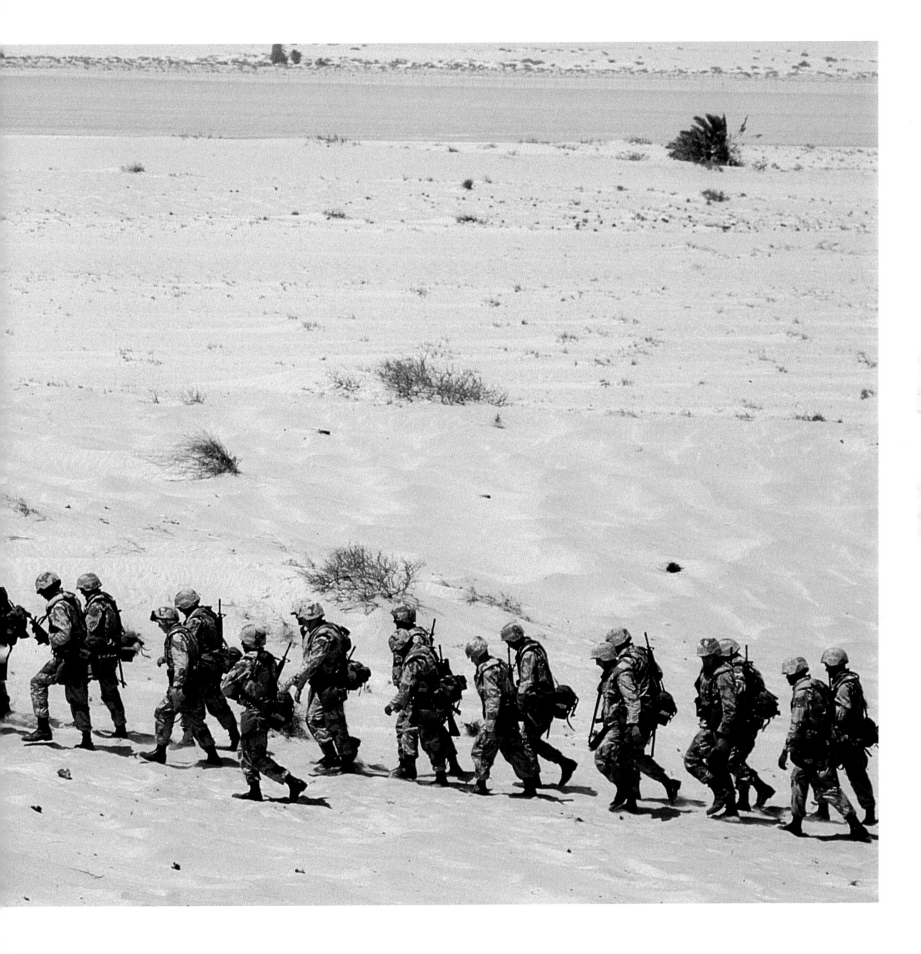

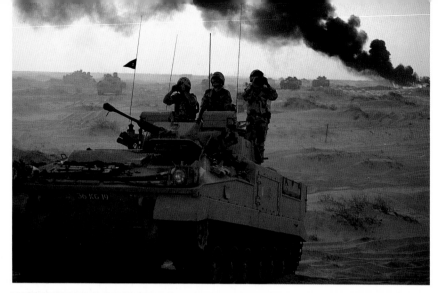

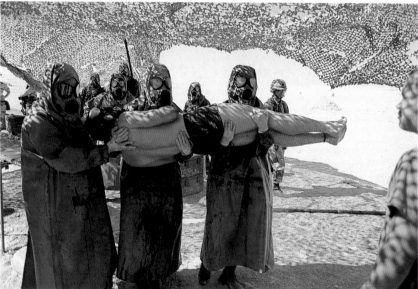

WAR GAMES

Eight days before the United Nations deadline of 15 January for the withdrawal of Iraqi forces from Kuwait, the British "Desert Rats" begin a fresh phase of their training using live ammunition for the first time. "There was a sandwich lunch just like a British tea party. Polite conversation with brigadeers, colonels, et al.," reminisces Derek Hudson, "and once the cake had been devoured, battle commenced." The 7th Armoured Brigade and the 1st Staffordshire Regiment train near Abu Hadriya, Saudi Arabia. 7 January 1991. *(Derek Hudson)*

"The process of decontaminating a victim of chemical warfare involved an elaborate and thorough cleansing," says Jacques Langevin. "During this training session of soldiers of the 82nd Airborne, the victim was totally undressed, except for gas mask and shorts. It's like a car going to the shop for a lube. Everything is washed, sprayed, and tended to." Saudi Arabia. 6 November 1990. *(Jacques Langevin)*

British troops of the Staffordshire Regiment train for desert combat. Abu Hadriya, Saudi Arabia. 6 January 1991. *(Derek Hudson)*

A British soldier carrying a rocket launcher through the trenches in a live-ammo exercise. Abu Hadriya, Saudi Arabia. 6 January 1991. *(Derek Hudson)*

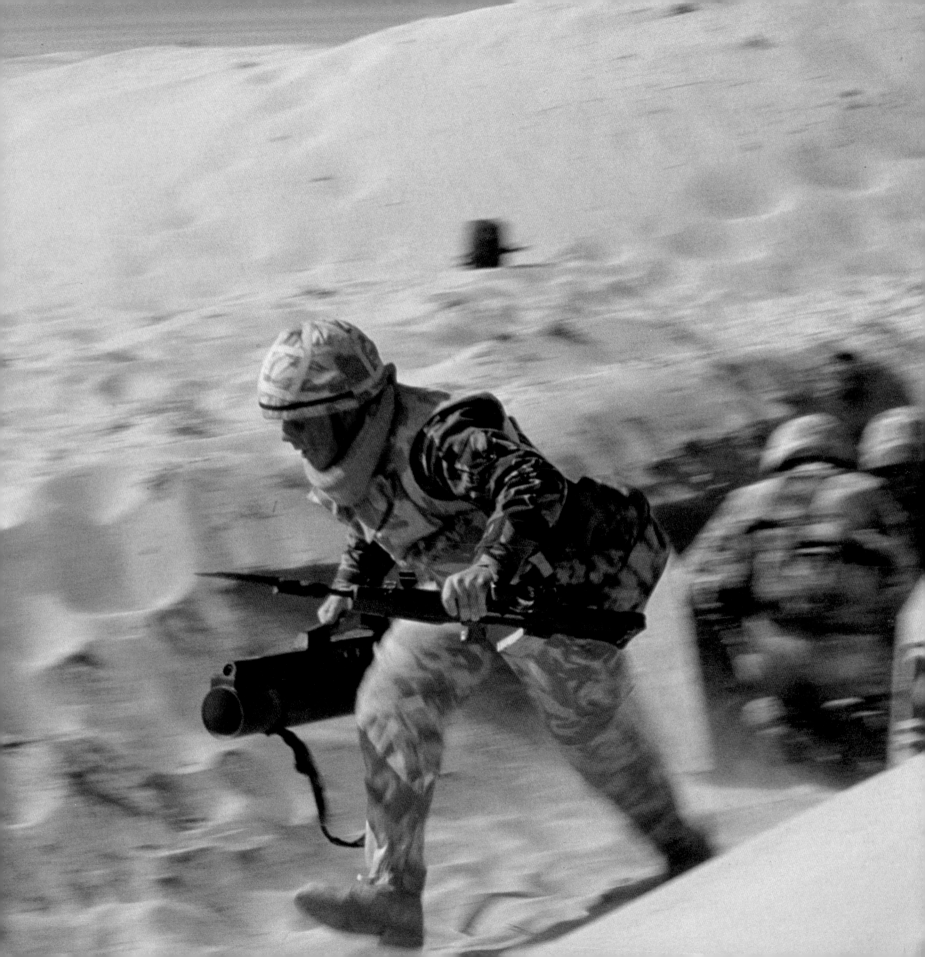

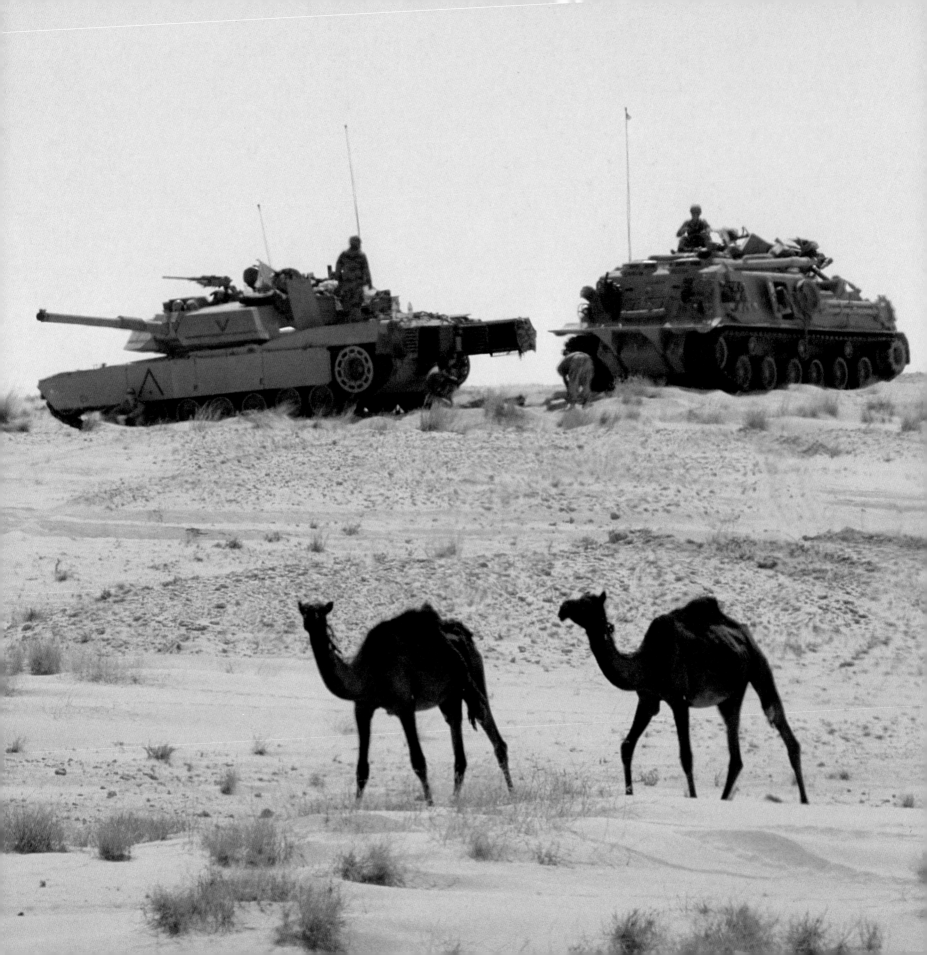

DESERT FAUNA

OPPOSITE

"Somehow the camels did not seem surprised by a dozen U.S. tanks involved in an exercise intruding into their universe," says Patrick Durand. "They were the only creatures in this desert able to bear the heat." Saudi Arabia. 12 September 1990. *(Patrick Durand)*

ABOVE

A U.S. tank crew breaks for rations. Saudi Arabia. 12 September 1990. *(Patrick Durand)*

BELOW

"The British took the press to a demonstration of a mine-clearing device called a Giant Viper," Derek Hudson reports, "a huge coil of explosive charge that flies through the air and clears the mines in a passage ten yards wide and 220 yards long. Afterward, a young soldier pulled a real desert rat out of his pack — he'd found it and kept it as a pet. It provided an amusing interlude in the serious warmongering. After all, the troops of the 7th and the 4th Armoured Brigades were known as the 'Desert Rats.'" Saudi Arabia. December 1990. *(Derek Hudson)*

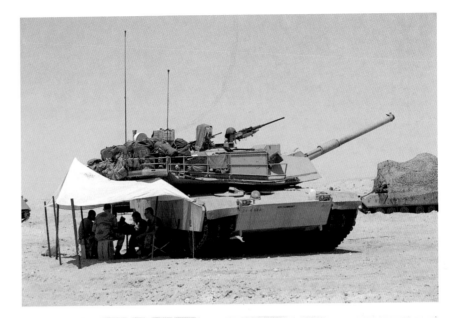

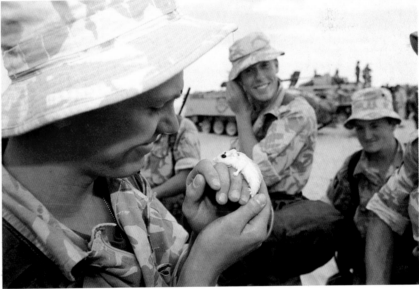

NEW SOLDIERS

ABOVE

"Upon arrival at the Dhahran military airport, U.S. Marines waited several hours before being dispatched to various parts of Saudi Arabia," notes Jacques Langevin. "This was a chance for the soldiers to relax after the long trip from the U.S. For the photographers it was an unusual sight to see young women soldiers. This woman was quite at ease with the boys. She could have been playing cards on a California beach." Dhahran, Saudi Arabia. September 1990. *(Jacques Langevin)*

OPPOSITE ABOVE LEFT

"A field hospital was set up beside the Dhahran military airfield, and this young doctor briefed the media about her functions there," says Jacques Langevin. "The image reminded me of the movie *M*A*S*H* and all the intrigues it had." Dhahran, Saudi Arabia. August 1990. *(Jacques Langevin)*

OPPOSITE BELOW LEFT

Navigator on board an American KC-135 fuel tanker over the Red Sea. September 1990. *(F. Lee Corkran)*

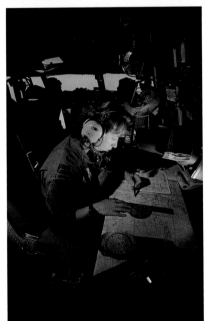

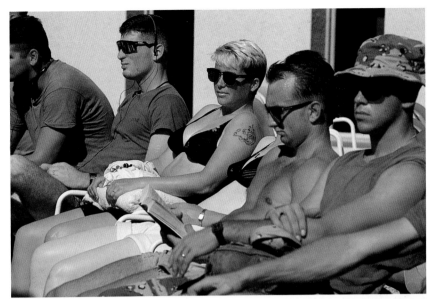

ABOVE RIGHT

"Not expecting much more than a controlled view of U.S. personnel having a 'good time,' I was surprised to enter this U.S. Army camp and find a swimming pool, an outdoor gym donated by Arnold Schwarzenegger, and a hot dog and burger stand," remarks Derek Hudson. "It could have been a scene from a beach or lido anywhere. Nothing special — except that it was in Saudi Arabia, where restrictions on life are completely over the top. In my hotel, women were not allowed to use the swimming pool, nor could they watch the men using it." "Camp Desertworld," Jubail, Saudi Arabia. December 1990. *(Derek Hudson)*

BELOW RIGHT

"It was an odd sight, but one of modern times — a Soviet reporter in a press pool escorted by the U.S. Army," F. Lee Corkran recalls. "The reporter [center] was interviewing a female Army soldier, and from his questions you could tell he knew very little about the role women play in American society. He asked her if she would rather be home having children. Did she feel out of place wearing Army pants and carrying a rifle? If she came up against a good-looking enemy, would she still shoot him? I might have guessed he was being cynical, but he questioned her with a genuine air of innocence. And the soldier was great. She didn't even blink, just responded with tact and sincerity." Saudi Arabia. November 1990. *(F. Lee Corkran)*

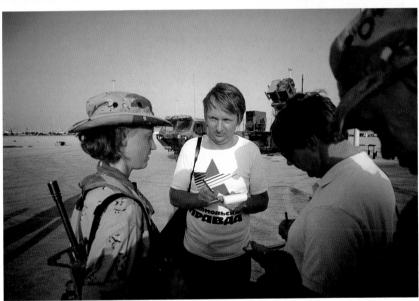

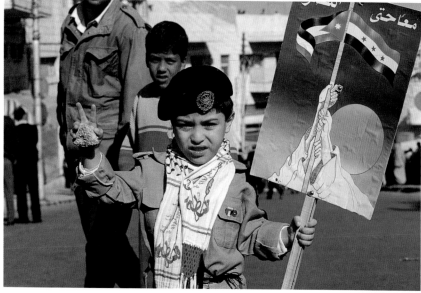

SAFE HAVEN

TOP

Refugees queue up for water along the Jordanian-Iraqi border. Later, some of the more tenacious hitch a ride to the water truck's next stop (right). From early fall 1990, Jordan became the most crowded destination for foreign workers fleeing the threat of war in Iraq and Kuwait. 10 September 1990. Al Rueshed, Jordan. *(Dominique Aubert)*

ABOVE

At a pro-Iraqi demonstration a child signals victory with stone in hand, symbol of the Palestinian *intifada* (uprising) in the Occupied Territories. Palestinians represent sixty percent of Jordan's population, and the vast majority rallied behind Saddam Hussein, who stated that he would withdraw from Kuwait when Israel withdrew from the Occupied Territories. Amman, Jordan. 25 January 1991. *(Patrick Robert)*

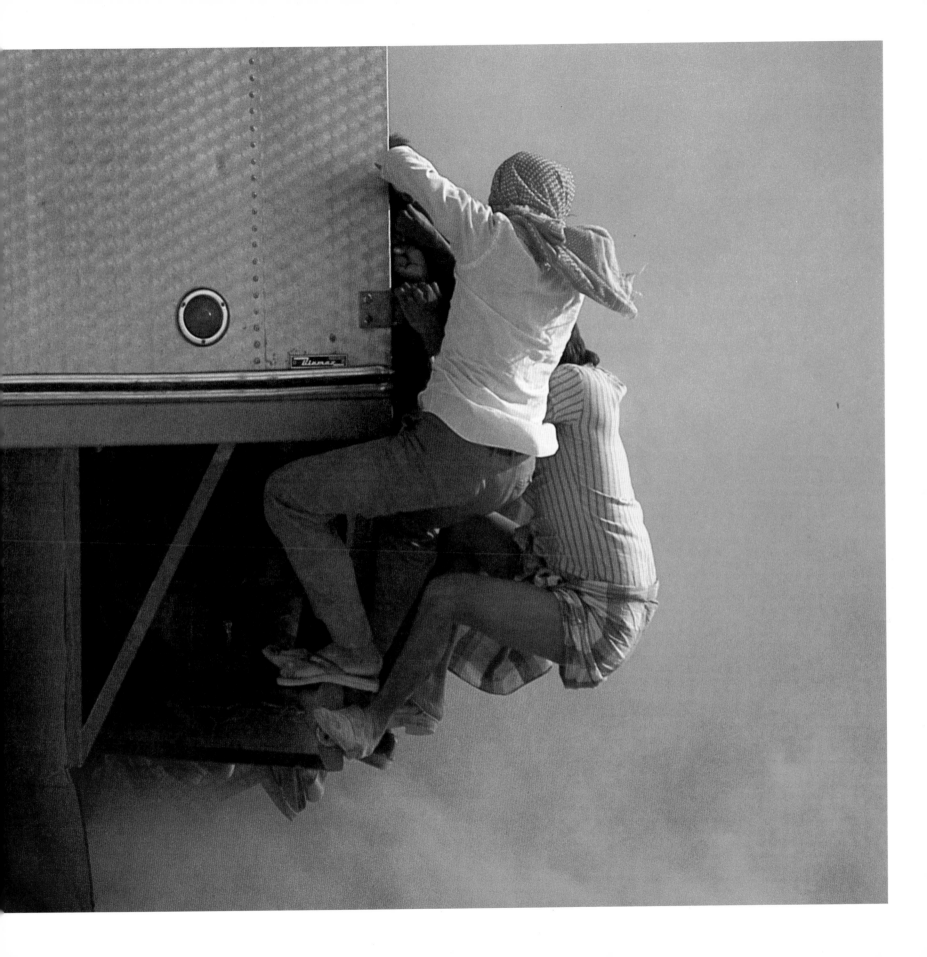

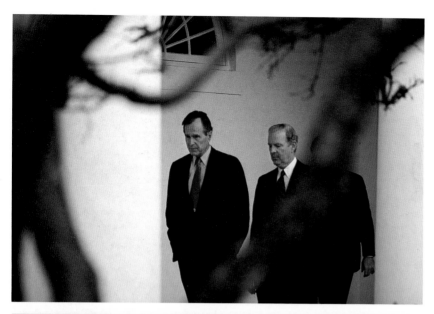

DEADLINE IN THE SAND

ABOVE

"There was a feeling around the White House that we were going to war, and it would happen today," recalls Jean-Louis Atlan. "The fact that the President had spent the morning at his residence and not in his office was our biggest clue. Then the White House Press Office informed us of a photo opportunity around noon. Only photographers were invited — no television crews or writers. Clearly, they wanted us to capture this dramatic image of Bush and Baker contemplating war. Hours later the White House spokesman Marlin Fitzwater announced 'the liberation of Kuwait has begun.'" Washington, D.C. 16 January 1991. *(Jean-Louis Atlan)*

BELOW

Baghdad under siege by allied bombing on the first of thirty-eight consecutive days and nights of attack. Antiaircraft artillery shells fill the sky in a view from the Palestine Hotel. Baghdad, Iraq. 17 January 1991. *(Gary Orso)*

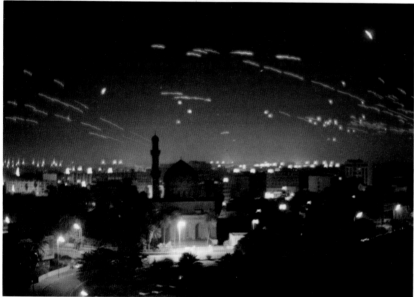

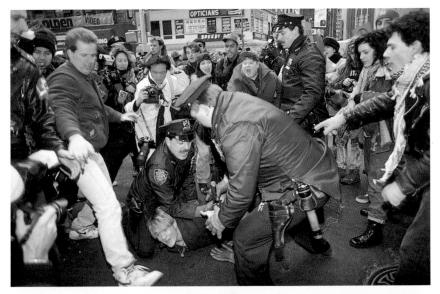

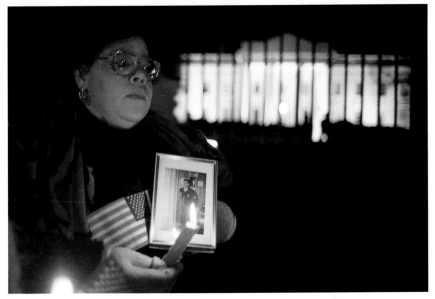

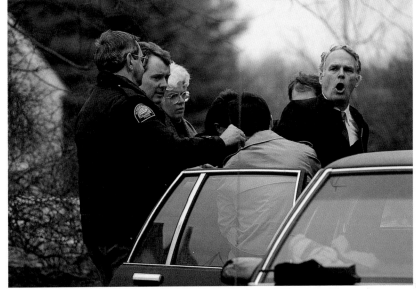

BETWEEN PEACE AND WAR

TOP RIGHT

Commuters at the gates of the naval base at Pearl Harbor learn of the allied air strike against Iraq. Honolulu, Hawaii. 16 January 1991. *(James Cachero)*

TOP LEFT

"This demonstration started in Times Square and moved downtown accompanied by a large contingent of police," remembers Nola Tully. "The voice of opposition was having a hard time making itself heard, and the efforts to suppress it were strong. I've never witnessed a protest in New York that actually became violent, but this was getting close. And some of the authorities were the more threatening participants — many of them mounted on horses." New York City. 14 January 1991. *(Nola Tully)*

ABOVE RIGHT

Police remove a protester after he shouted his opposition to the war during a church service attended by President Bush. Kennebunkport, Maine. 17 February 1991. *(Jean-Louis Atlan)*

ABOVE LEFT

On the eve of the U.N. deadline demanding that Iraq withdraw from Kuwait or face military retaliation, families of American troops in the Gulf display their anguish for loved ones as they mount a vigil in front of the White House. 14 January 1991. *(Jean-Louis Atlan)*

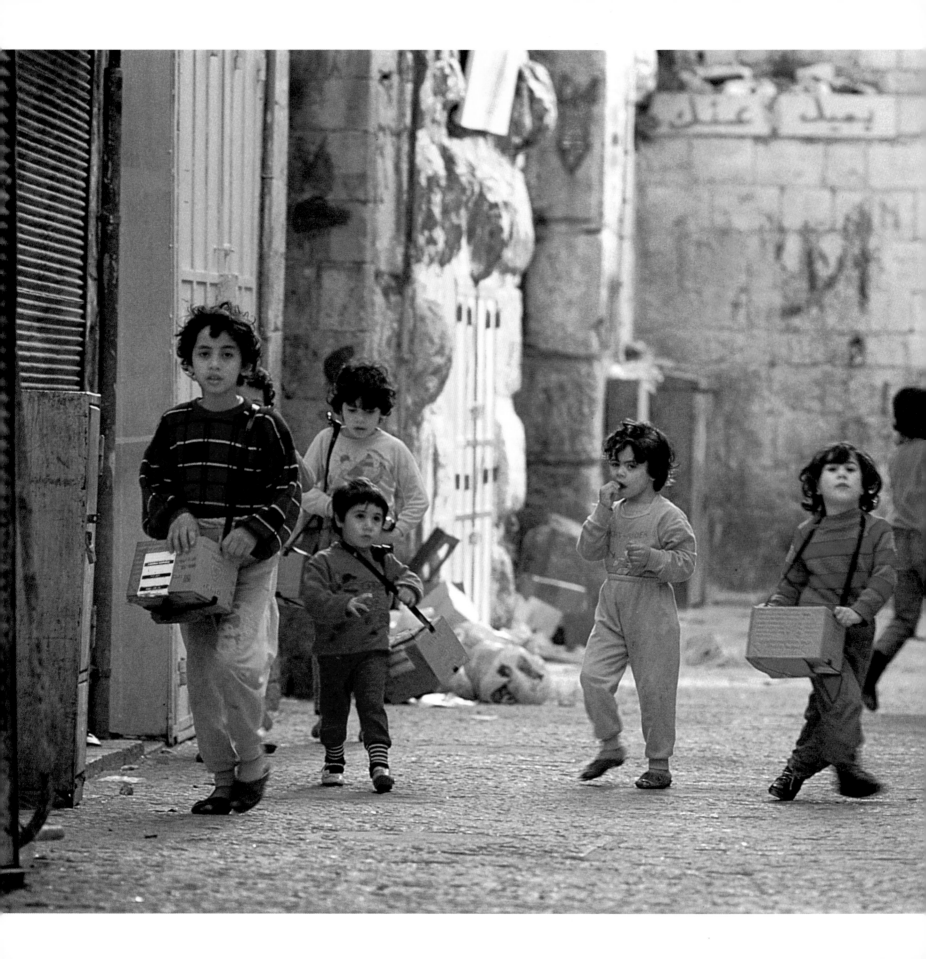

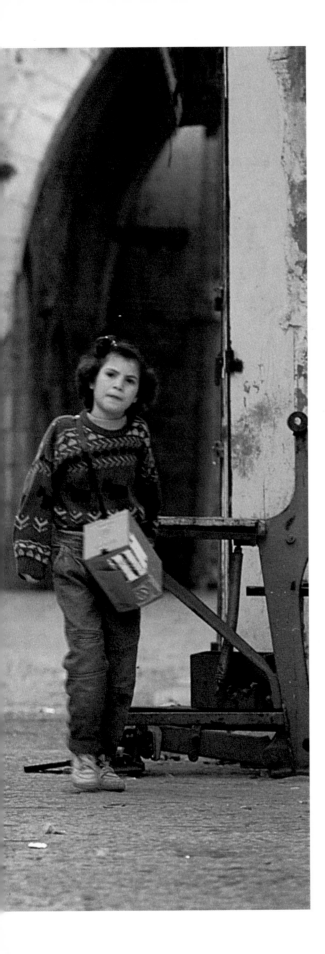

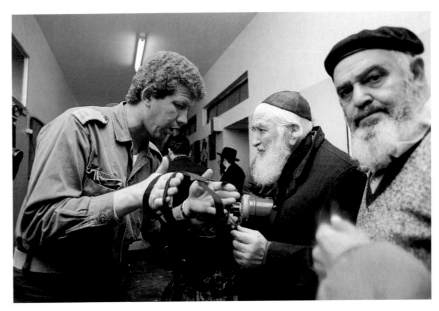

READY TO WEAR

ABOVE

"After extended arguments among religious Jews in Israel," says Moshe Milner, "it was decided that their beards would remain intact, and beard-conforming gas masks should be provided by the government. There was a lot of tension and fear of the unknown as people prepared in a high school auditorium for an Iraqi Scud missile attack." Bnei Brak, a suburb of Tel Aviv, Israel. January 1991. *(Moshe Milner)*

LEFT

Palestinian children with gas mask kits in the old quarter of Jerusalem. 18 January 1991. *(Dominique Aubert)*

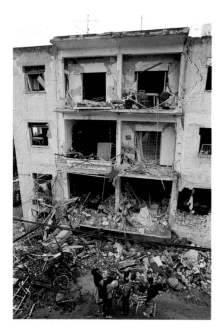

WHAT SCUDS DO BEST
ABOVE

"The morning after a Scud attack, this apartment building reminded me of an aquarium, as residents collected their belongings from their nakedly exposed apartments," observes Moshe Milner. Ramat Gan, Israel. January 1991. *(Moshe Milner)*

AN UNCENSORED PATRIOT
RIGHT

This is the first published photograph taken of a Patriot missile over Tel Aviv aimed at an incoming Iraqi Scud missile. The split-second opportunity to capture the picture came at the first sound of air raid sirens. "I had only one chance to take the shot because of the missile's speed," says Dominique Aubert. "And I had to do it wearing my gas mask." His photograph miraculously passed through otherwise stringent Israeli military censors only because they reviewed slides using an ordinary desk lamp, instead of a light table, in the early stages of the war. Tel Aviv, Israel. 23 January 1991. *(Dominique Aubert)*

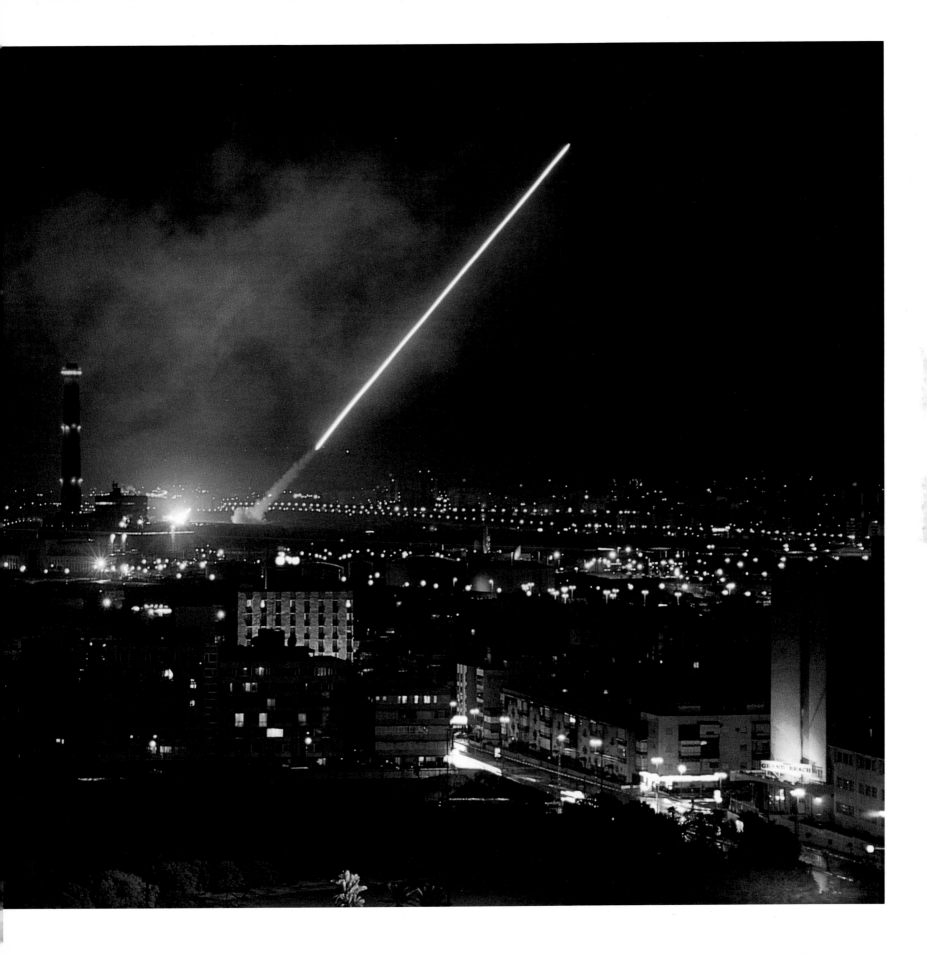

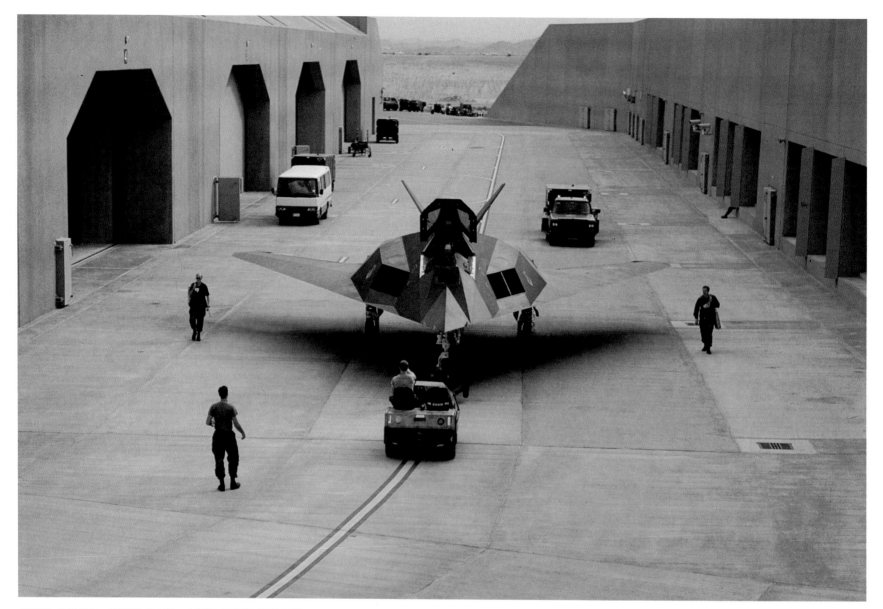

THE GOOD, THE BAD, AND THE UGLY

"I was astounded by how ugly the F-117 Stealth was when I finally saw it
in person," says F. Lee Corkran. "There was nothing familiar or sexy about
it as with other fighter jets. Even parked, it looked menacing, like a black
raven awaiting its prey." Saudi Arabia. September 1990. *(F. Lee Corkran)*

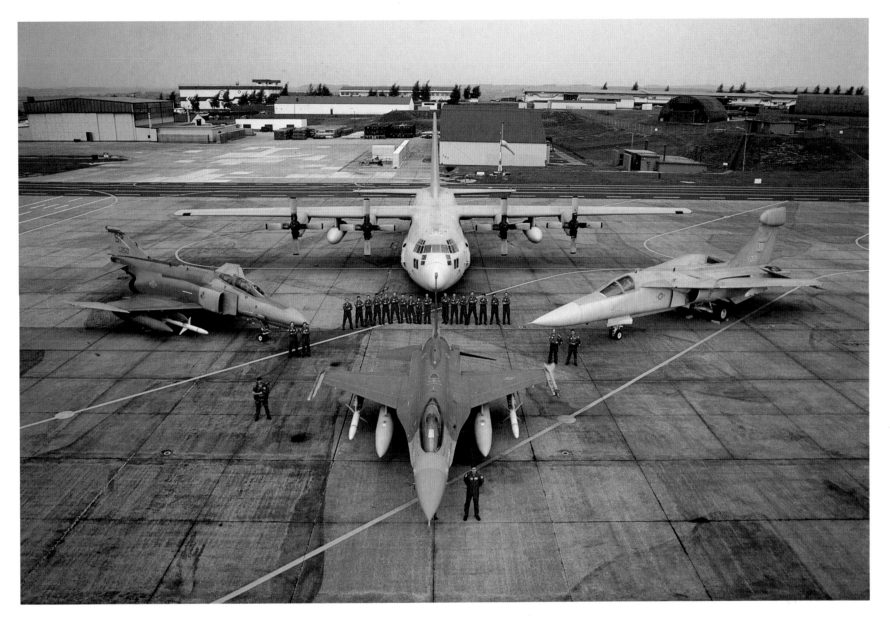

ABOVE
A family portrait of the latest in electronic countermeasure (ECM) aircraft employed in the Gulf War. Their specialties included jamming radar and firing HARM missiles to destroy radar transmitters. Pictured here, clockwise from top: an EC-130 Hercules, an EF-111 Raven, an F-16C Falcon, and an F4-G Wild Weasel. *(F. Lee Corkran)*

OVERLEAF
"Every time I watch refueling operations, it always amazes me," says Corkran. "Two planes, flying several hundred miles per hour, several thousand feet up, working quietly and with surprising grace, insert a small hose into a small receptacle. The planes get so close you can sometimes read the lettering on the other pilot's helmet." A KC-135 Stratotanker refuels a Navy F-14 Tomcat fighter over the Red Sea. September 1990. *(F. Lee Corkran)*

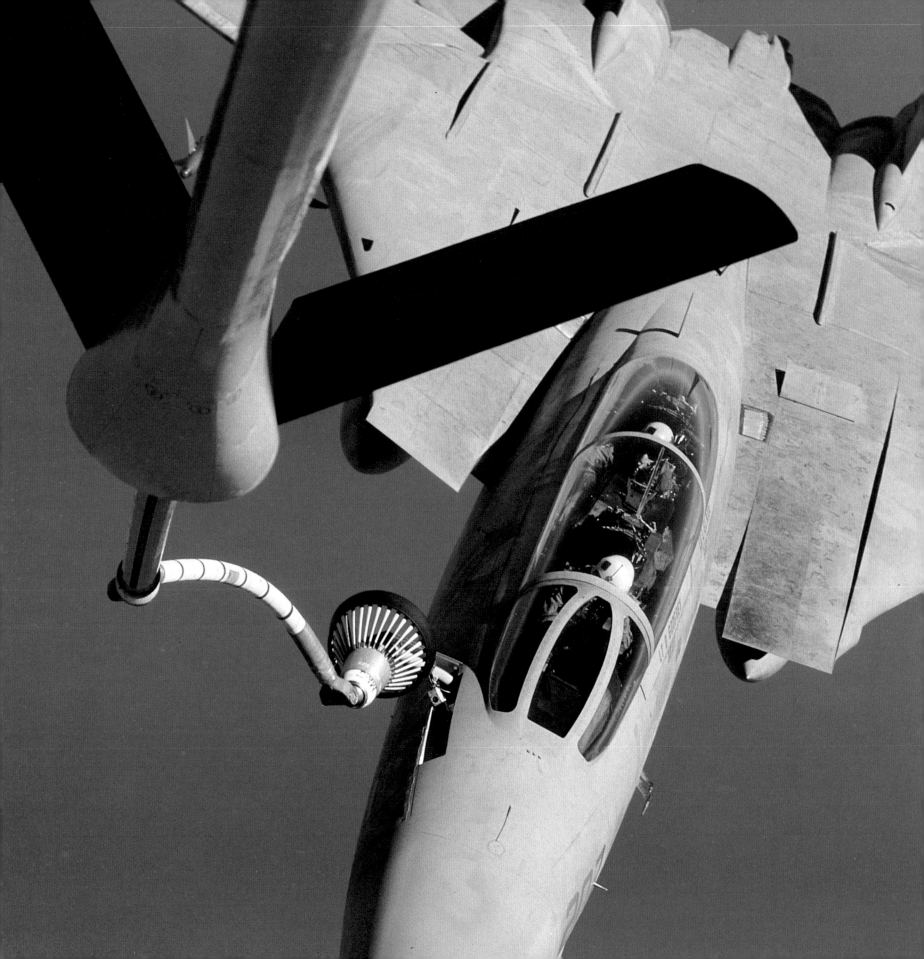

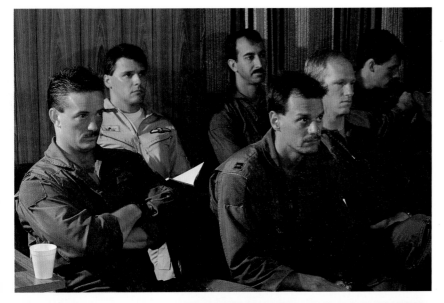

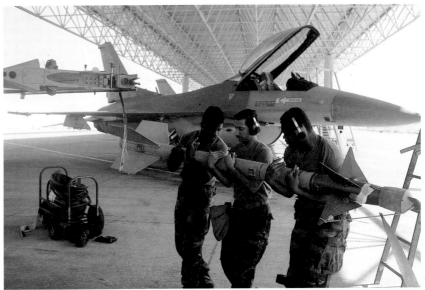

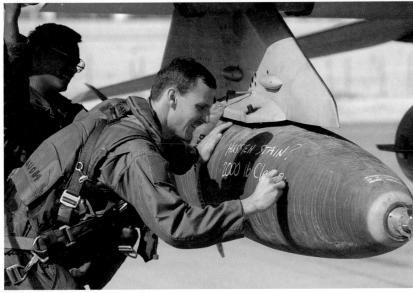

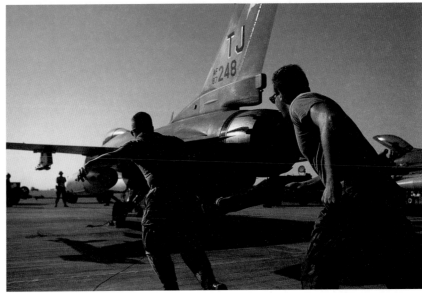

TOP LEFT

"Every day the pilots flying missions gathered together for the 'mass brief' to hear what to expect," says F. Lee Corkran. "This was the start of their business day, sometimes as early as three in the morning. The details of their missions needed to be perfectly understood. There was no room for miscommunication. Later, in the air, they might not get a second chance for interpretation of air-to-air maneuvers, targets, or ground threats." Briefing to pilots of the U.S. 614th Tactical Fighter Squadron. Qatar. October 1990. *(F. Lee Corkran)*

TOP RIGHT

Three airmen load an AIM-9 Sidewinder missile onto an F-16C Falcon fighter-bomber during an exercise called Immediate Combat Turnaround in which planes flying missions make pit stops for fuel, munitions, and, sometimes, a new pilot. F. Lee Corkran observes, "This is an unusual combination of high-tech weaponry and manual labor, as these men cradle the missile in their arms, walk it to the plane, hoist it up, and mount it on the wingtip with nothing more than their muscles and a wrench." Qatar. October 1990. *(F. Lee Corkran)*

ABOVE LEFT

Just minutes before taking off, a pilot from the Lucky Devils, better known as the U.S. 614th Fighter Squadron, scribbles "Hussein Stain 2000 lb. cleaner" on an Mk 84 bomb he will deliver over Iraq. Qatar. February 1991. *(F. Lee Corkran)*

ABOVE RIGHT

Airmen rush toward an F-16 with a fuel hose during an Immediate Combat Turnaround exercise. Qatar. September 1990. *(F. Lee Corkran)*

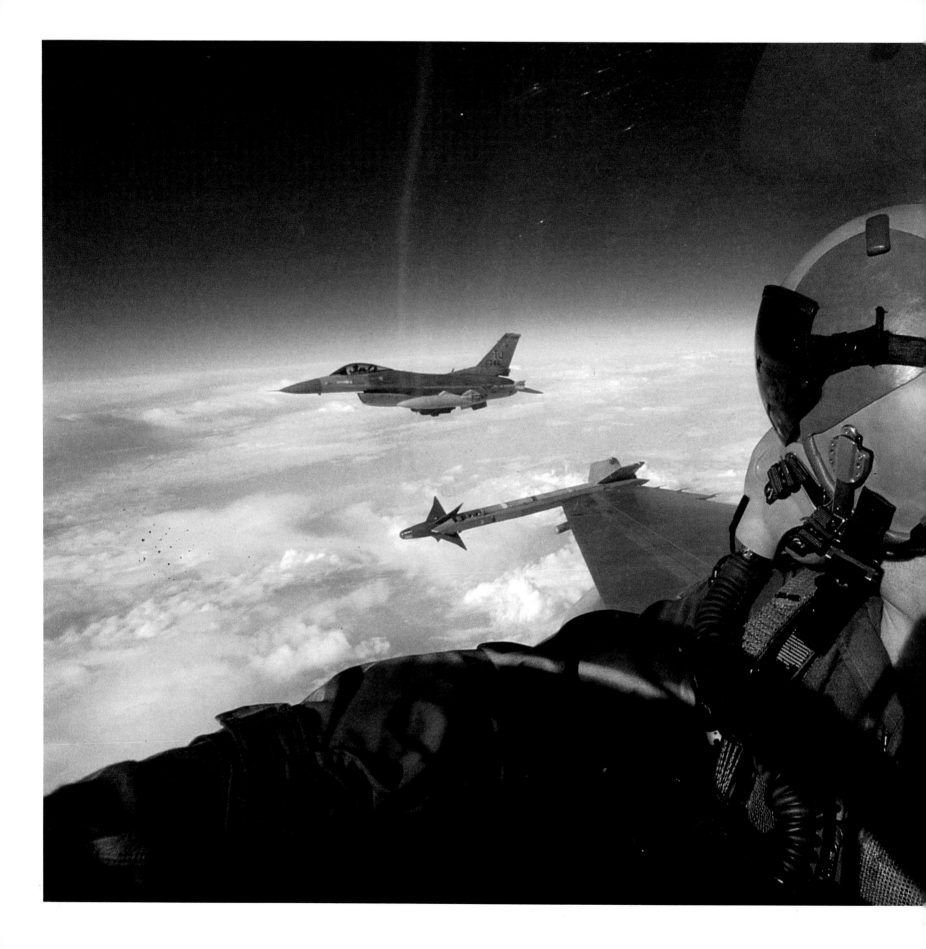

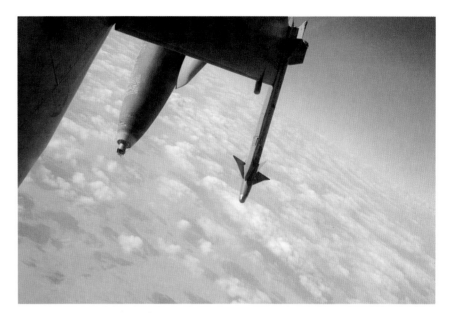

DROPPING BOMBS

ABOVE

"This was the second mission I flew," says F. Lee Corkran. "The first one was like a walk in the park. I calmly watched the puffy clouds over the desert as we dropped in, released our bombs, and went home. I realized this was a distorted view of combat. No sounds of guns, no explosions, no bodies, or carnage. Very quick, very quiet, and, to someone else, very deadly. But on this second mission, we were about twenty seconds away from firing on Iraqi artillery positions when 'friendly' multiple rocket launchers began firing in the same direction we were headed. The silver points of fire with their great white smoke trails were like fingers pointing us where to go. Unfortunately, this also alerted the Iraqis, who then were ready for us as we came by seconds later for a visit. I was photographing this bomb hanging off our left wing as we were diving in. At the same time, we began receiving antiaircraft artillery and getting lock-on tones from surface-to-air missiles. On the radio, the pilots were excitedly passing defensive maneuvers. The jet jerked and weaved, creating powerful G-forces as we dodged the threats coming at us. When the bomb was released, I could feel the jet lighten with relief from its load. Only later was I struck by the blindingly fast instant of life and death drama that fighter pilots faced every time they went up." In an F-16 over the Kuwaiti desert. February 1991. *(F. Lee Corkran)*

LEFT

"After takeoff, we would look over at the other planes to make sure the bombs were in place and everything looked right," says Corkran. "After the bombing run, returning to the base, we would again scan each other's planes to check that all the bombs were off and there were no bullet holes or damage. Pilots plan their own missions and have to calculate fuel consumption, weather factors, and the safest route to the target. The amount of time that went into planning the missions was phenomenal compared to the shortness of the actual flying — sometimes only a couple of hours — and the time spent dropping bombs — about three seconds." Over the Kuwaiti desert. February 1991. *(F. Lee Corkran)*

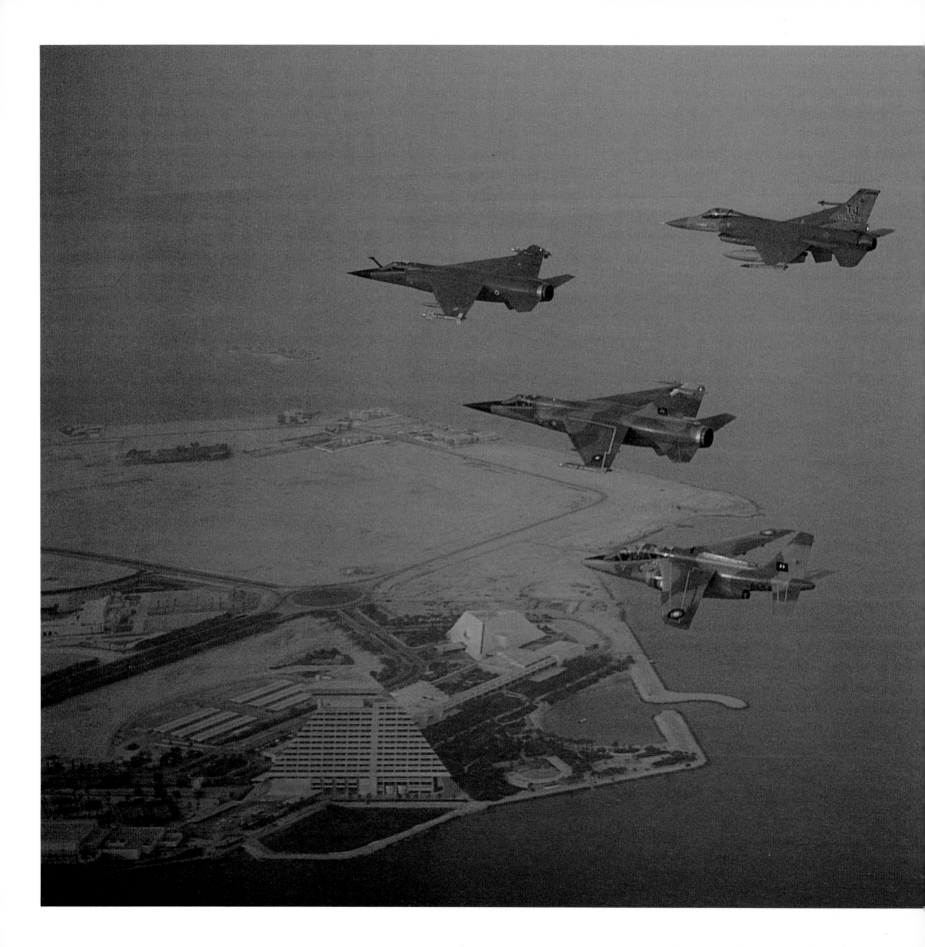

BASE QATAR

"The pilots had the idea of getting together an aircraft of each nation that had gathered in Qatar and flying for an aerial portrait," recalls F. Lee Corkran. "Flying together for one photo opportunity was no easy task. Five different aircraft, four different flying techniques, three different languages, and finding one time of day to bring them all together. We decided to make it easy by just doing this wedge formation, and everyone taking their position off the leader as we flew a simple figure-8 pattern ten miles long. We didn't have much time because the sun was setting and we'd started late to begin with. But the light was beautiful, and the shot actually worked out. This is the first and perhaps only time these forces will ever come together." Clockwise from left: a French F-1 Mirage, a U.S. F-16C Falcon, a Canadian CF-18 Hornet, a Qatari Alpha 2 Jet, and a Qatari F-1 Mirage. Over Qatar. October 1990. *(F. Lee Corkran)*

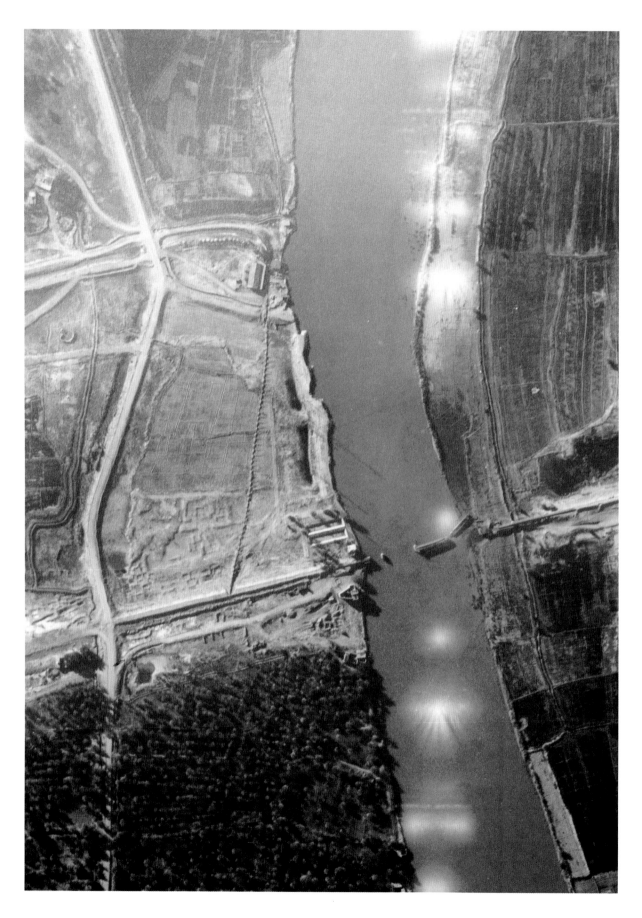

ENEMY TARGETS
In a "surgical" strike, allied air power destroys a strategic Iraqi bridge over which support and supplies must travel to reach Kuwait. Basra, Iraq. February 1991. *(Sygma)*

A French Jaguar fighter-bomber drops 550-pound bombs on a base of Iraq's elite division, the Republican Guard. Over Iraq. February 1991. *(Sygma)*

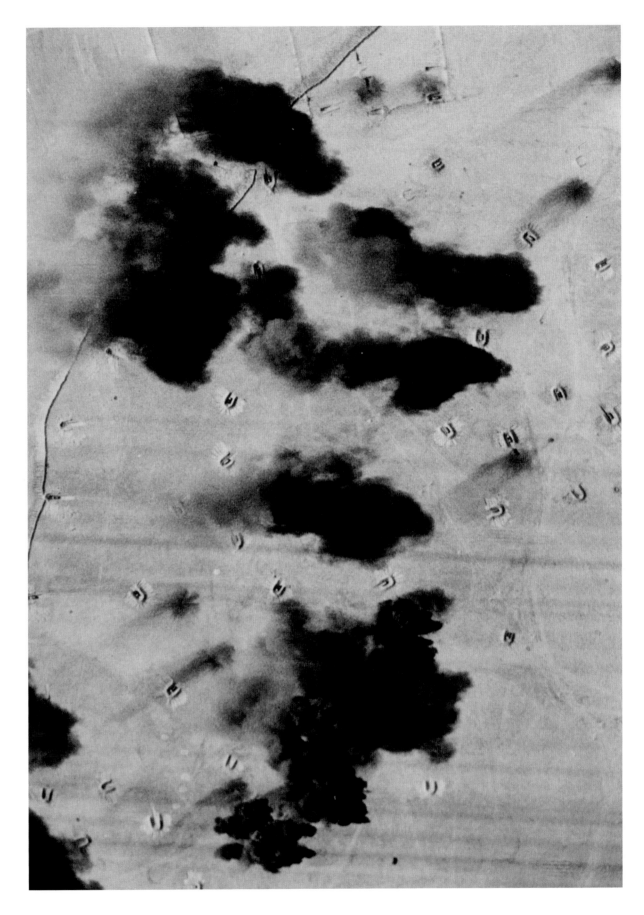

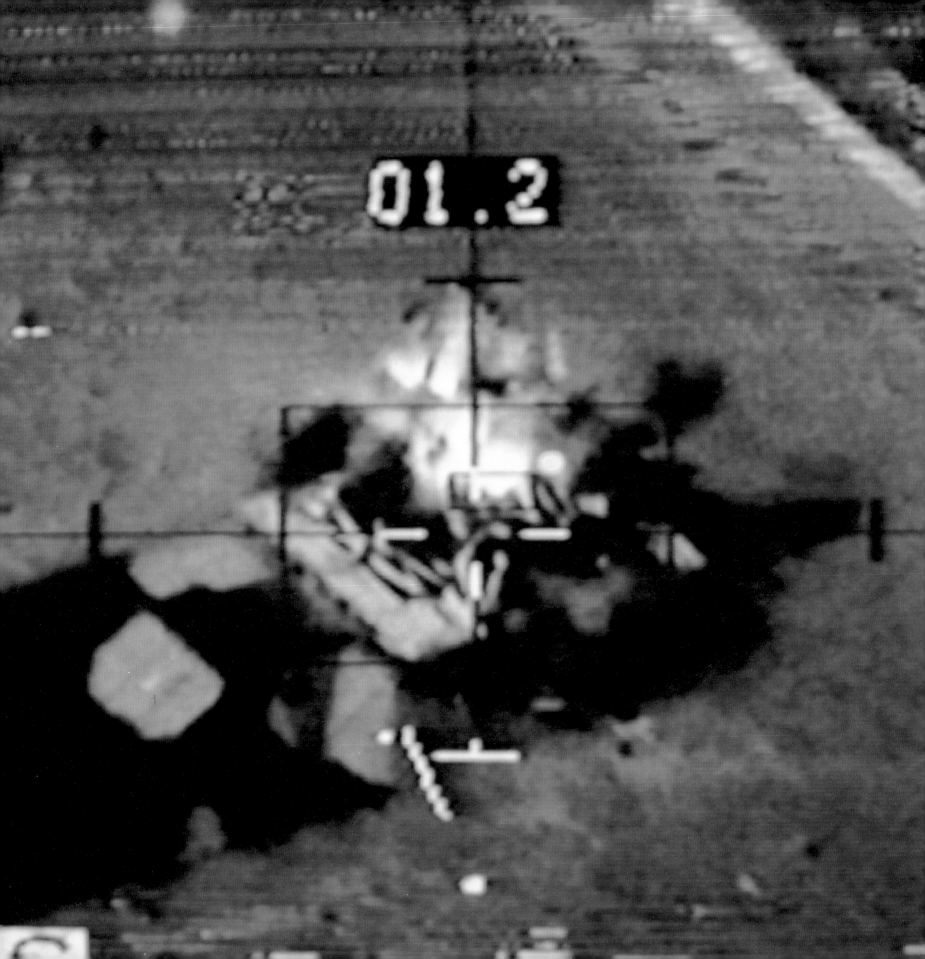

PRIME TIME

As seen through the pilot's infra-red camera, this is an image of French missiles fired from Jaguar bombers destroying an Iraqi ammunition depot. The firing is done about ten miles from the target and, as each plane heads back to base, a camera mounted on it records the laser-guided missile's journey. Over Iraq. February 1991. *(Sygma)*

"This is the view from room 925 at the Al-Rashid Hotel, where all the foreign media stayed in Baghdad," says Gary Orso. "In the distance, the Dora refinery burned after allied bombing." Baghdad, Iraq. 26 January 1991. *(Gary Orso)*

"The Iraqi Minister of Information organized this visit for foreign journalists to the Yarmuk hospital to show that allied bombings caused many civilian casualties," Gary Orso states. Baghdad, Iraq. 28 January 1991. *(Gary Orso)*

American fighter pilot and POW Lieutenant Jeffrey Zaun, seen on Iraqi TV. 20 January 1991. *(Sygma)*

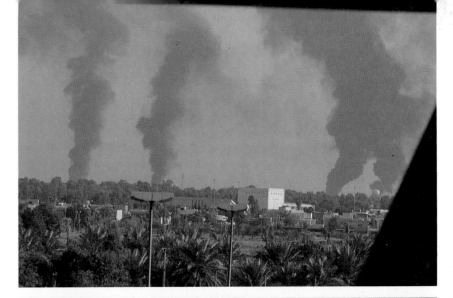

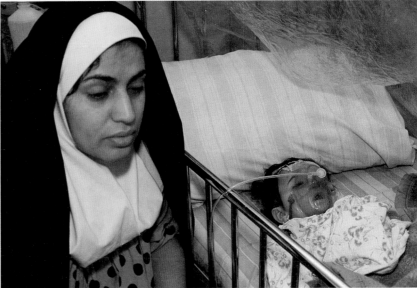

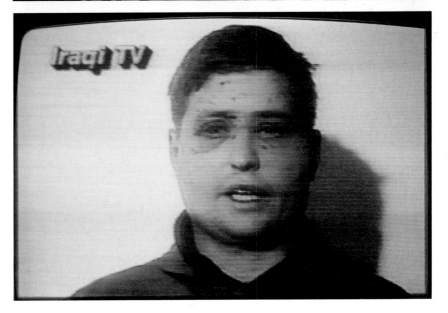

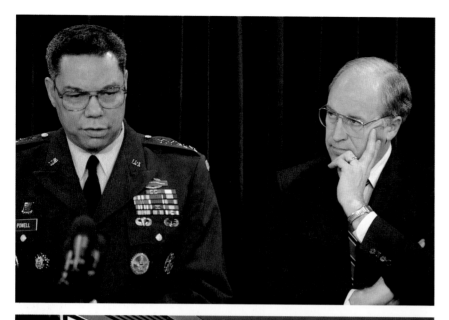

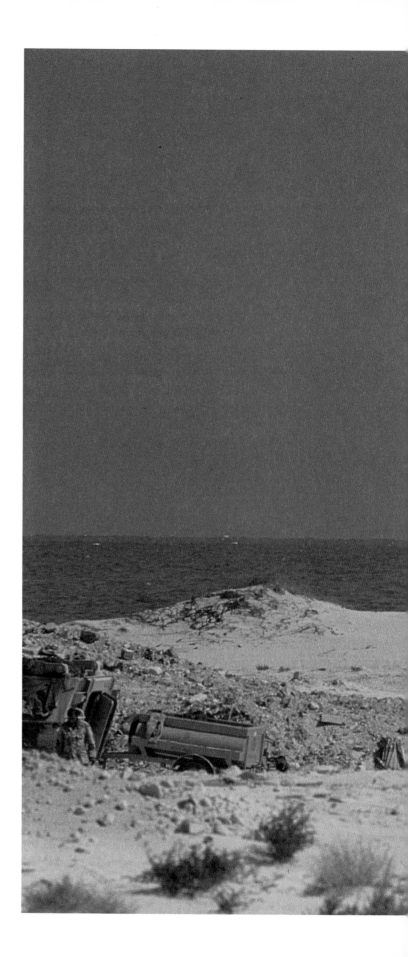

SONIC BOOMS

TOP

"A major controversy erupted at the second Pentagon press conference, when General Powell, with Defense Secretary Cheney at his side, stated that the war plan was 'first to cut off Hussein's army, then kill it,'" recalls Jean-Louis Atlan. Washington, D.C. 17 January 1991. *(Jean-Louis Atlan)*

ABOVE

"Schwarzkopf reminded me of a college professor, intelligent, with a sense of humor," says Jacques Langevin. "He was imposing, as big as a mountain. Huge torso, huge chest, huge head. Those standing next to him looked like strands of barbed wire." Riyadh, Saudi Arabia. 30 January 1991. *(Jacques Langevin)*

RIGHT

"Some said the USS *Missouri* fired a shell the weight of a Cadillac, but most agreed it was closer to a VW," says Langevin. "One first saw a flame-burst, then heard a roaring boom, at which time someone always remarked, 'There goes another Beetle.'" Off Khafji, Saudi Arabia. February 1991. *(Jacques Langevin)*

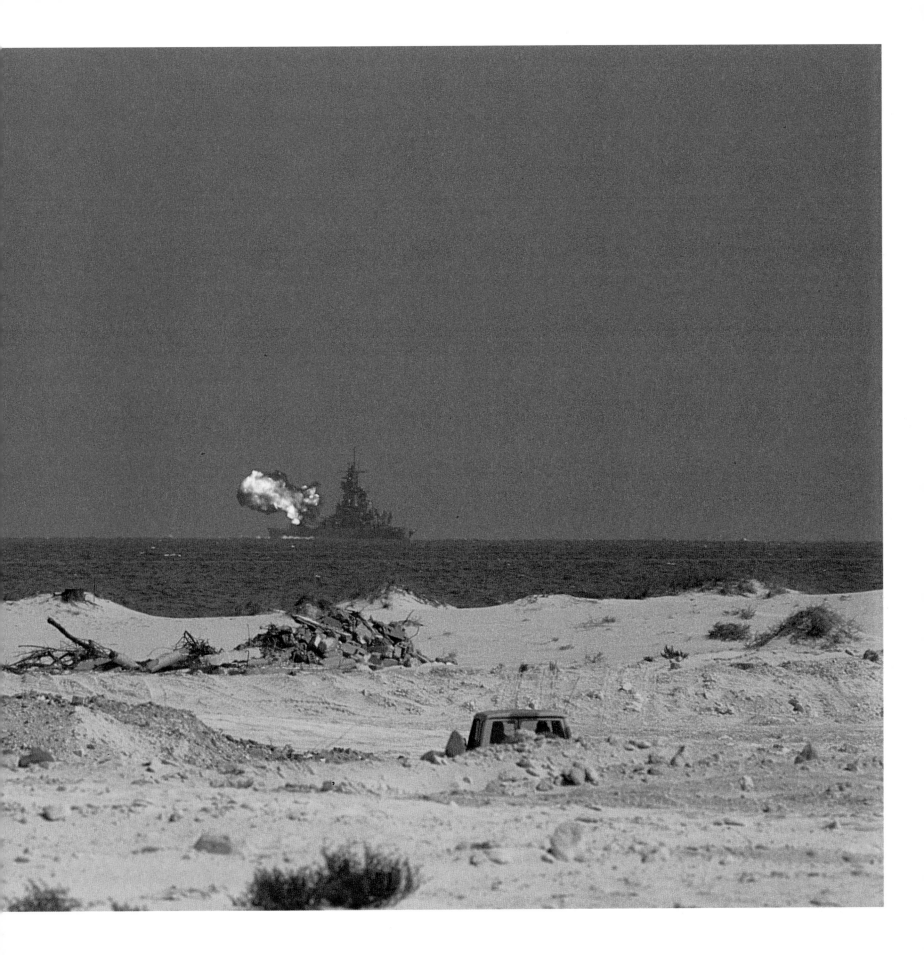

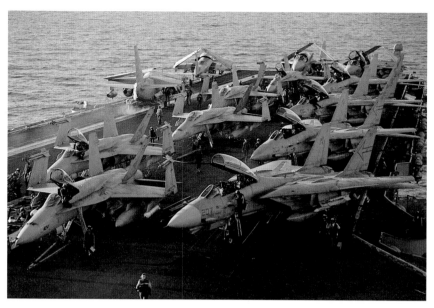

SMOKE ON THE WATER

ABOVE

"The planes on deck had just returned from a reconnaissance mission," reports Thomas Hartwell. "Aircraft on the USS *Saratoga* were involved in enforcing the embargo against Iraq." In the Red Sea. October 1990. *(Thomas Hartwell)*

RIGHT

During Iraq's occupation of Kuwait, Saddam Hussein had often threatened to destroy its oil fields and release oil into the Gulf to foil allied amphibious operations. When his soldiers opened the taps of this oil buoy along the Kuwaiti shoreline, an environmental nightmare was realized. An F-111 was dispatched to bomb the source and thereby set the well afire, which the allies declared would be more manageable. At the time of the bombing, the oil slick was already thirty-five miles long and ten miles wide. Off Mina al Ahmadi, Kuwait. 26 January 1991. *(Sygma)*

OVERLEAF

"As the days wore on in Saudi Arabia and the aerial bombing continued, the question became when would the ground war begin, and what signs would tip us off," Derek Hudson recalls. "Our days were spent going up and down the road from Hafar al Batin to the frontier post of Rugei, and then one evening, we saw huge dust clouds — the telltale signs of a convoy moving west across the desert. Now we knew we were about to see fireworks." Hudson was witnessing the first stage of Schwarzkopf's famous Hail Mary flanking maneuver, in which massive allied troop movements encircled, cut off, and defeated Hussein's army. Hafar al Batin, Saudi Arabia. 19 February 1991. *(Derek Hudson)*

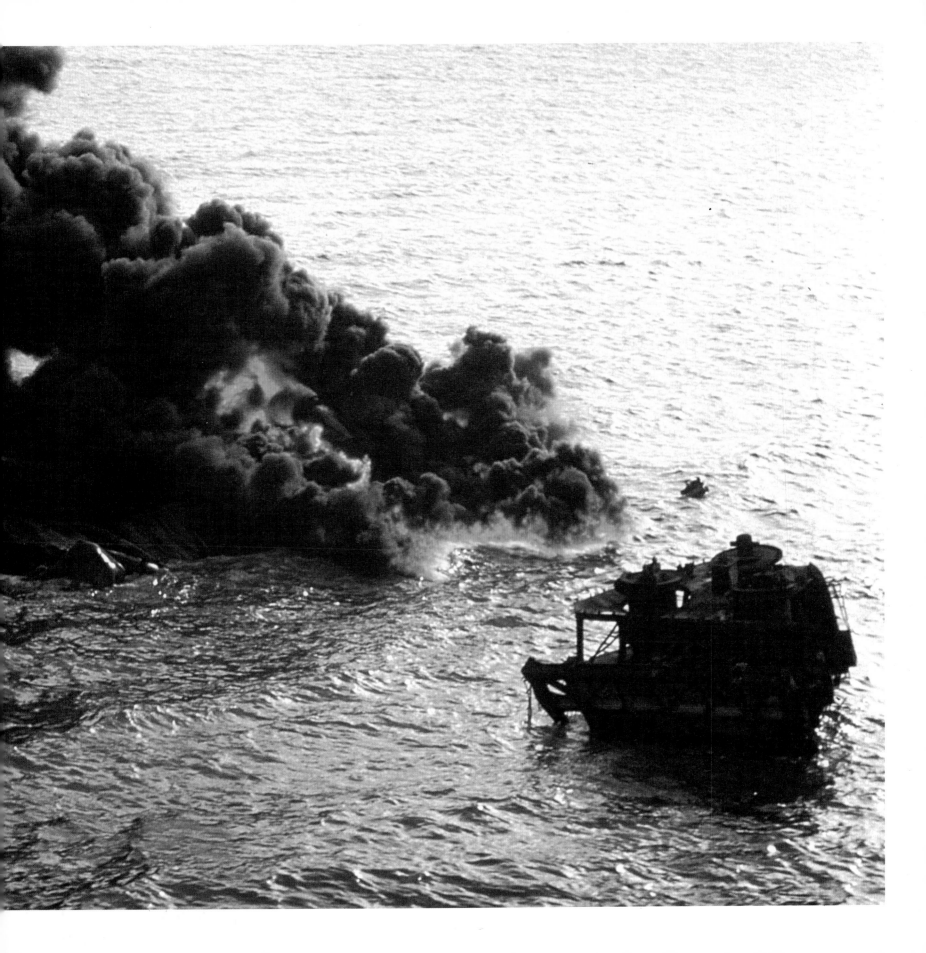

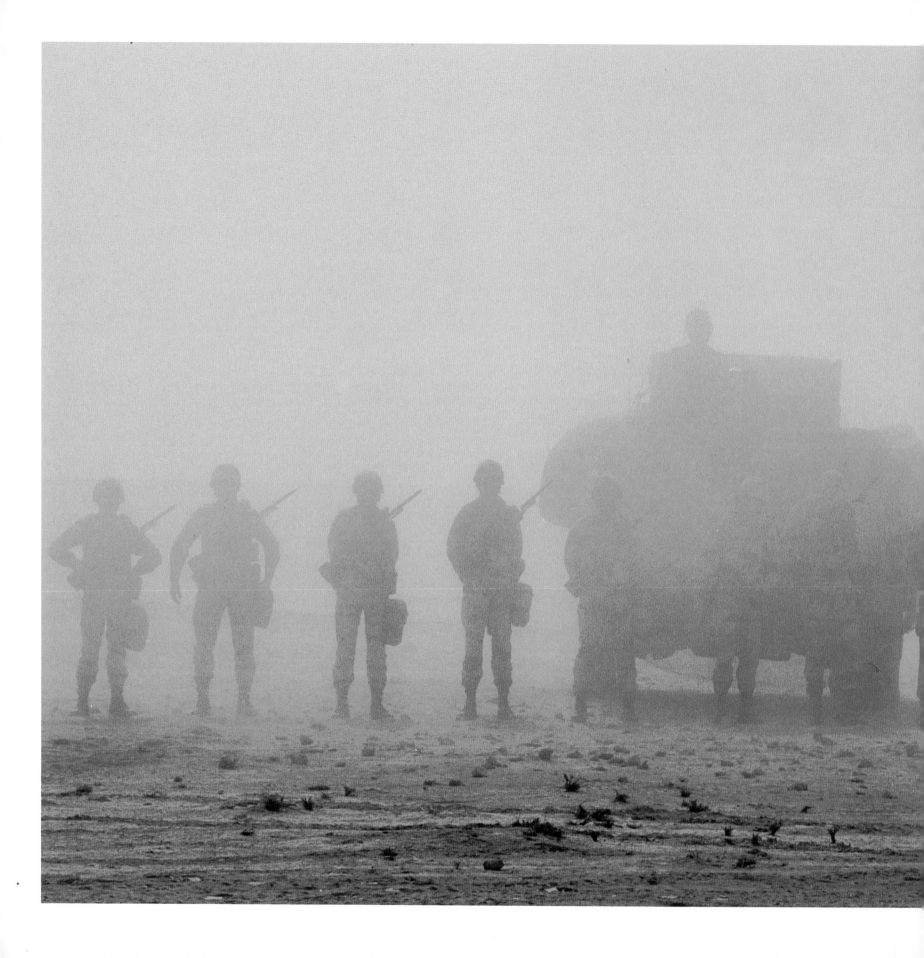

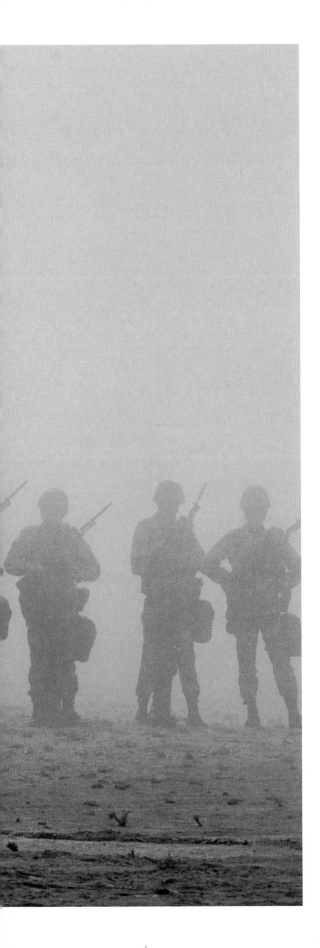

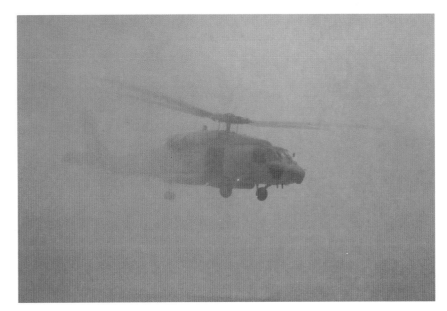

DESERT STORM

LEFT
"At the end of the visit of French Prime Minister Michel Rocard, troops of the Foreign Legion lined up as helicopters lifted off and raised an unbelievable cloud of sand," recalls Thierry Orban. "The Legionnaires had to stand at attention during this sandstorm." Saudi-Iraqi border. 14 February 1991. *(Thierry Orban)*

ABOVE
A U.S. Navy HH-60 Seahawk helicopter takes off in the Saudi Arabian desert. January 1991. *(Sygma)*

OVERLEAF
A Saudi tank is stuck in the mud while APCs (armored personnel carriers) advance toward a burning coastal village. Kuwait. 25 February 1991. *(Jacques Langevin)*

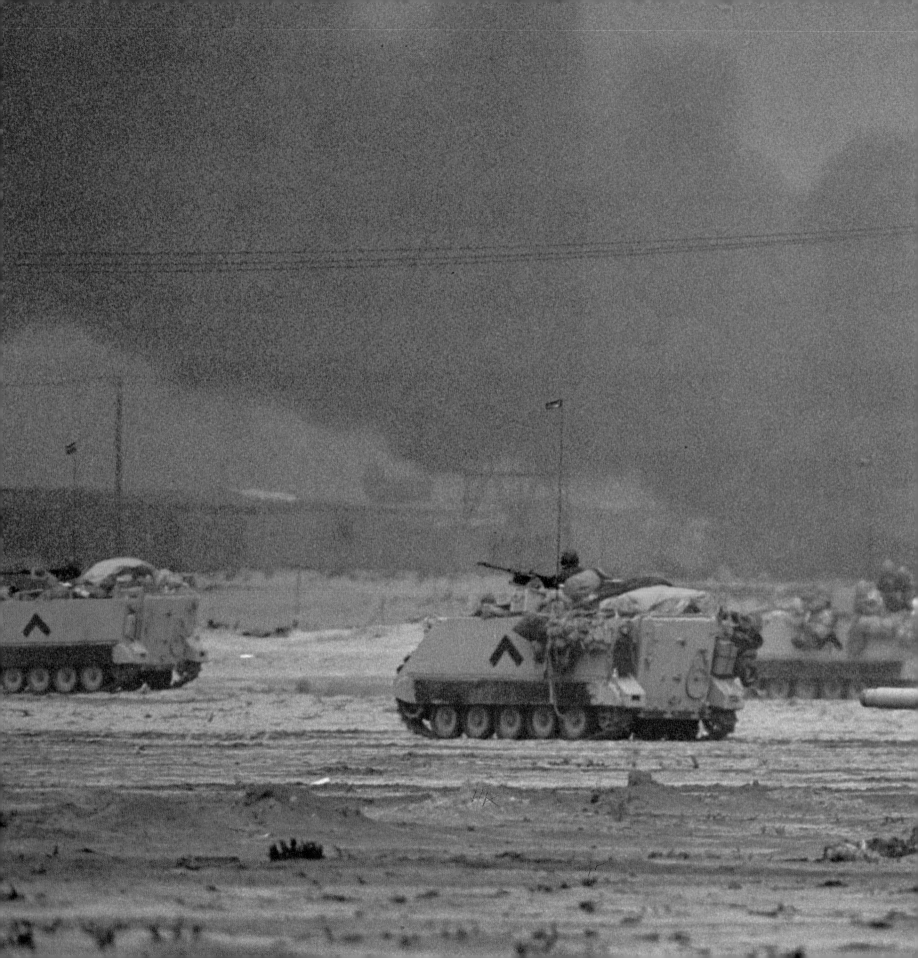

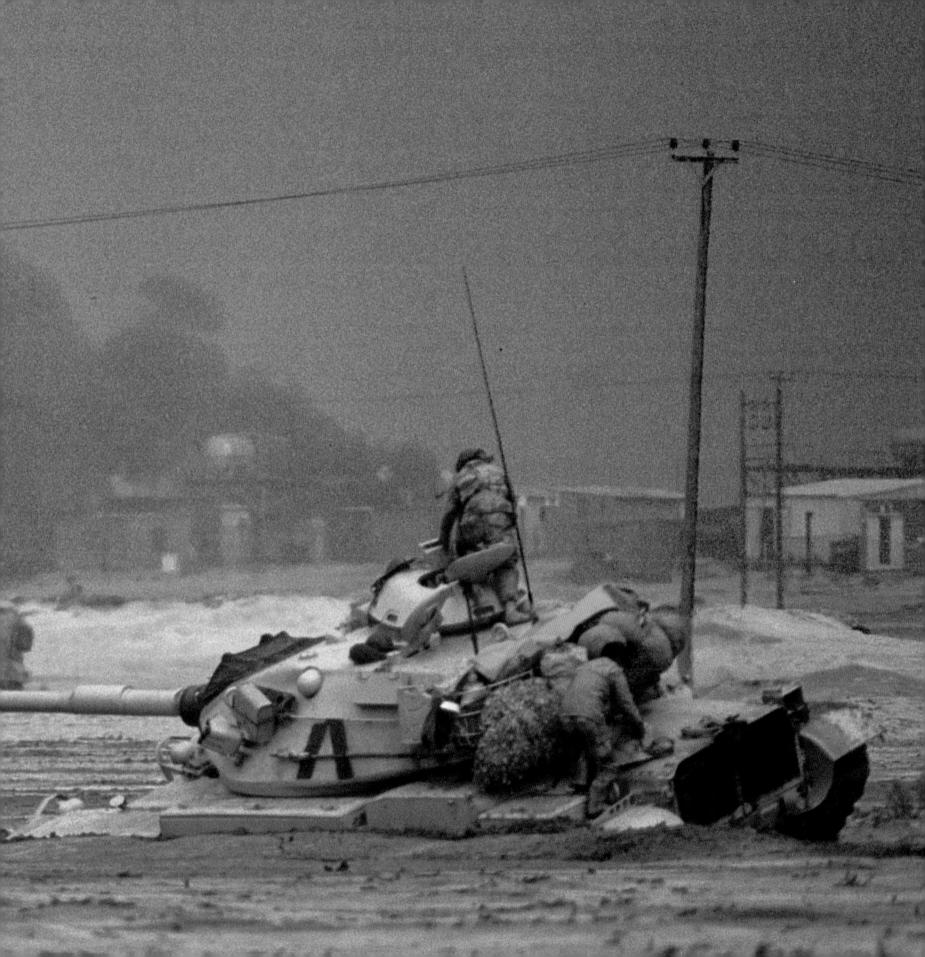

KHAFJI'S METAMORPHOSIS

Iraq was the first to capture a territory during the war, though Khafji, Saudi Arabia, was not much of a prize. It is near the Kuwaiti-Saudi border and its 45,000 inhabitants had been evacuated, but as propaganda it answered Saddam's prayers. For thirty-six hours anyway. Schwarzkopf considered Khafji "about as significant as a mosquito on an elephant," but the action greatly annoyed him. Meanwhile, twelve Marine artillery observers, hiding out in an apartment house, were caught off guard when the Iraqis marched into town. Eventually, Saudi and other Arab forces joined by American artillery blasted their way back, and Iraqis fought hard for two days but retreated with heavy losses, surrendering the city.

RIGHT

"Although Khafji had been evacuated and was off-limits to the press," says Patrick Durand, "I passed the last checkpoint with a French TV crew — all of us dressed in U.S. Army uniforms, our cars draped with camouflage netting. As we drove into the city, Saudi and Qatari tanks were on fire. Once we passed under the arches marking the city entrance, Qatari APCs suddenly began firing TOW missiles in our direction. We took cover in a gas station, but the missiles kept coming, making a terrifying sound. We realized that their target was the water tower where Iraqis were hiding out, just about a hundred yards behind us. For about thirty minutes we were trapped in our makeshift shelter, desperately hoping the Saudis and Qataris knew which side we were on. It was impossible to get any farther into the city, as there was street fighting down the road. We decided to leave Khafji with the first images of fighting in Saudi Arabia. The retreat was very 'hot,' with Iraqi artillery fire blasting huge craters behind us as we sped away." 31 January 1991. *(Patrick Durand)*

ABOVE

Saudi and Qatari artillery shells the water tower, where Iraqi soldiers are hiding. Khafji, Saudi Arabia. 31 January 1991. *(Patrick Durand)*

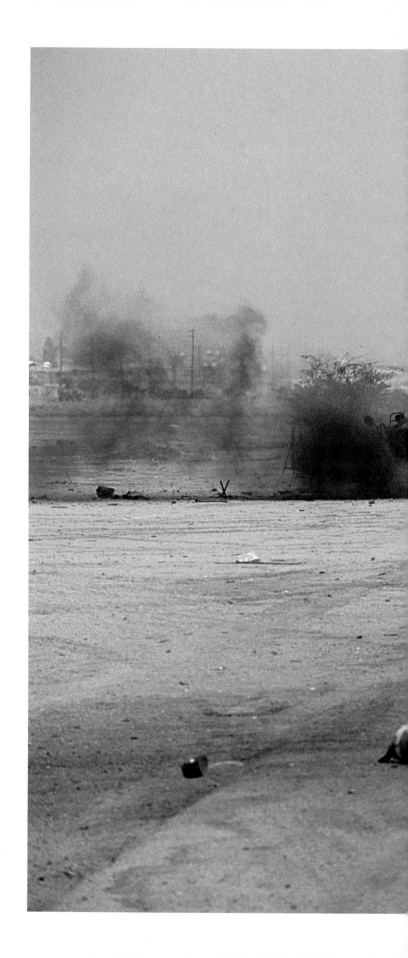

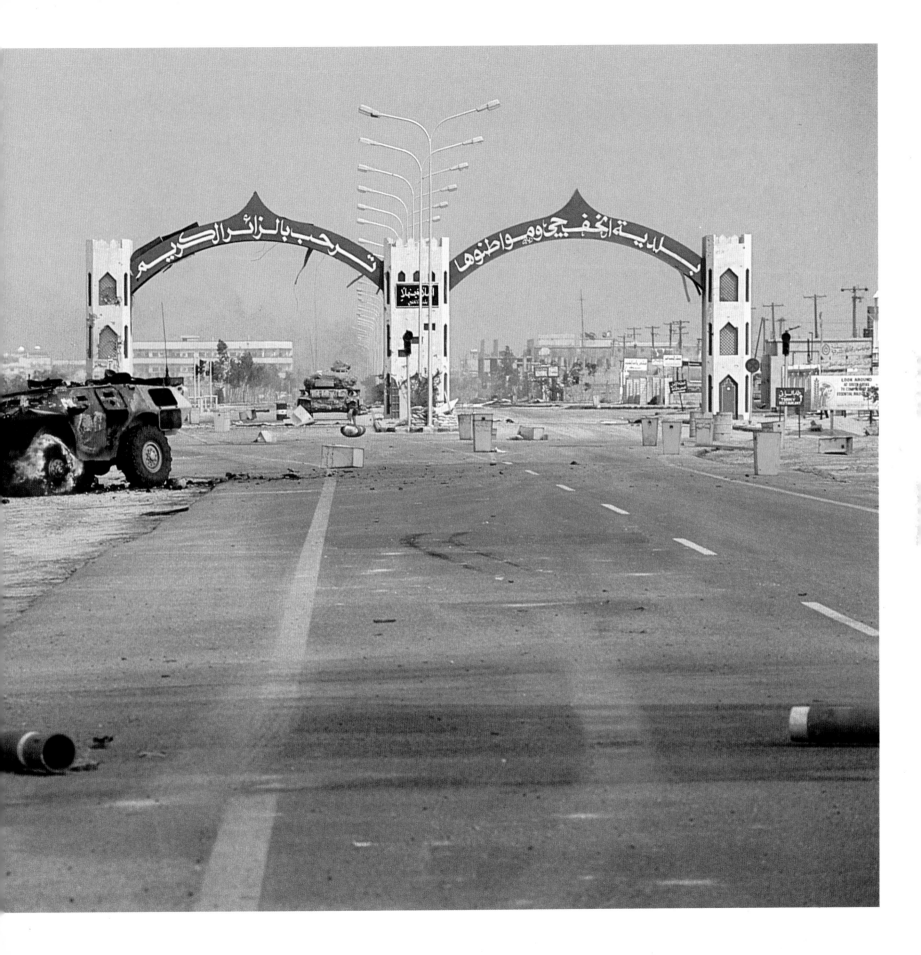

"This position was just a few miles south of Khafji, and U.S. artillery was shelling the city from it," says Patrick Durand. "I feared getting closer without a military escort, but finally I decided to risk it and came upon a group of U.S. soldiers and their captain, who gave me carte blanche to shoot whatever I wanted as long as I promised not to report their position. After several hours of firing away, they quit their work, opened their ration cans, and sat eating lunch and telling jokes. I watched in amazement. It was lunchtime at the war factory." Khafji, Saudi Arabia. 31 January 1991. *(Patrick Durand)*

THE MAIN EVENT

"After months of desert training exercises, after every imaginable war scenario discussed ad nauseam, after the success of massive allied bombing, there was now the ground war," says Thierry Orban. "I had incorporated myself into the 6th Engineering Regiment of the Foreign Legion, where I traveled north in the first reconnaissance APC along the strategic road we called the Texas Highway. Along with the 2nd Brigade of the 82nd Airborne, we were the frontline of Schwarzkopf's Hail Mary maneuver, which brought troops west, north, then east. We found ourselves about sixty-five miles deep in Iraq on this dangerously raised highway that exposed us to enemy fire, so we had to keep moving at all times. The Fifth Dragon, a French tank unit, was receiving Iraqi artillery fire, and we had gone through four chemical alerts, and had our NBC suits on throughout the advance. The U.S. employed its Multiple Launch Rocket System and 155 howitzers. Far ahead, American A-10 Warthog planes were decimating the Iraqi tanks and artillery positions. It was on this early morning that the Legionnaires came upon their first group of surrendering Iraqi soldiers huddled by an underpass. The Iraqis were shell-shocked, hungry, thirsty, abandoned by their officers. For these men, this was liberation. They were, however, at first unconvinced about giving themselves up to Frenchmen, as they expected Americans." As Salman, Iraq. 25 February 1991. *(Thierry Orban)*

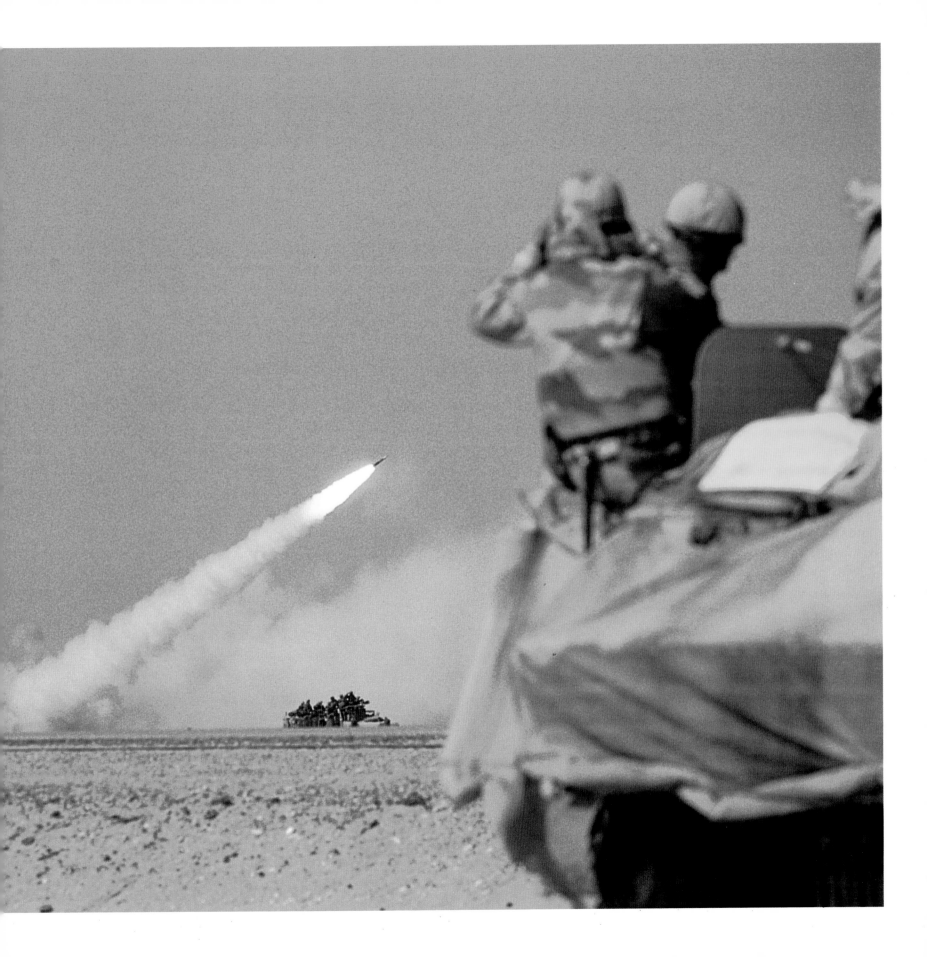

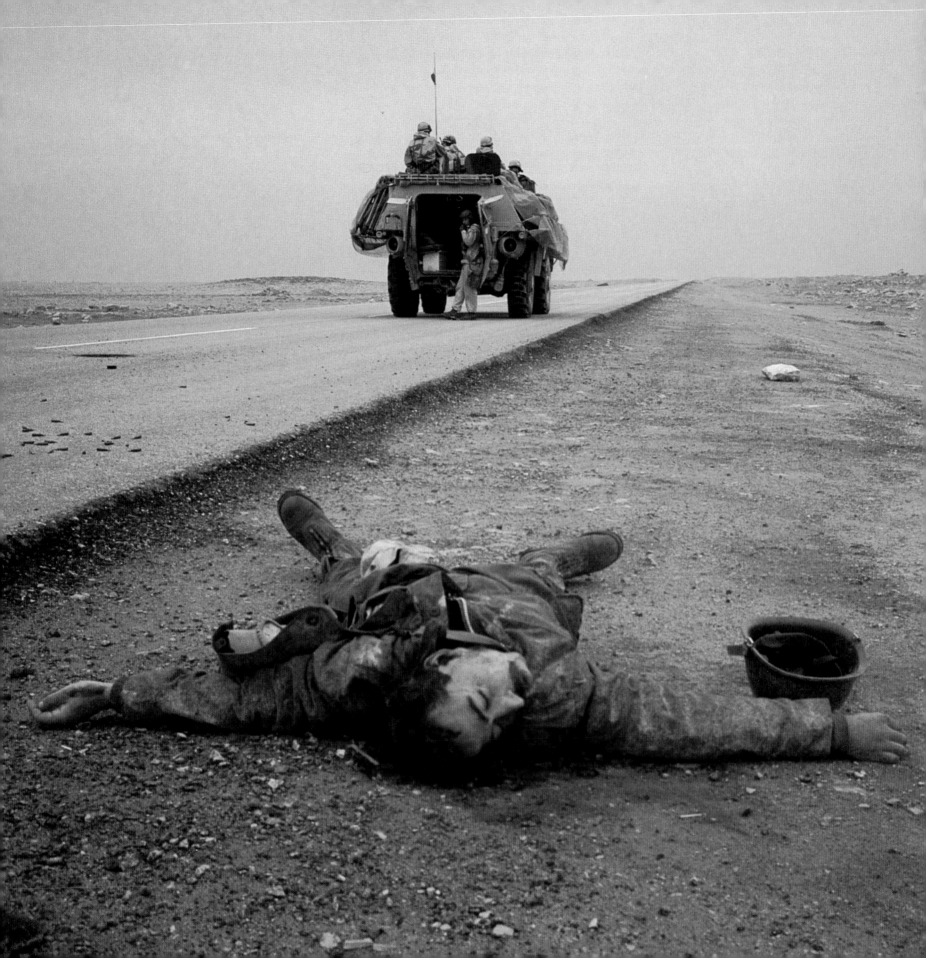

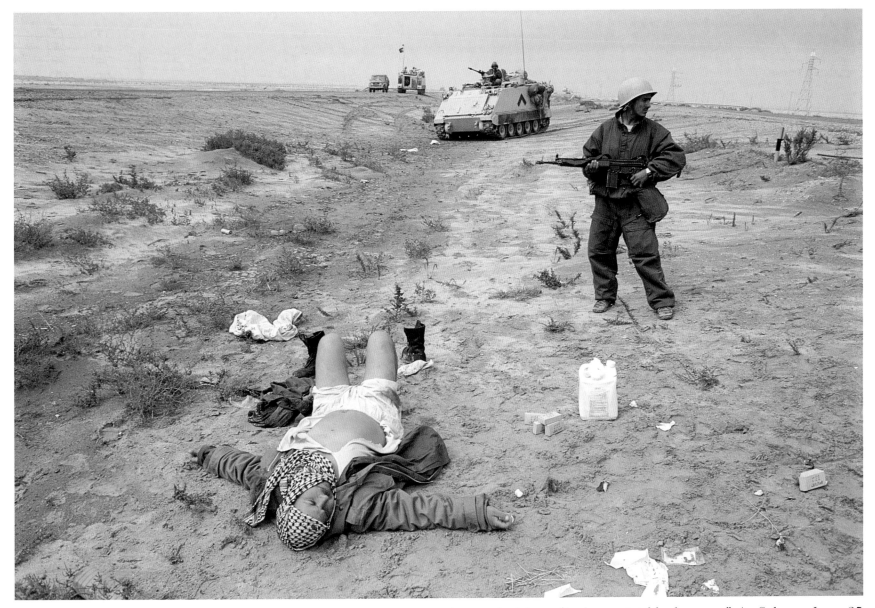

RED DESERT

LEFT

"The uniform on this Iraqi corpse stood out from the others," notes Thierry Orban. "He was probably an officer, though any indication had been removed from his uniform. The body lay spread-eagled with a bullet through the temple. This may have been a suicide, or possibly an execution by his deserting company. But the soldiers and their doctor all agreed that the gun had been fired at point-blank range." As Salman, Iraq. 25 February 1991. *(Thierry Orban)*

ABOVE

Waiting to be evacuated for medical assistance, an Iraqi prisoner with a stomach wound is guarded by a Saudi soldier. The inverted "V" on the tank identifies allied armor. Al Ahmadi, Kuwait. 25 February 1991. *(Jacques Langevin)*

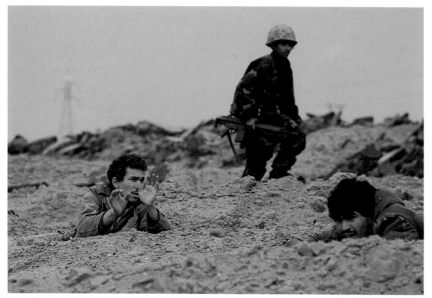

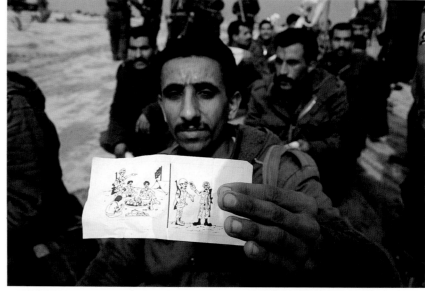

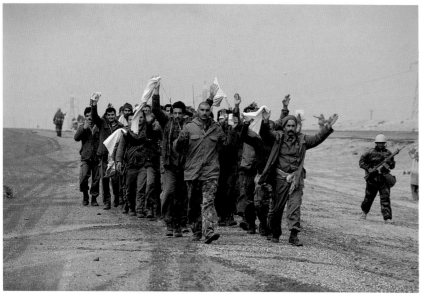

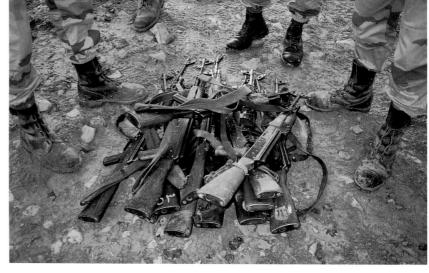

THE SURRENDER

From the onset of the allied land offensive, which began on 24 February, Iraqi prisoners surrendered in great numbers. Sometimes as many as a hundred soldiers abandoned their positions and poured into the roads with their hands over their heads. Some were injured, most were desperately hungry and thirsty. As agreed by the allied forces, Arab nations were responsible for the supervision of Iraqi prisoners.

TOP LEFT

Allied Arab soldiers take prisoners as they advance toward Kuwait City during the ground war. 25 February 1991. *(Jacques Langevin)*

TOP RIGHT

An Iraqi prisoner shows a flier dropped by allied planes that explains how to surrender. On the road to Kuwait City. 25 February 1991. *(Jacques Langevin)*

ABOVE LEFT

Iraqi soldiers surrender on the road to al Ahmadi, Kuwait. 25 February 1991. *(Patrick Durand)*

ABOVE RIGHT

"The Foreign Legionnaires were renowned connoisseurs of the Kalashnikov AK-47 and spent hours discussing the various models and countries of origin of these confiscated weapons," says Thierry Orban. As Salman, Iraq. 25 February 1991. *(Thierry Orban)*

OPPOSITE

"This little piece of paper seemed so precious to the surrendering Iraqi soldiers," recalls Orban. "They held it tightly in their hands and would not let go of it. Some had it hidden for weeks in their shirt collars and despaired in panic if they lost it. Upon surrendering many insisted on keeping it as a sort of guarantee." Southern Iraq. 25 February 1991. *(Thierry Orban)*

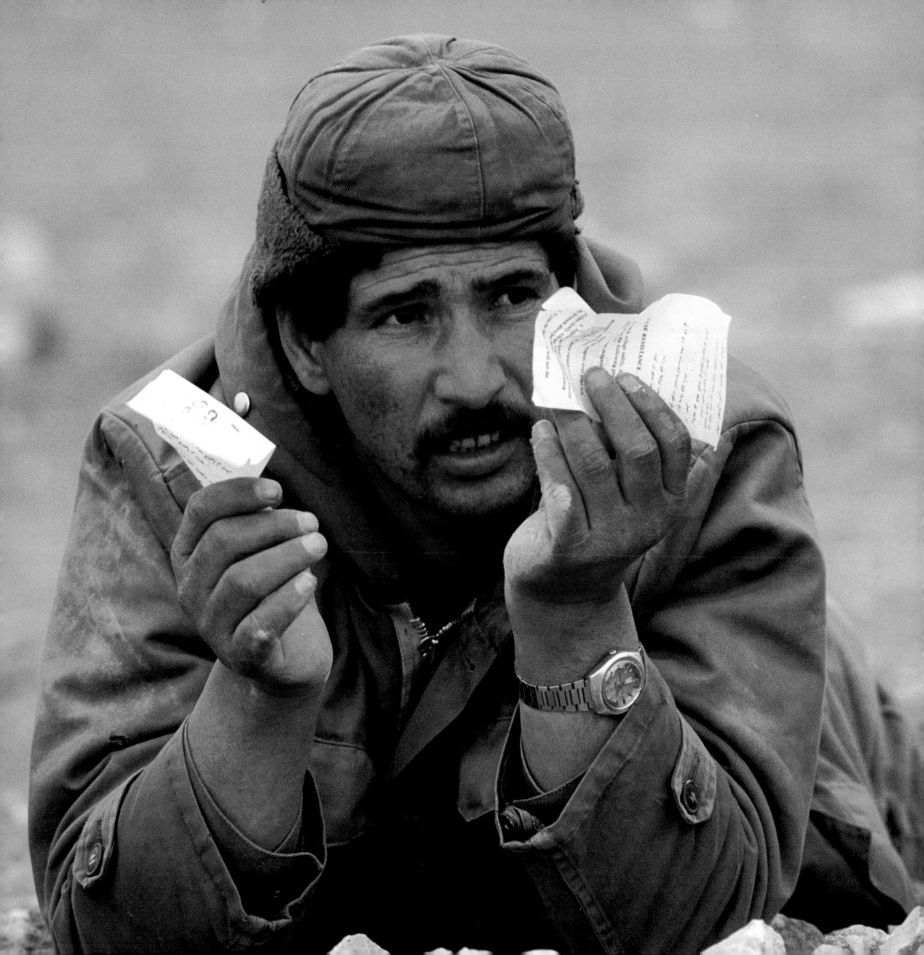

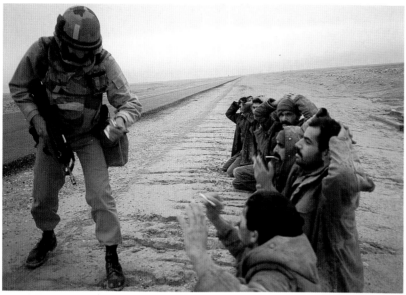

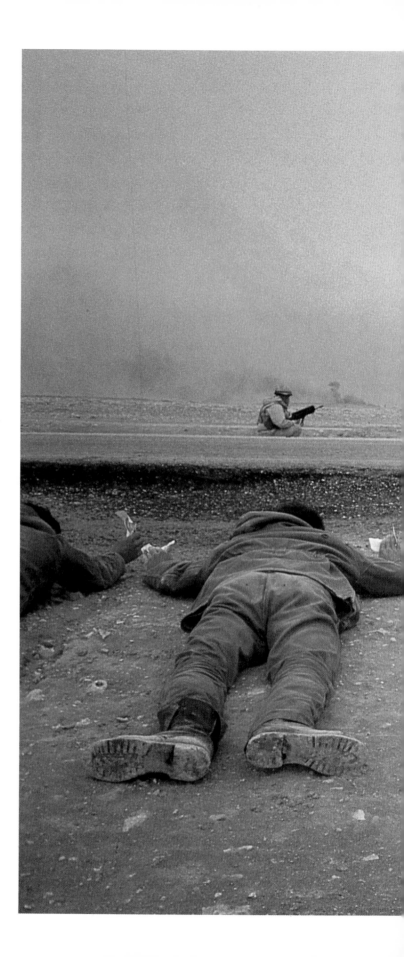

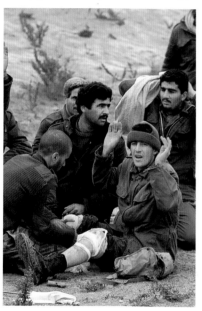

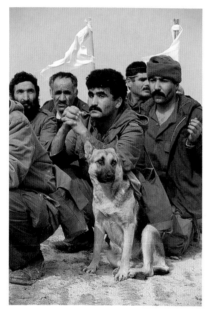

"When these Iraqi soldiers surrendered to the Foreign Legion, we first thought it was a diversion," says Thierry Orban. "I know only one instance of an Iraqi faking surrender — the man detonated dynamite he carried hidden, killing himself and a U.S. soldier." Southern Iraq. 25 February 1991. *(Thierry Orban)*

A French soldier hands out American cigarettes to Iraqi prisoners. Southern Iraq. 25 February 1991. *(Thierry Orban)*

A wounded Iraqi POW on the highway to Kuwait City. Al Ahmadi, Kuwait. 25 February 1991. *(Jacques Langevin)*

Iraqi POWs and their dog, which will be left behind when they are taken away by their Saudi captors. Al Ahmadi, Kuwait. 25 February 1991. *(Patrick Durand)*

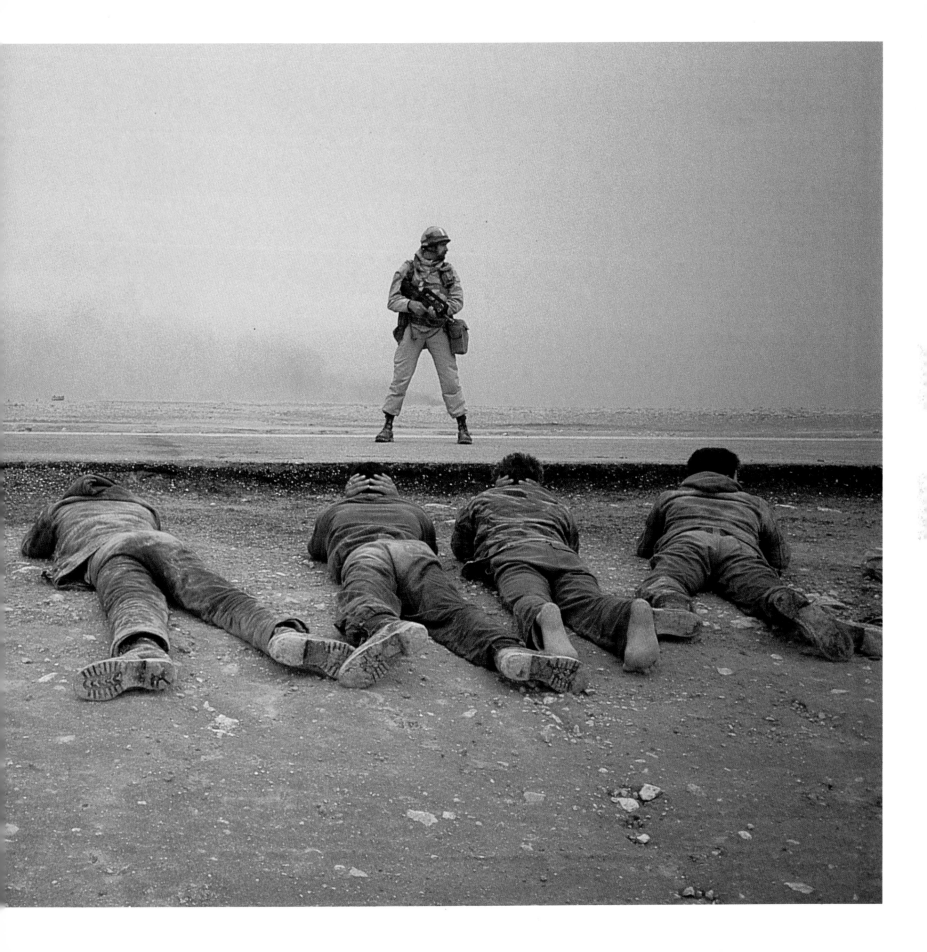

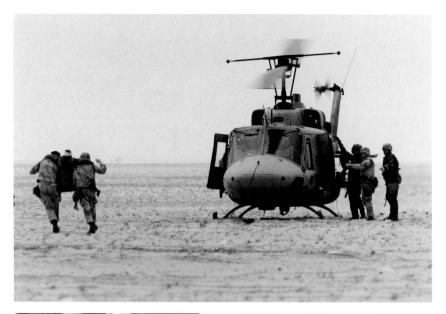

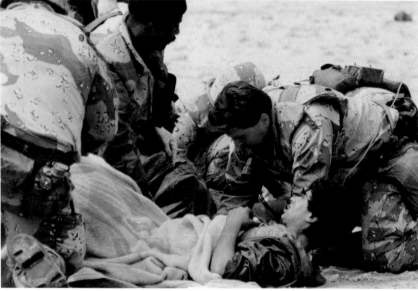

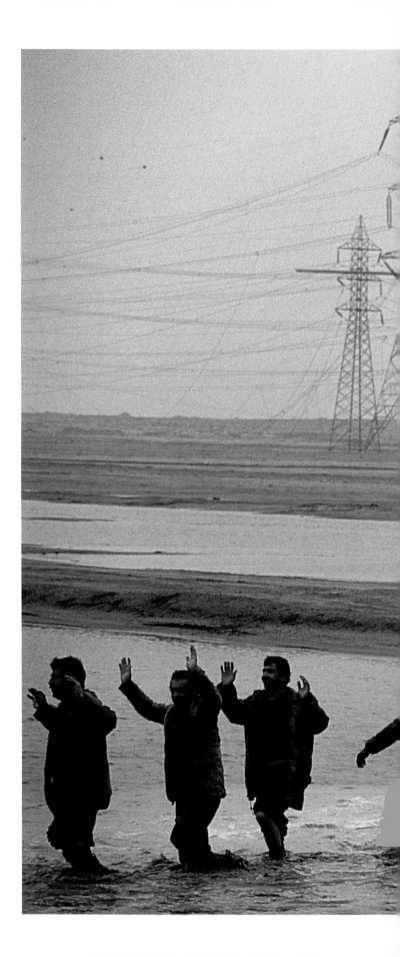

RIGHT
A Gazelle helicopter flown by the Saudi Army supervises surrendering Iraqi soldiers. Al Ahmadi, Kuwait. 25 February 1991. *(Patrick Durand)*

TOP AND ABOVE
Iraqi prisoners requiring medical attention are evacuated by U.S. Navy medics. Outside Kuwait City. 25 February 1991. *(Derek Hudson)*

OVERLEAF
American Marines throw MREs (Meals Ready to Eat) to a crowd of over four thousand Iraqi POWs. The Geneva Convention prohibits photographing prisoners of war, but Derek Hudson managed to take a few shots unobserved by General Walter Boomer, who was temporarily distracted. "I stood next to him as he watched prisoners lunging wildly for the plastic food packets," says Hudson, "then I slipped my autofocus camera by my side and snapped away. It was a terrible way to record such a moment of history but better than not at all." Kuwait. 26 February 1991. *(Derek Hudson)*

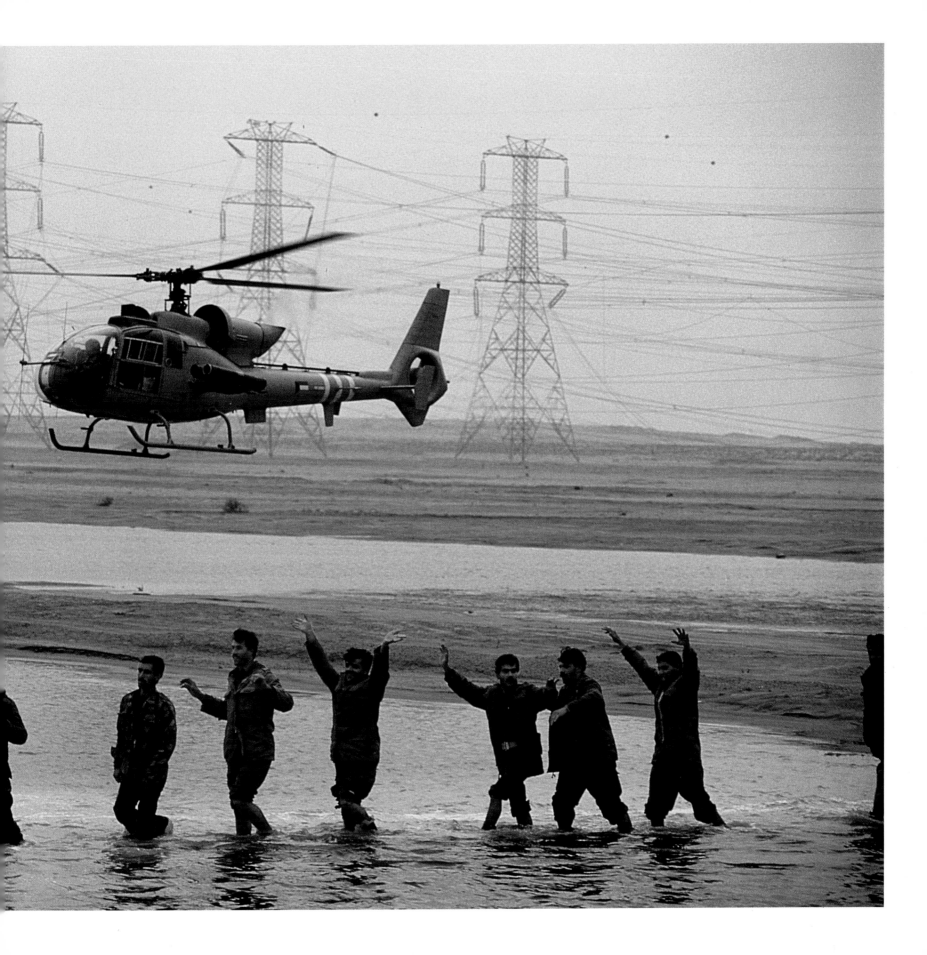

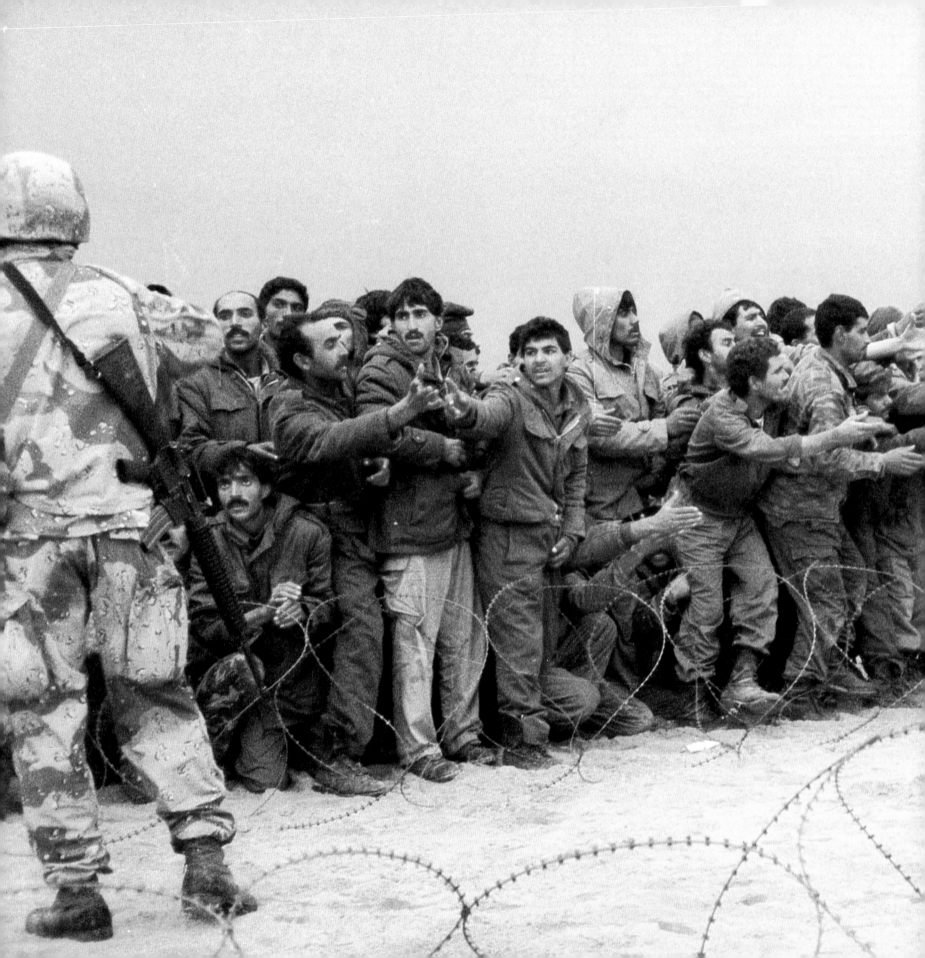

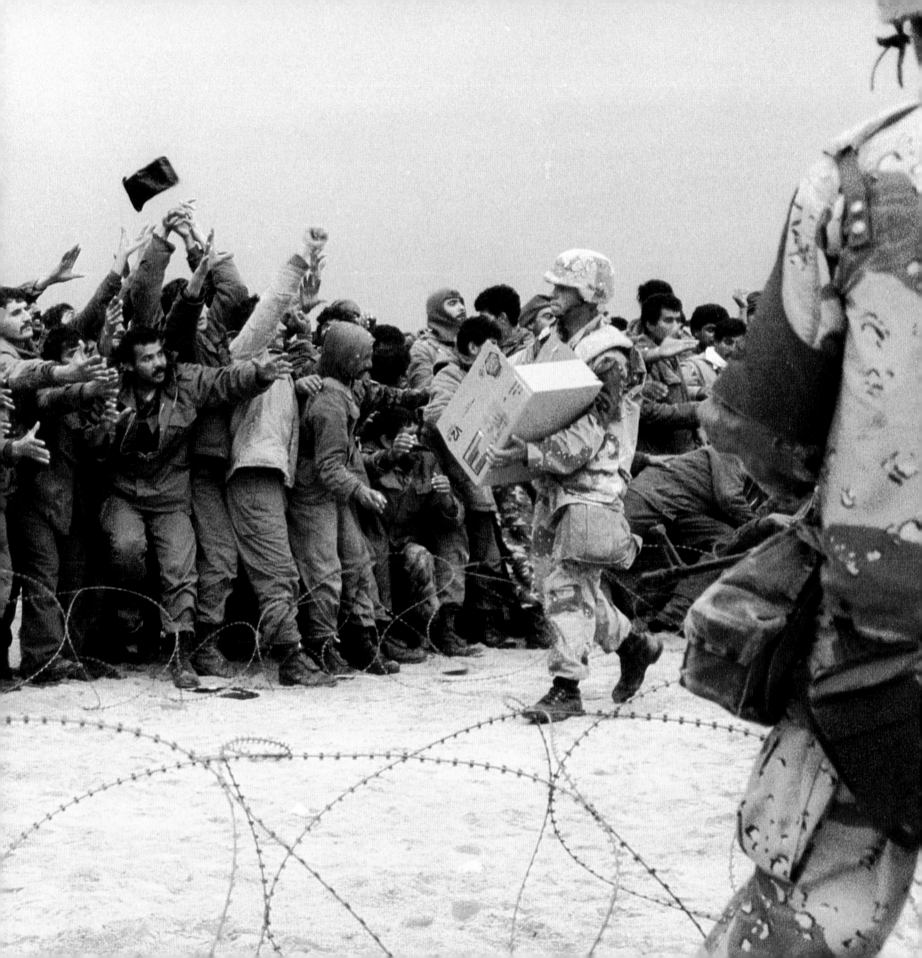

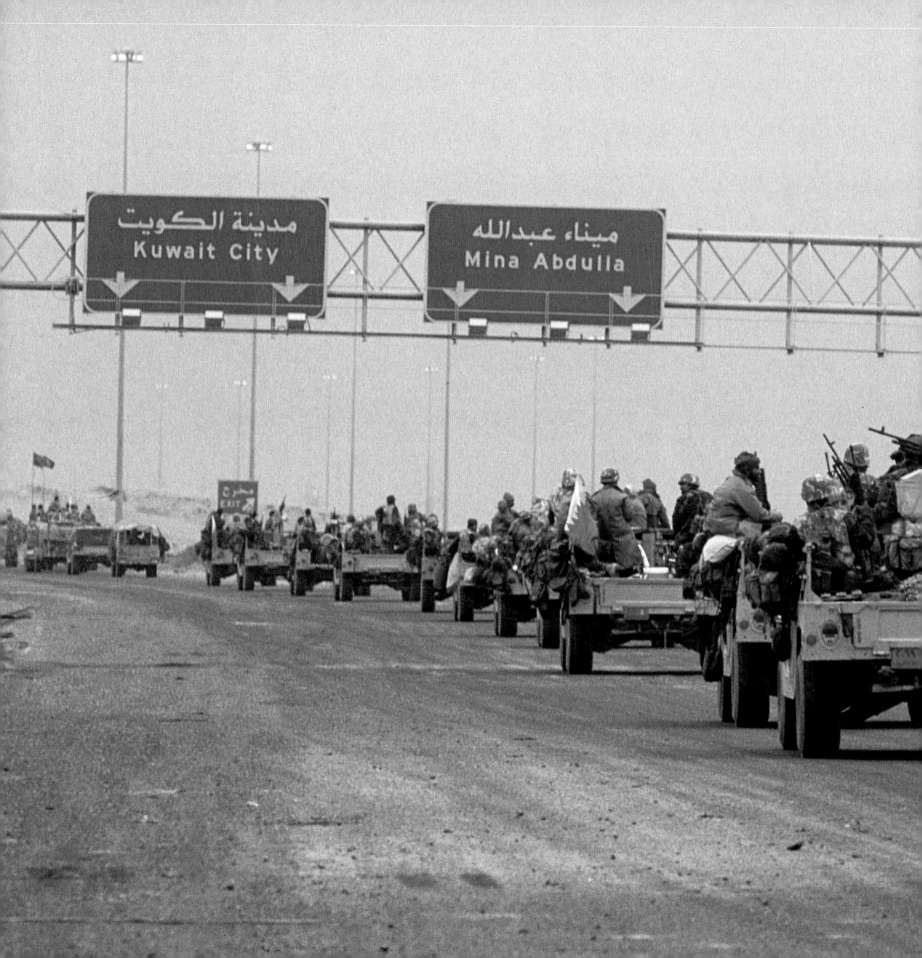

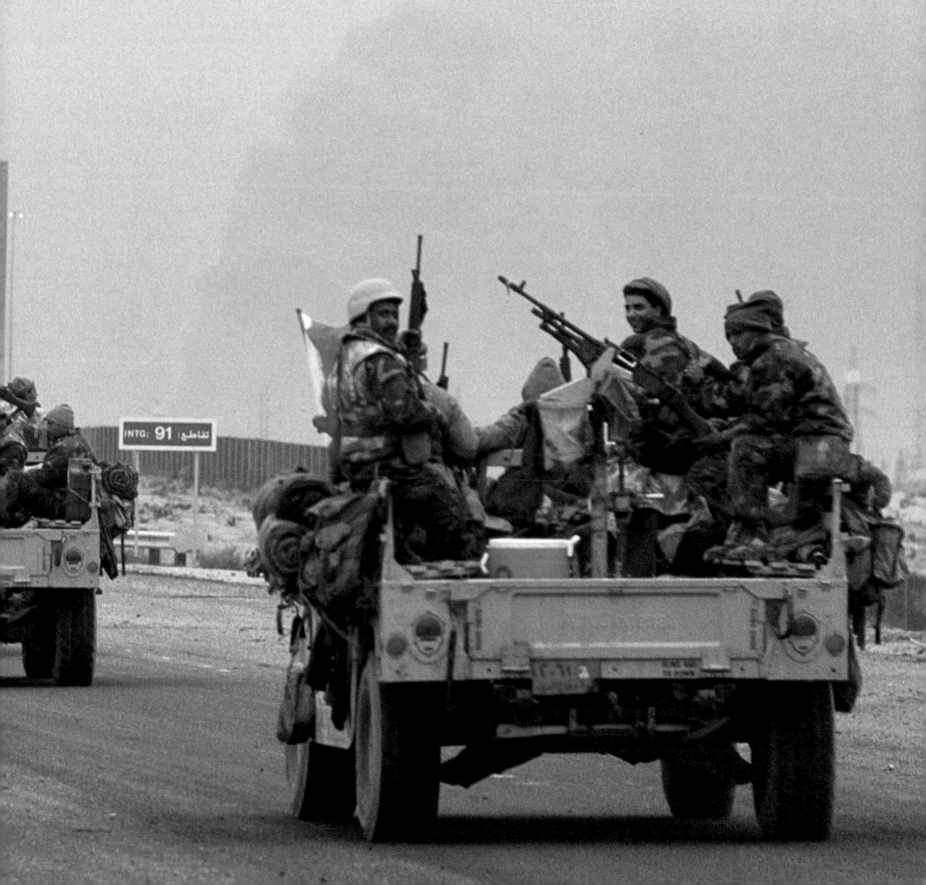

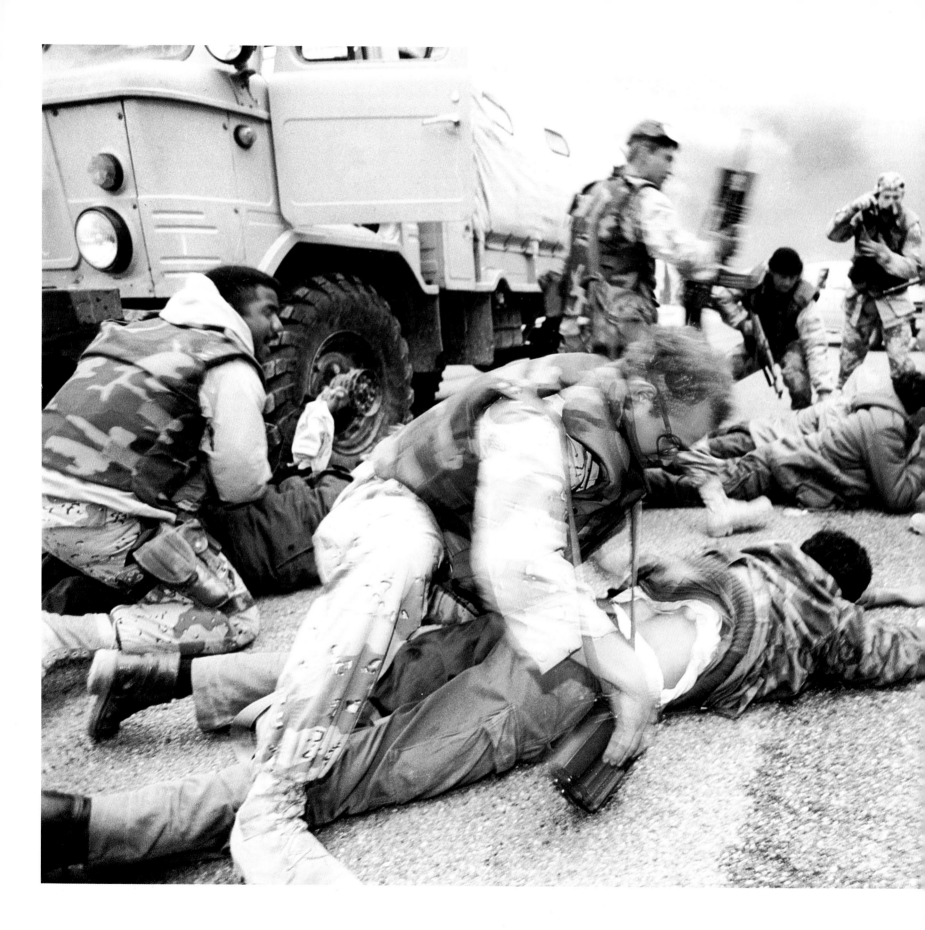

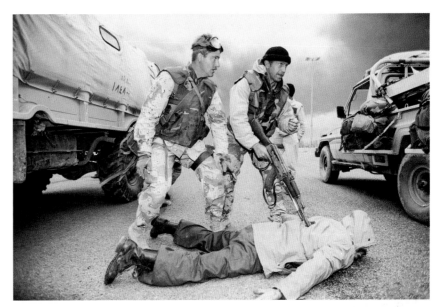

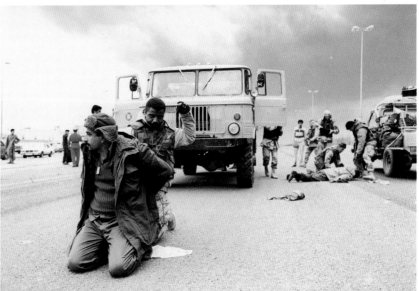

SPECIAL FORCES

PAGES 98-99

"As the allied soldiers rolled toward the capital, the only threat of injury was friendly fire," says Jacques Langevin. "But ahead of this convoy, two four-man U.S. Special Forces units scouted for remaining pockets of Iraqi resistance." Near Kuwait City. 25 February 1991. *(Jacques Langevin)*

THESE PAGES

"The U.S. Special Forces had been on their way to join their convoy when some Kuwaitis yelled and pointed at a military truck," says Patrick Durand. "U.S. Special Forces intercepted the truck, which was headed northward in the direction of Iraq, and found it full of Iraqi soldiers, arms, and baggage. Their arrest by the American soldiers was quite spectacular as the Iraqis were searched SWAT team-style. The Kuwaitis around us wanted to lynch the terrified Iraqis, but the Americans held them back." Near Kuwait City. 26 February 1991. *(All photographs by Patrick Durand)*

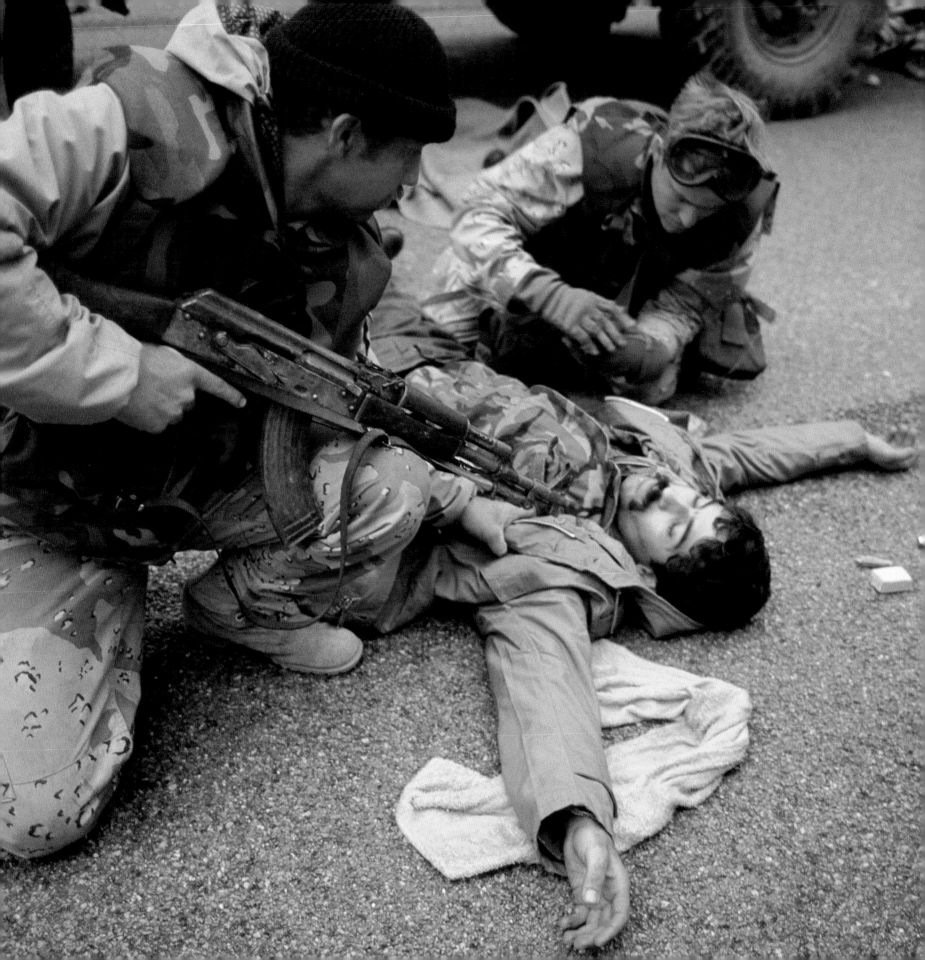

U.S. Special Forces capture and frisk Iraqis trying to flee Kuwait City to escape the allied advance. Outside Kuwait City. 26 February 1991. *(All photographs by Jacques Langevin)*

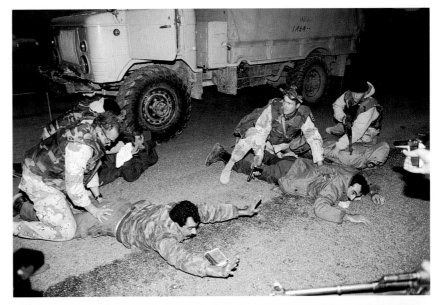

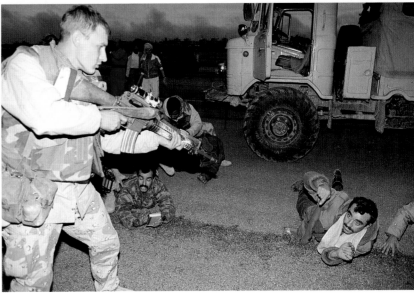

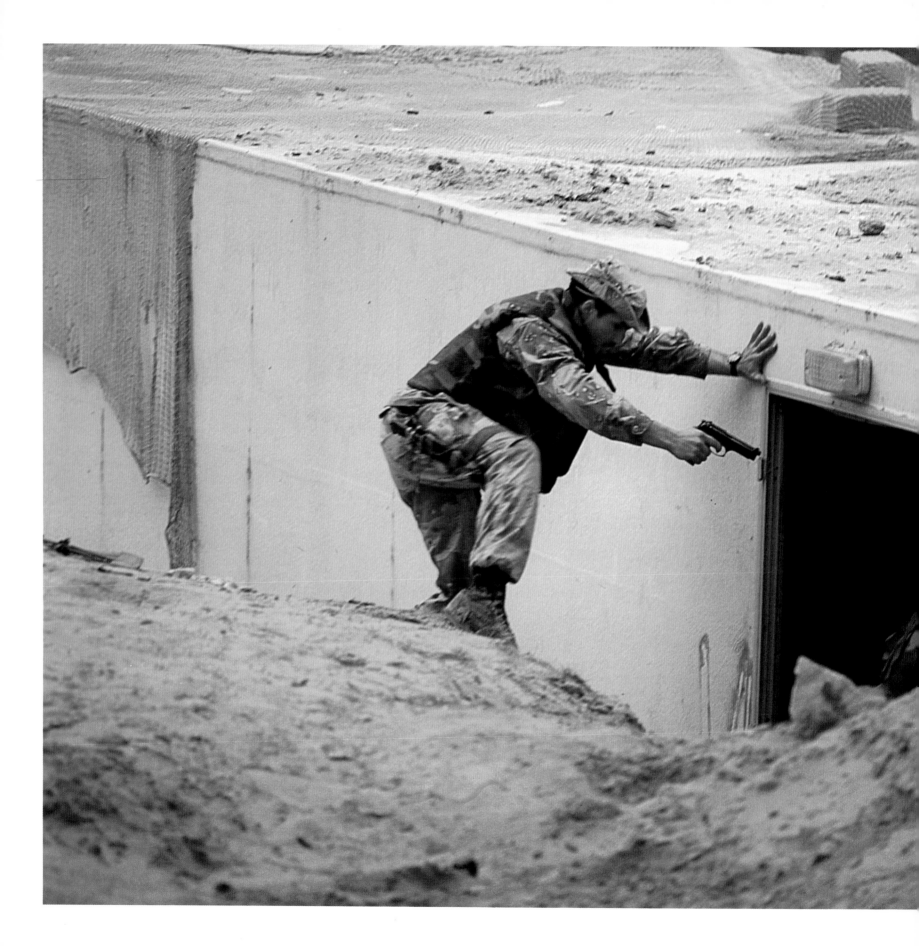

IN SEARCH OF

"On the highway to Kuwait City, U.S. Special Forces sped ahead of the Saudi and allied convoys and effectively cleared the way for the liberation of Kuwait City," Jacques Langevin recalls. "A soldier searched a location for Iraqi soldiers, but only found ammunition." Outside Kuwait City. 26 February 1991. *(Jacques Langevin)*

Saudi armor near Kuwait City. 26
February 1991. *(Jacques Langevin)*

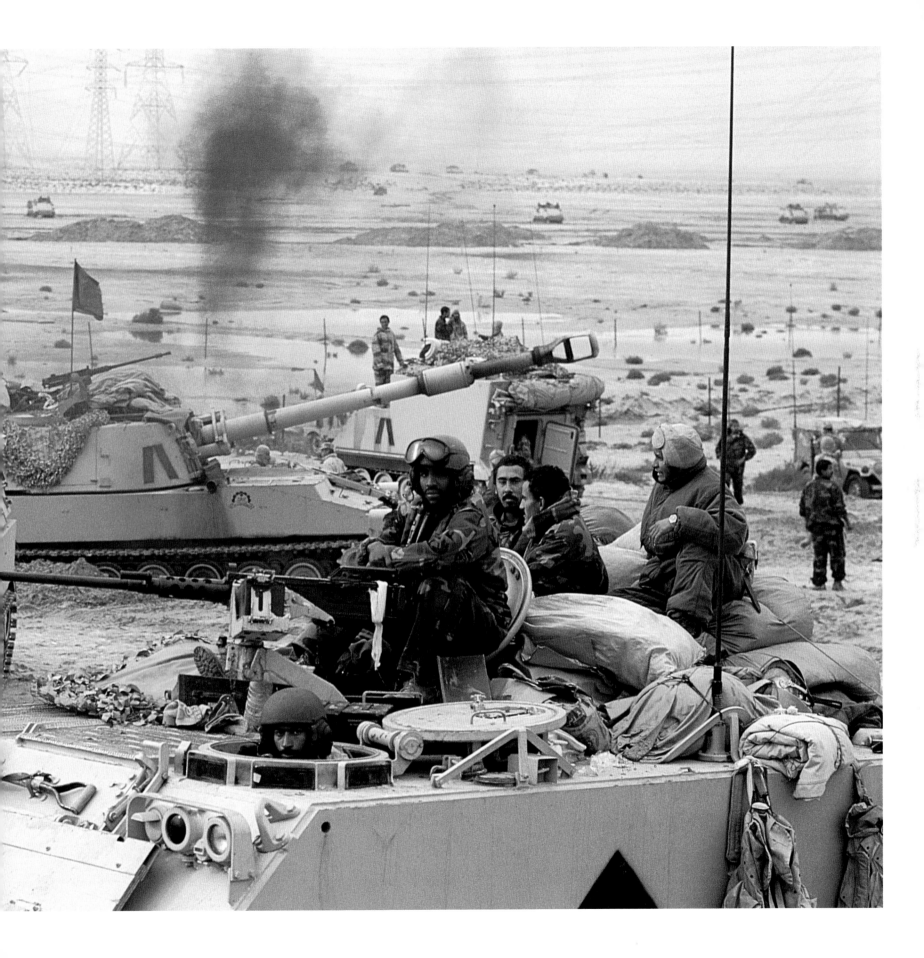

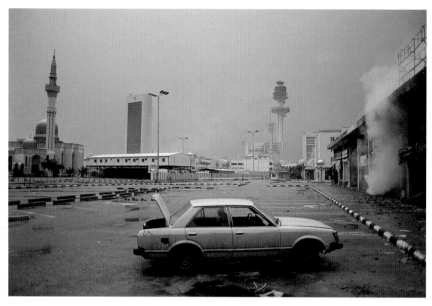

MOSTLY CLOUDY SKIES

ABOVE

A desolate scene in Kuwait City during the liberation. In the distance the main communication tower is still standing. 28 February 1991. *(Jacques Langevin)*

RIGHT

Kuwait City under a pall of smoke from burning oil wells. View from the Plaza Hotel. March 1991. *(Stephane Compoint)*

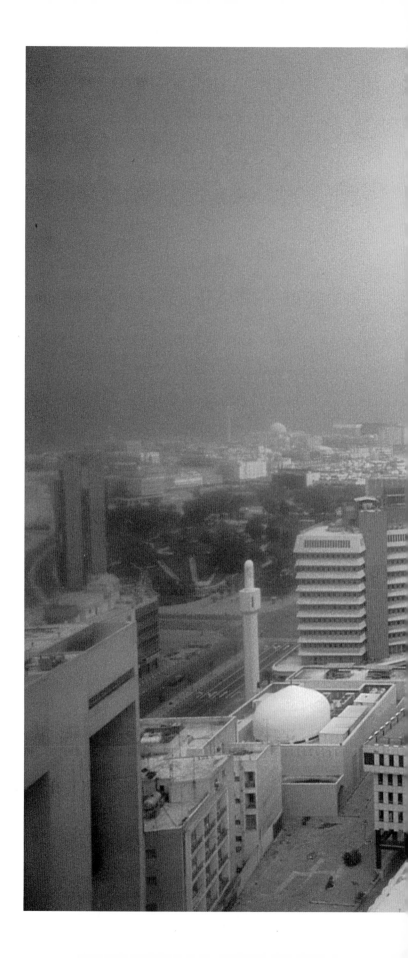

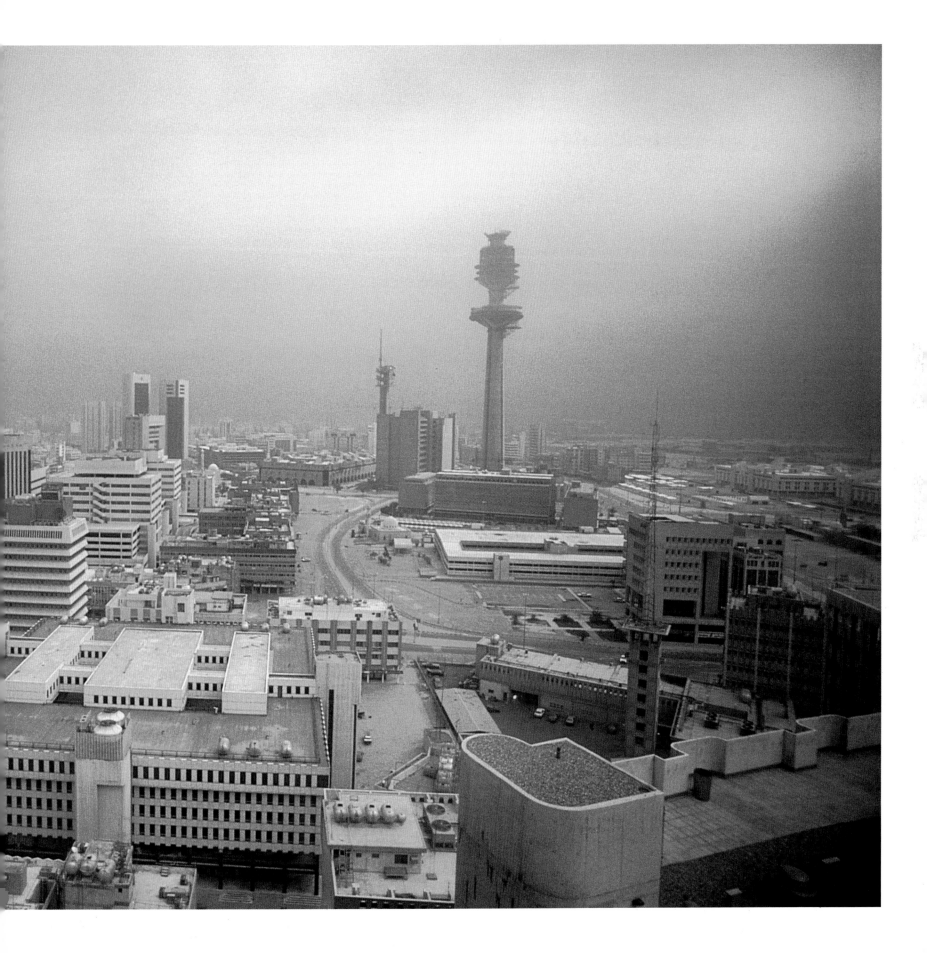

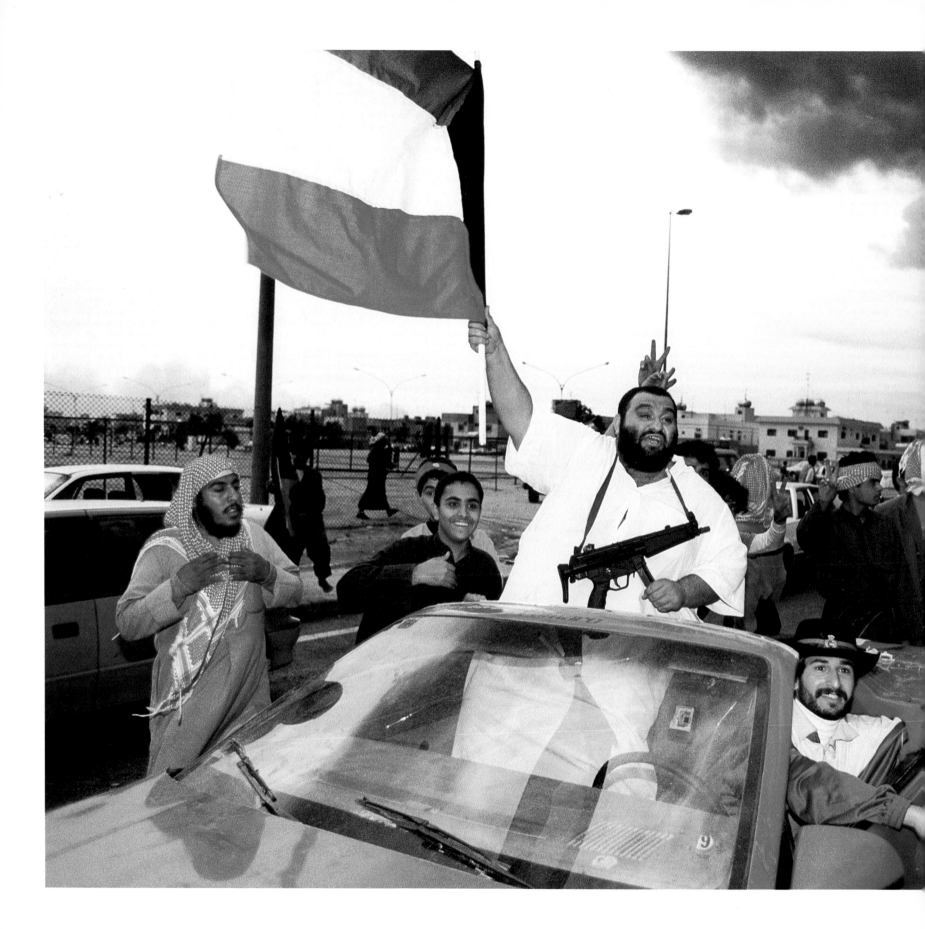

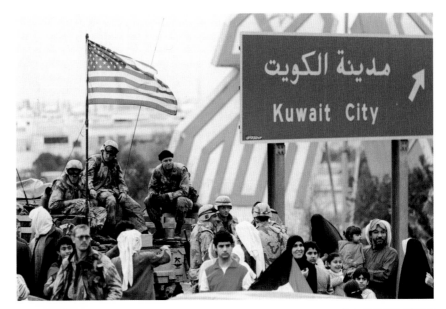

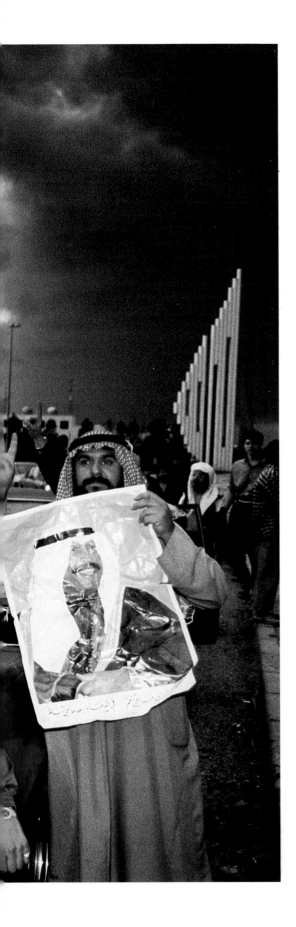

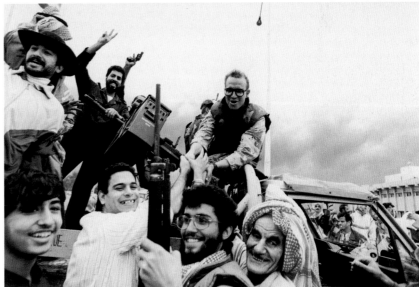

RETURN TO POWER

LEFT
Cheering Kuwaitis parade with their flag, a submachine gun, and a poster portrait of the Emir's brother, Crown Prince and Prime Minister Sheik Saad al-Abdullah al-Sabah. Kuwait City. 26 February 1991. *(Patrick Durand)*

TOP
U.S. soldiers entering the outskirts of Kuwait City. 26 February 1991. *(Jacques Langevin)*

ABOVE
Kuwaitis congratulate a U.S. Special Forces soldier. Kuwait City. 26 February 1991. *(Patrick Durand)*

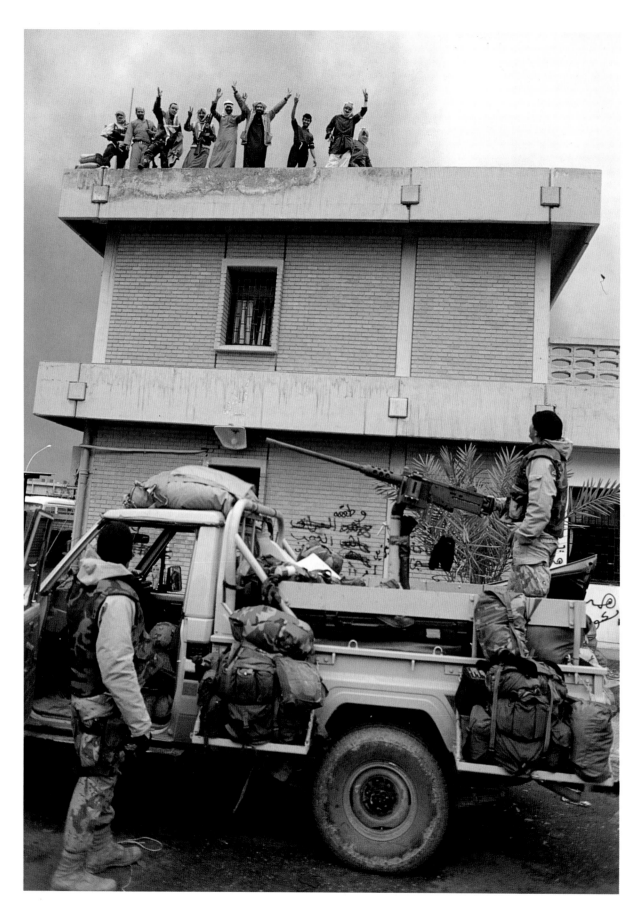

"The few French journalists that followed the U.S. Special Forces were also greeted as liberators," recalls Jacques Langevin. "We were, in fact, dressed in U.S. military uniforms in order to be included in the field operations. In the background, the sky was black but the problem of the pollution was forgotten for the moment. It will be the principal burden of Kuwait for years to come." Kuwait City. 26 February 1991. *(Jacques Langevin)*

"It was agreed that a minimum of U.S. soldiers should participate in the day of liberation and street celebrations that followed," says Patrick Durand. "Their mission was to reopen the U.S. embassy. The 'liberation' was mainly left to the Gulf states armies. Saudi and Qatari soldiers were engaged in combat as they opened the road from the Saudi-Kuwaiti border into Kuwait City, but when it came to entering the city, the Kuwaitis found themselves leading the parade. The festivities that followed were the first chance for many of these soldiers to fire their guns." A Kuwaiti man celebrates the victory with his national flag. Kuwait City. 26 February 1991. (Patrick Durand)

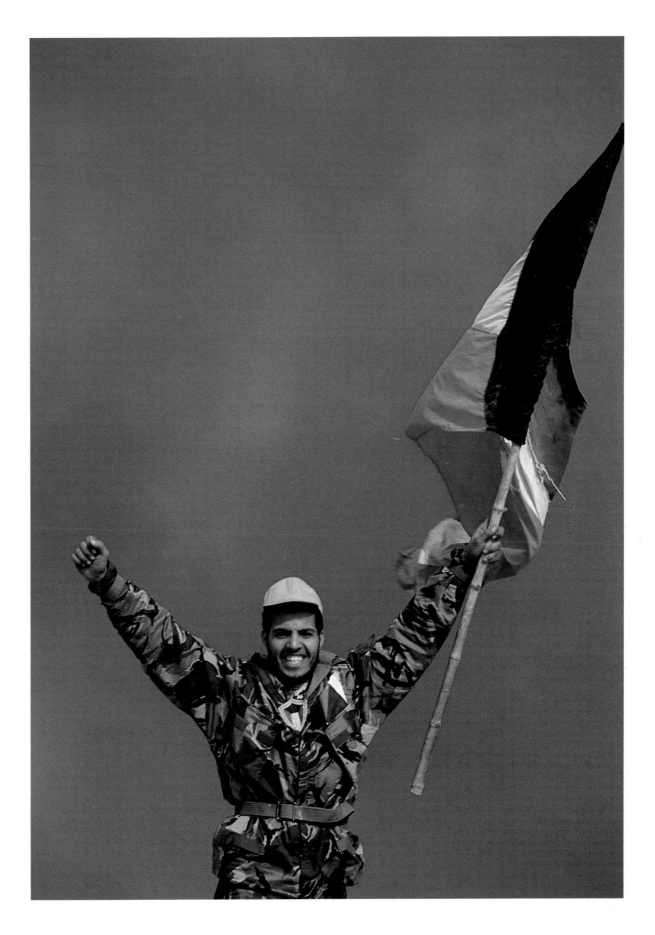

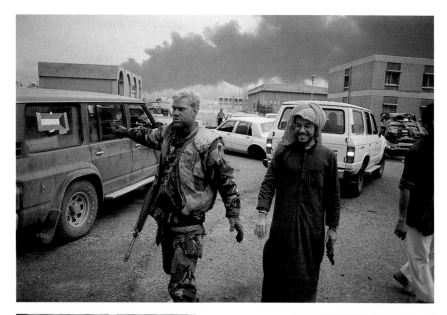

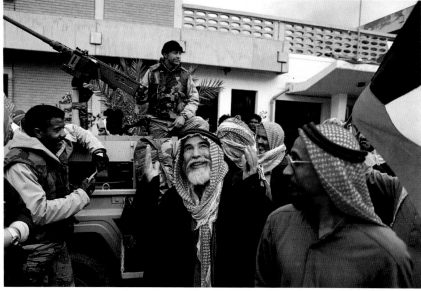

RIGHT

"Journalists were being refused entry into Kuwait, and I felt lucky in my U.S. military uniform when I slipped past the border in a convoy of a hundred cars escorted by Saudi police with blinking lights and sirens," says Patrick Durand. "A few miles farther along, everybody got out of the cars. I soon learned that I had returned to Kuwait with the Emir's brother, Defense Minister Sheik Nawaf al-Ahmad al-Sabah. Many of the soldiers kissed him, and then they all prayed." Just north of the Kuwaiti-Saudi border. 1 March 1991. *(Patrick Durand)*

TOP AND ABOVE

U.S. Special Forces soldiers and Kuwaiti citizens during the liberation of Kuwait City. 26 February 1991. *(Jacques Langevin)*

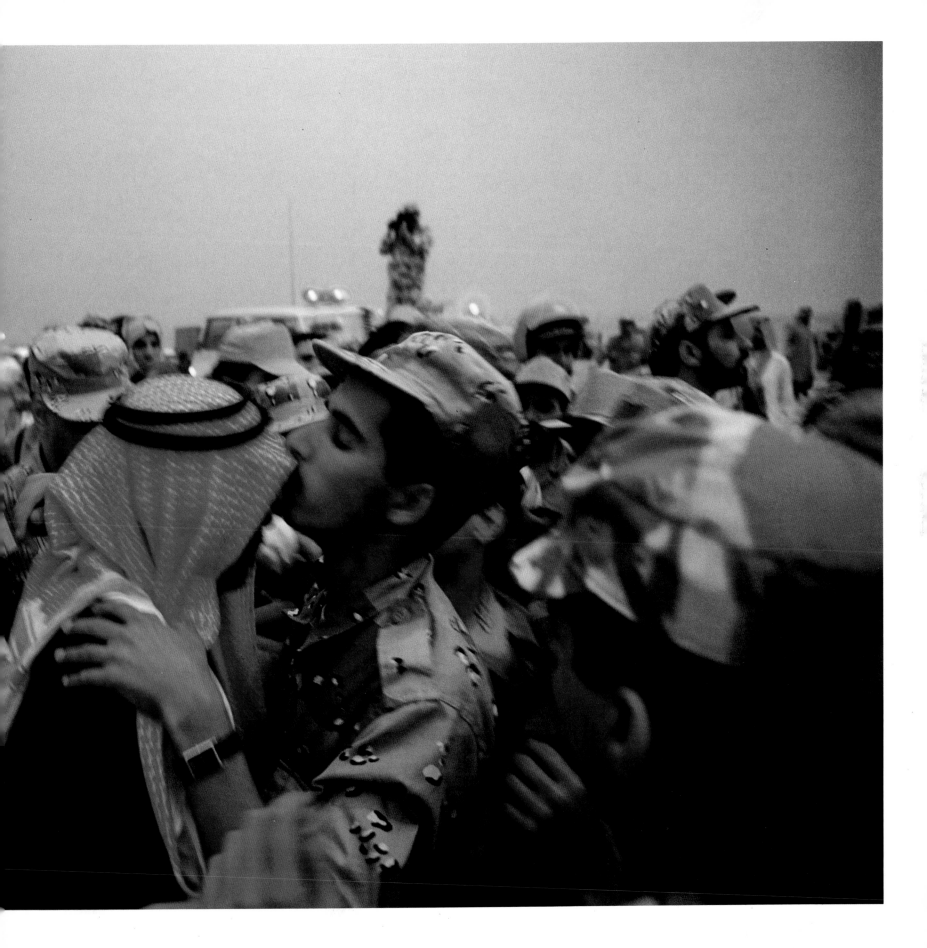

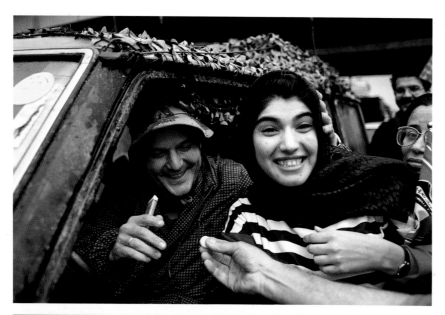

RIGHT

"The first U.S. troops arrived the night before to open the U.S. embassy," says Patrick Durand. "That morning they kept a low profile as Arab troops of the coalition made their entry amid the joyous population. All the civilians seemed to have weapons and were firing long bursts of AK-47 fire into the air. This woman seemed afraid of the shooting, but was crying with joy at the same time." Kuwait City. 28 February 1991. *(Patrick Durand)*

TOP

"Cheering Kuwaitis congratulated everyone for the liberation, including this French television cameraman," says Durand. "We had chased the Iraqis away and we were heroes, too. And we were kissed and kissed and kissed — unfortunately, only by the men. The women just shook our hands." Kuwait City. 27 February 1991. *(Patrick Durand)*

ABOVE

A Kuwaiti street takes an entirely new name. March 1991. *(Stephane Compoint)*

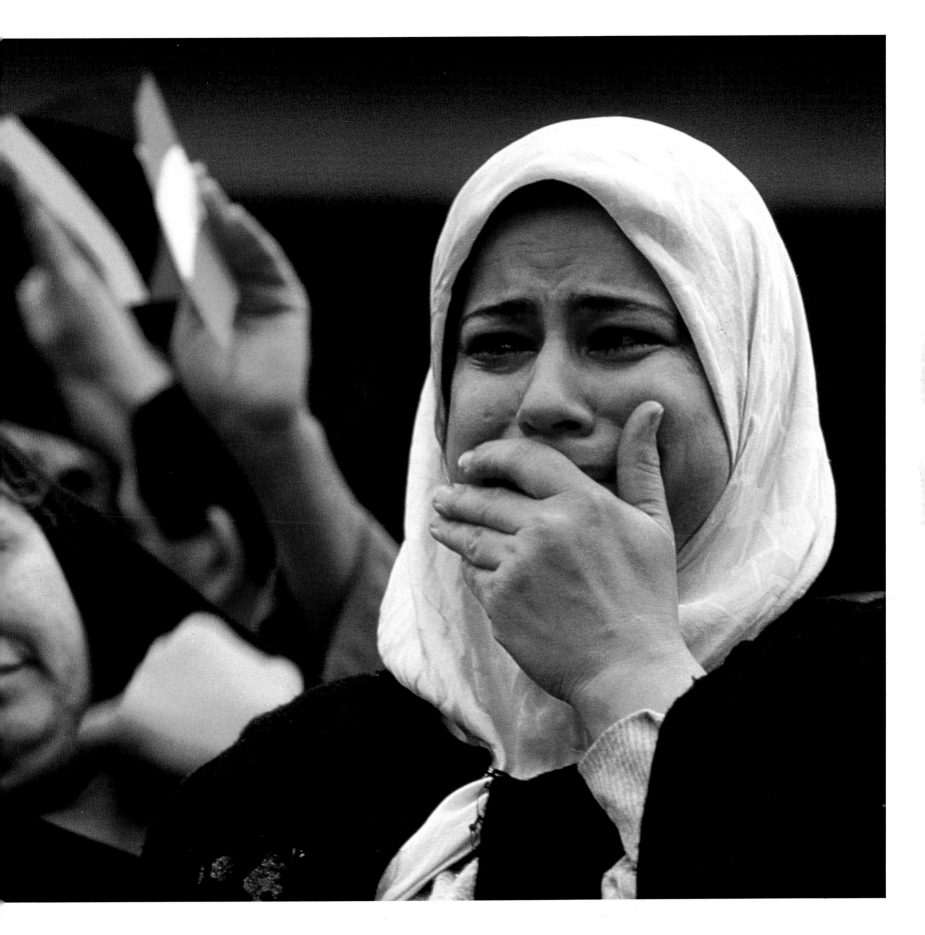

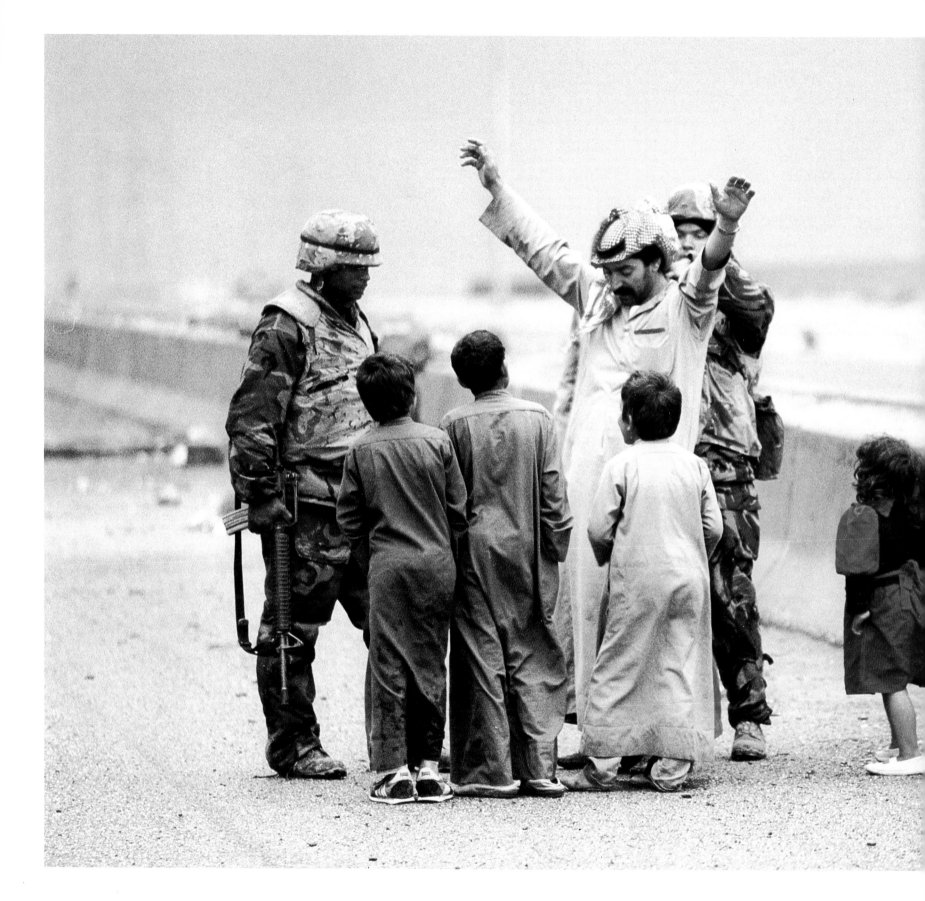

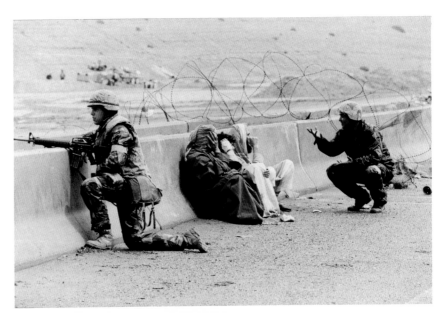

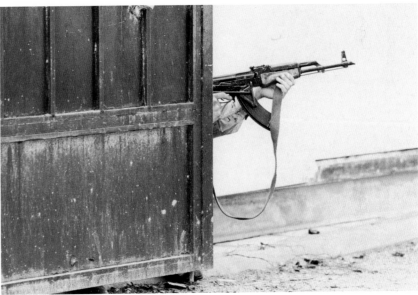

"We came to a checkpoint of U.S. Marines who told us this family was caught with Iraqi arms and grenades in their car," recalls Derek Hudson. "They were all searched one by one, but I particularly liked this moment when the Marine removes the father's *kuffiyah*, as the children and wife look on in amusement." Outside Kuwait City. 27 February 1991. *(Derek Hudson)*

Marines take cover from sniper fire during an interrogation on the outskirts of Kuwait City. 27 February 1991. *(Derek Hudson)*

A U.S. Special Forces soldier returns fire with a captured Kalashnikov AK-47 assault rifle near the U.S. Embassy. Kuwait City. 28 February 1991. *(Derek Hudson)*

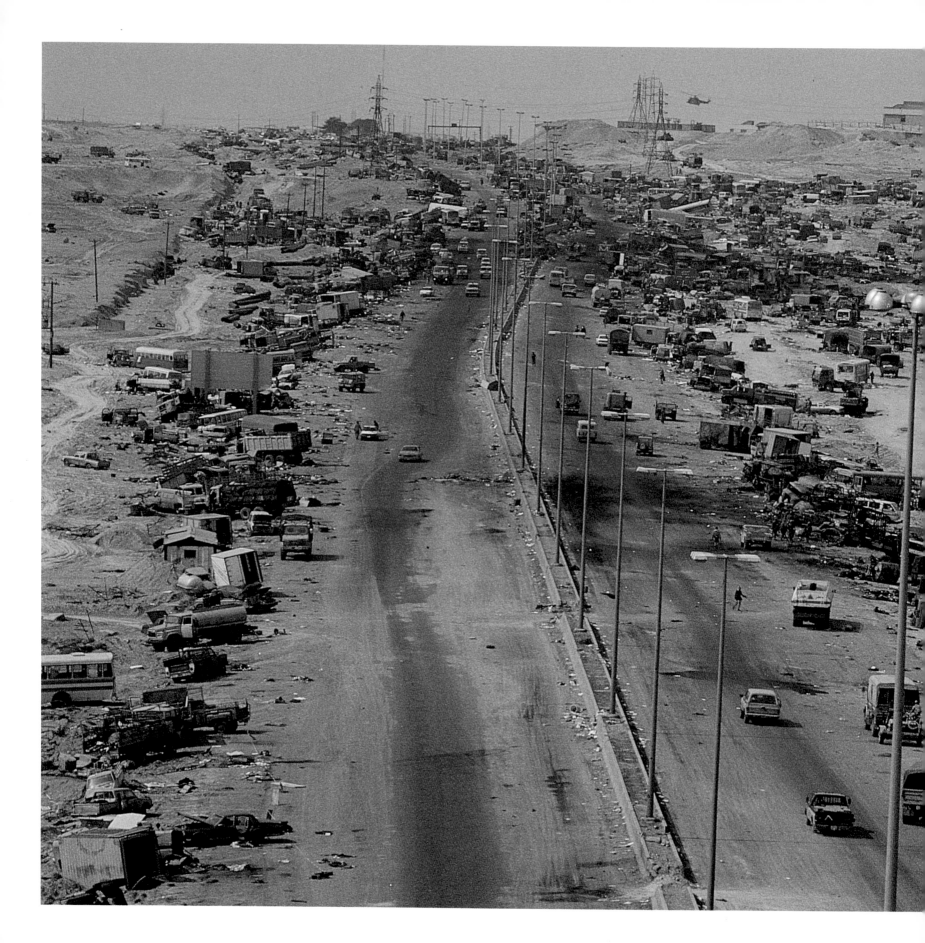

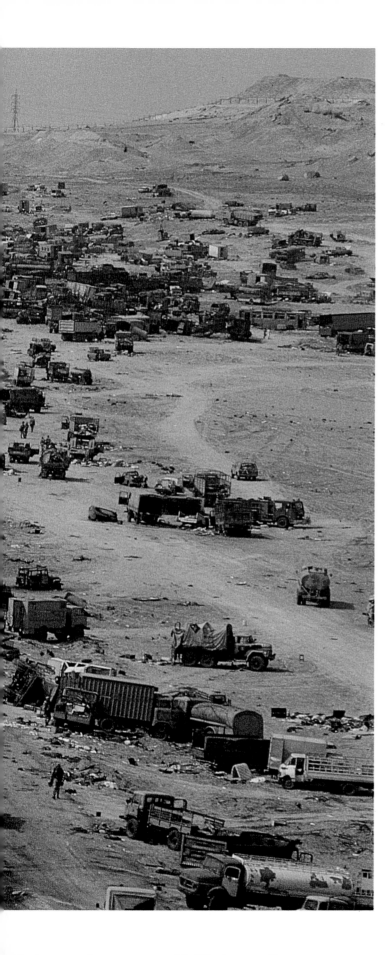

HIGHWAY TO HELL

On the night of 26 February and early the next day, allied air power descended on the masses of Iraqi soldiers fleeing Kuwait City. Their convoy of assorted vehicles was laden with their munitions and all the loot they could pack. War planes dropped cluster bombs; their razor-sharp shrapnel shredded everything in sight. Explosions resulted, and fires incinerated passengers, creating a ghoulish traffic jam of charred mummies. "When I arrived on this road midafternoon, the sky was black, and the scene was from another planet where all signs of life had just stopped," recalls Jacques Langevin. "Several car and tank engines were still running, with their headlights on and radios playing. And this was three days after the bombing. One can only imagine the panic of these soldiers during the attack."

LEFT

An aerial view of the carnage along the highway to Basra, Iraq, now known as the Highway of Death. North of al Jahrah, Kuwait. March 1991. (Eddie Adams)

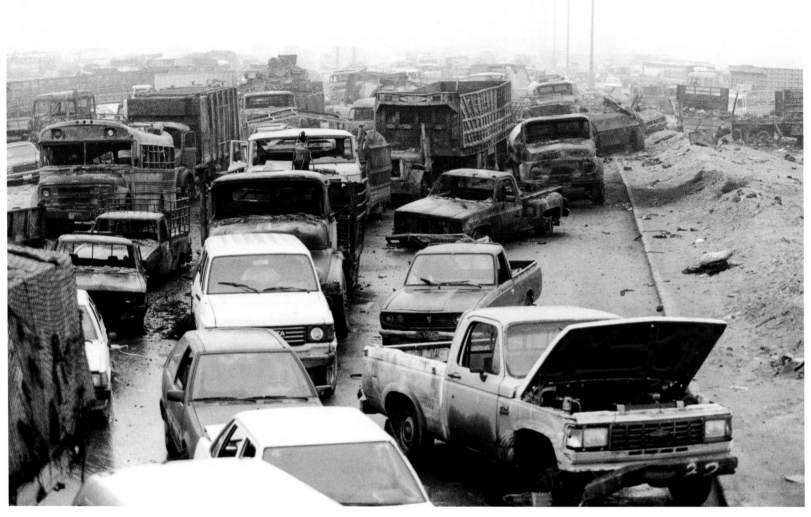

"The strange thing about the Iraqi convoy was that for the most part the vehicles were nonmilitary," notes Derek Hudson. "They were mostly stolen Kuwaiti trucks, buses, and private cars filled with guns and personal effects. A few chickens roamed around looking for scraps to eat amongst scattered jewelry boxes, packs of Dunhill cigarettes, and gas masks."

ABOVE AND OPPOSITE
Wreckage along the stretch of road known as the Highway of Death. Al Jahrah, Kuwait. 1 March 1991. *(Jacques Langevin)*

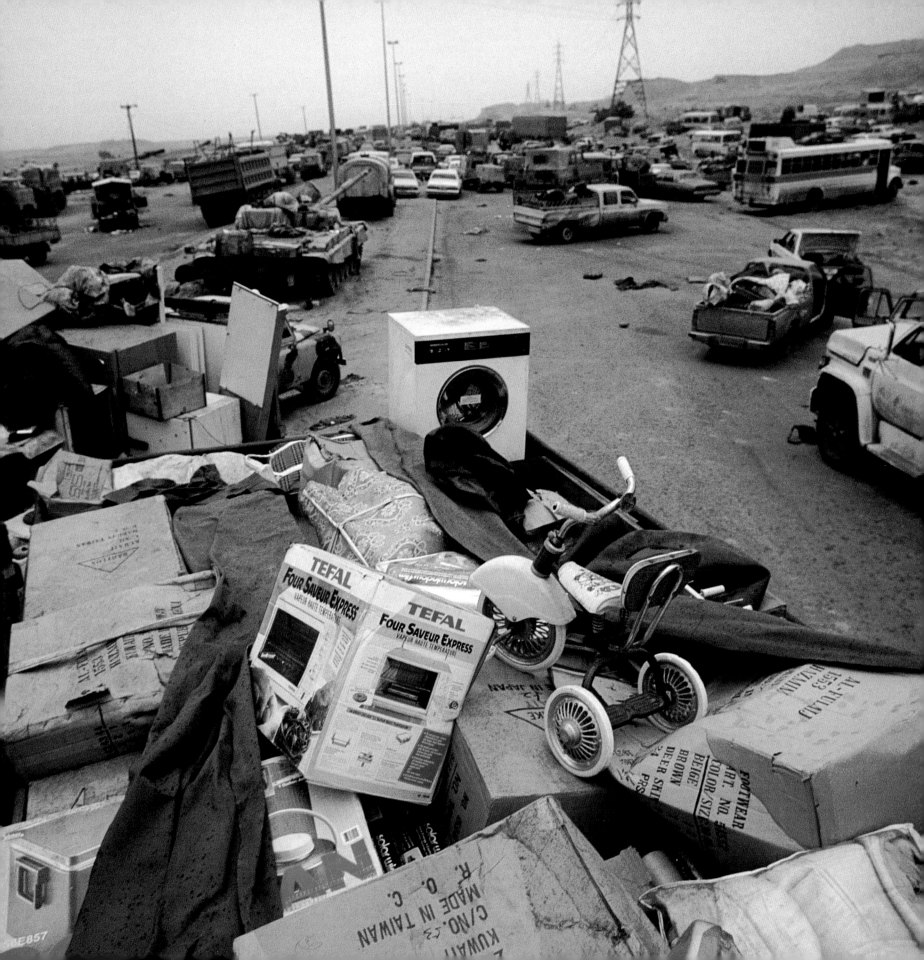

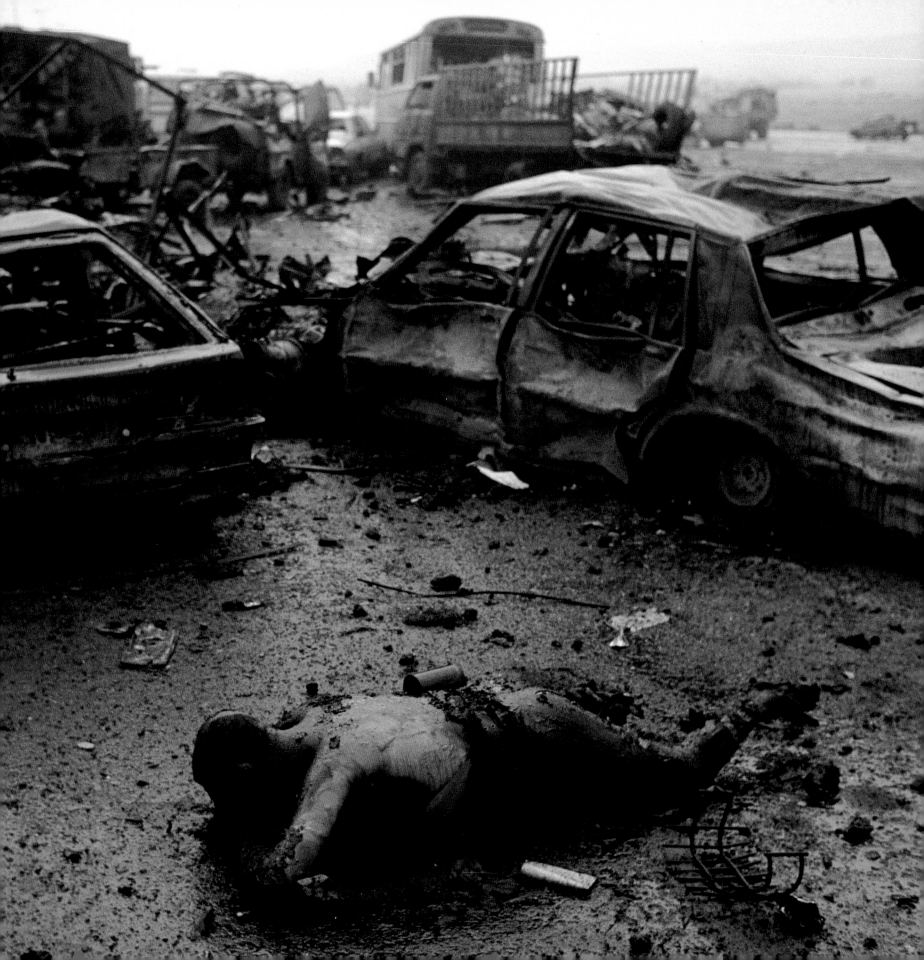

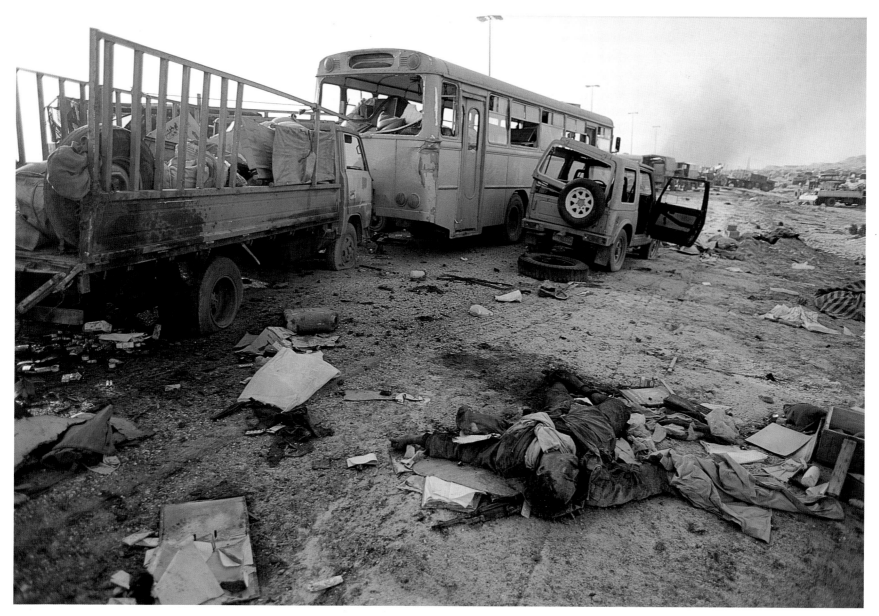

ABOVE

"The poignancy of this picture is that the soldier is lying on his Kalashnikov," observes Derek Hudson. "This is the only angle he could be photographed from as his lower body was badly destroyed and his limbs were twisted. It is horrible to see this, but it must be seen. This is war. Soldiers die, but I don't imagine this one died very gallantly." Along the Highway of Death. Al Jahrah, Kuwait. 28 February 1991. *(Derek Hudson)*

OPPOSITE

Iraqi caught by allied air power on the Highway of Death. Al Jahrah, Kuwait. 1 March 1991. *(Jacques Langevin)*

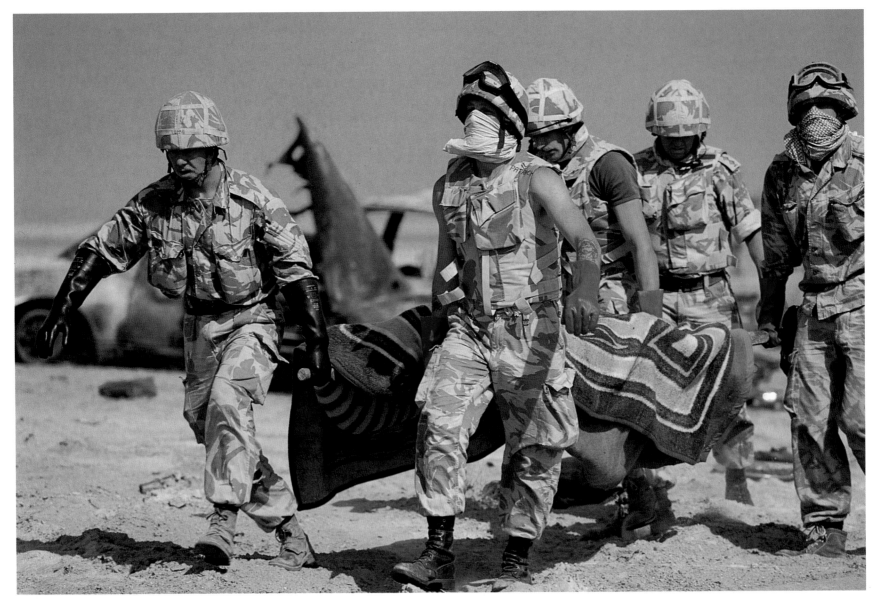

ABOVE

"British soldiers collected the remains from the inescapable highway disaster, a particularly painful duty," recalls Thierry Orban. "And Kuwaiti families had also come with their cameras. In front of the mangled and charred carcasses, they enthusiastically snapped souvenir shots. Another family, howling with laughter, drove along this apocalypse in their shiny Mercedes convertible with their video camera, as if this were a show for them." Al Jahrah, Kuwait. 2 March 1991. *(Thierry Orban)*

RIGHT

"Just to the north of the infamous convoy of death, I came across a group of U.S. Marines sticking bricks of plastic explosives on this portrait of Hussein," reports Patrick Durand. "As they were finishing their work, an abandoned Iraqi tank exploded and burned nearby." Al Jahrah, Kuwait. 2 March 1991. *(Patrick Durand)*

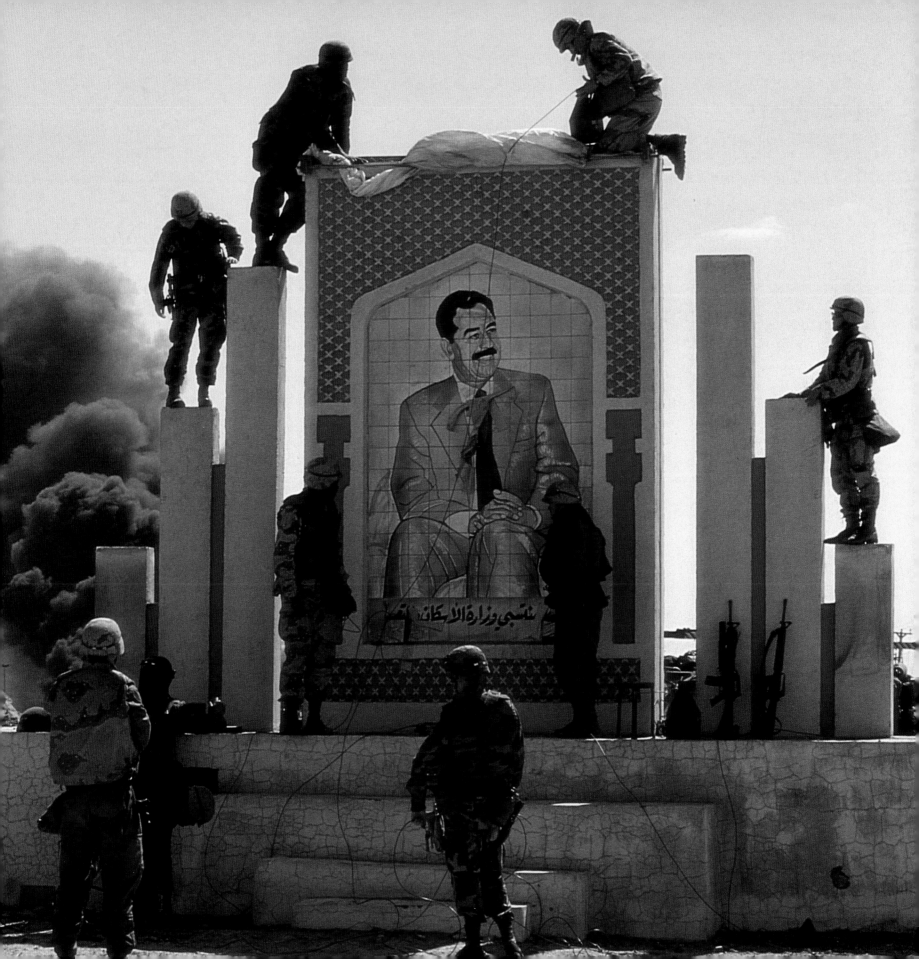

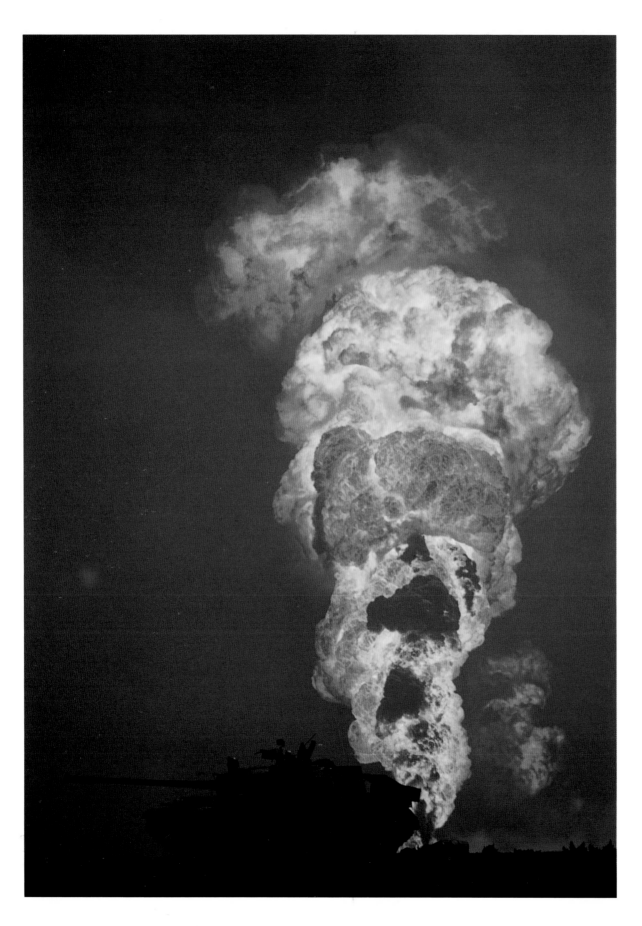

HIGH NOON

More than 550 Kuwaiti oil wells were set afire by Iraqi occupiers, sending thousands of tons of sulphur dioxide — a primary cause of acid rain — into the atmosphere. "An abandoned Iraqi tank sat by this burning oil field — only a quarter of a mile away there were houses in a town," noted Stephane Compoint. "It was impossible to get any closer than sixty yards because the heat of this fire was hellish, but the Kuwaiti police at the roadblock made it difficult to come even this far. Security was so tight because it was said there were land mines in the area." Burgan oil field, near al Ahmadi, Kuwait. March 1991. *(Stephane Compoint)*

RIGHT

Kuwaiti oil fires ignited by Iraqis burned a million tons of oil a day throughout the course of the war. The magnitude of this environmental catastrophe was immediately apparent: temperatures fell as smoke eclipsed the sun, "black rain" damaged crops and polluted water supplies, hospitals were filled with patients suffering severe respiratory disorders. "In this area, near Safwan and the Iraqi border, there were about fifty wells ablaze," says Jacques Langevin. "In the middle of the day the sky was black with a bizarre light filtering through, quite apocalyptic." In the midst of this, an American soldier stands atop his armored personnel carrier during the final phases of the ground war. Near Safwan, Iraq. 1 March 1991. *(Jacques Langevin)*

OVERLEAF

A Kuwaiti engineer watches oil fires as they darken the noon sky. Al Ahmadi, Kuwait. March 1991. *(Stephane Compoint)*

ON PAGES 132-33

Destroyed vehicles in a burning oil field. Northern Kuwait. 15 March 1991. *(Allan Tannenbaum)*

ON PAGES 134-35

An abandoned Iraqi tank sits in the vicinity of the flaming Burgan oil field. Near al Ahmadi, Kuwait. March 1991. *(Stephane Compoint)*

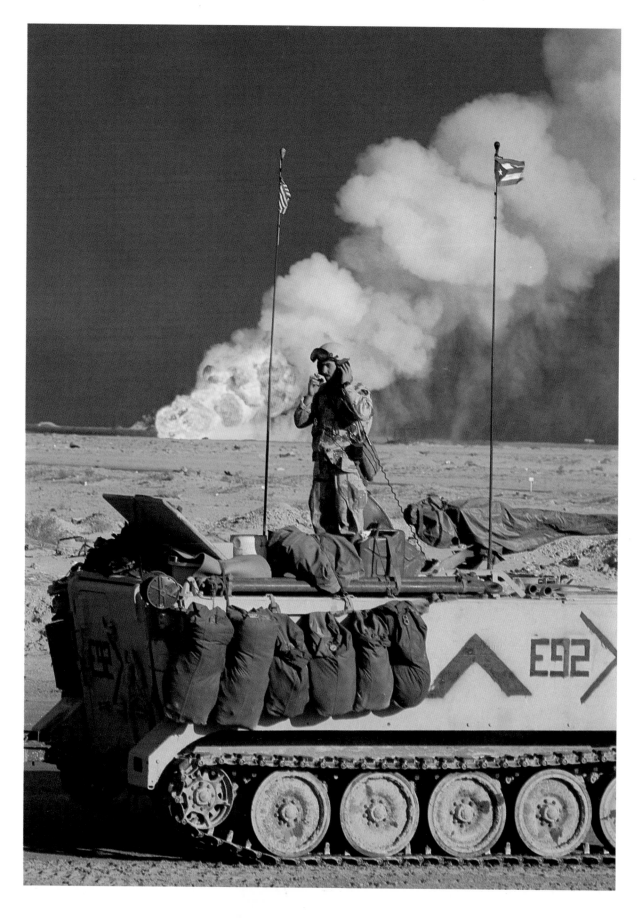

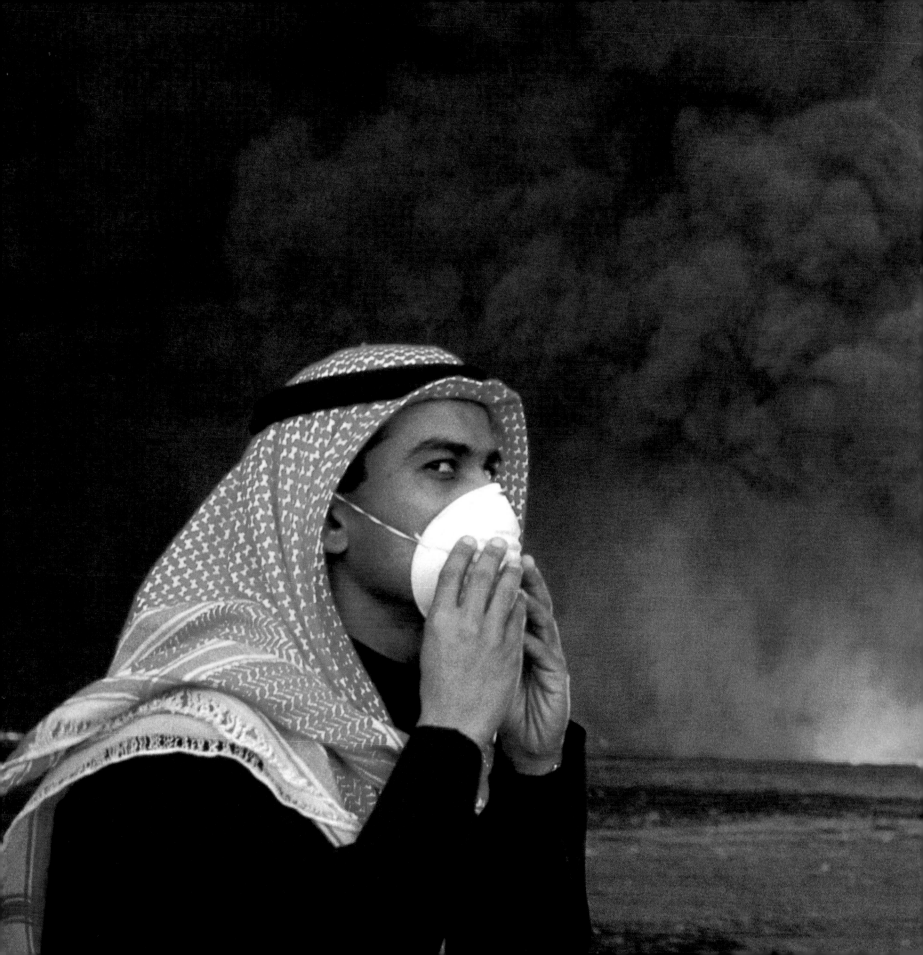

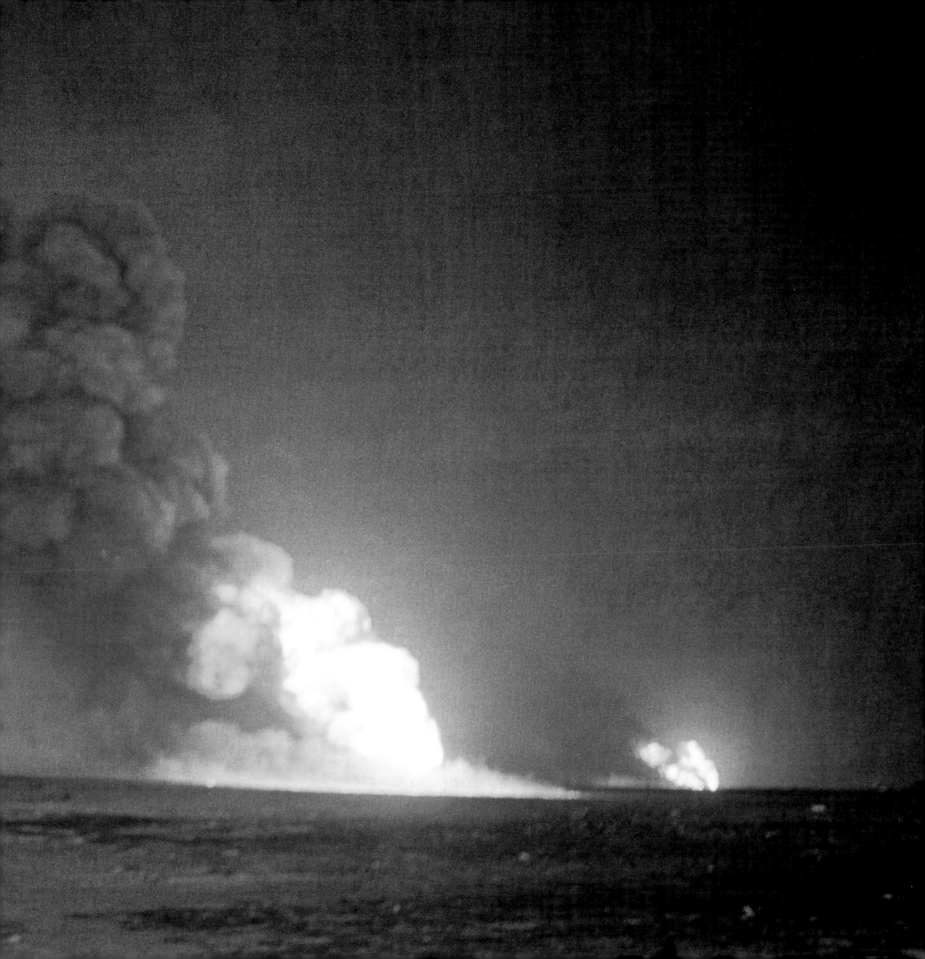

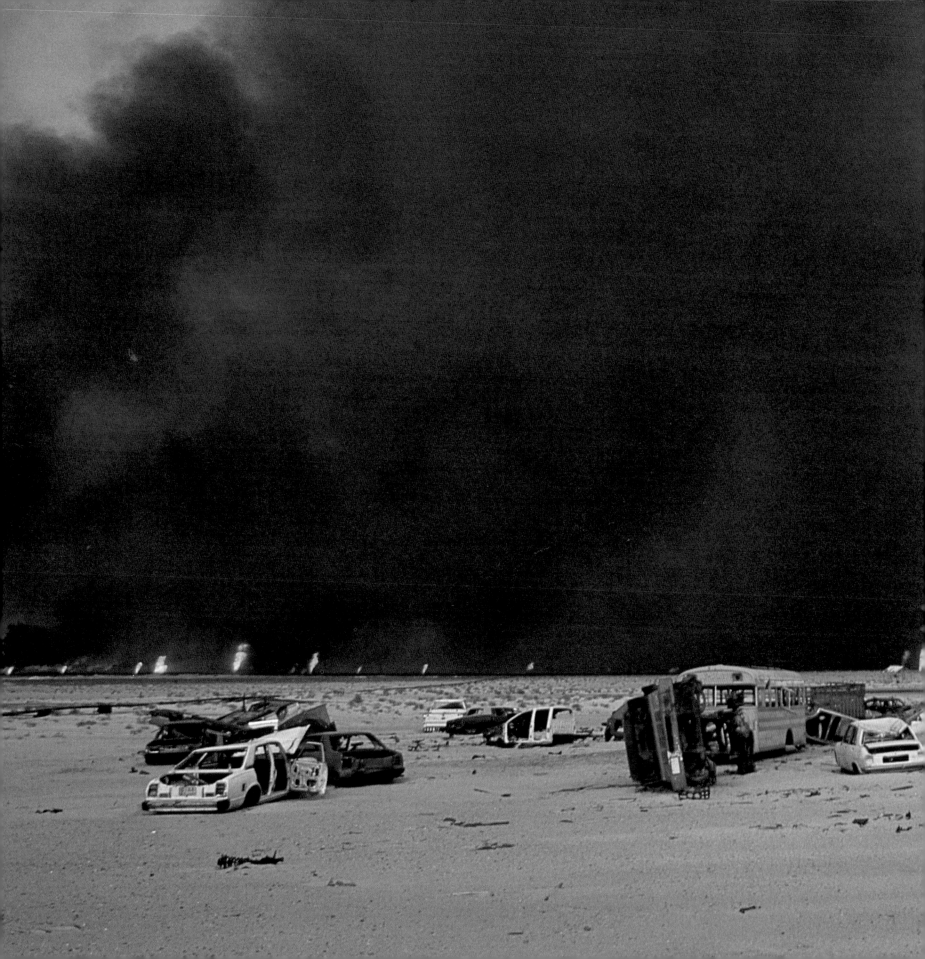

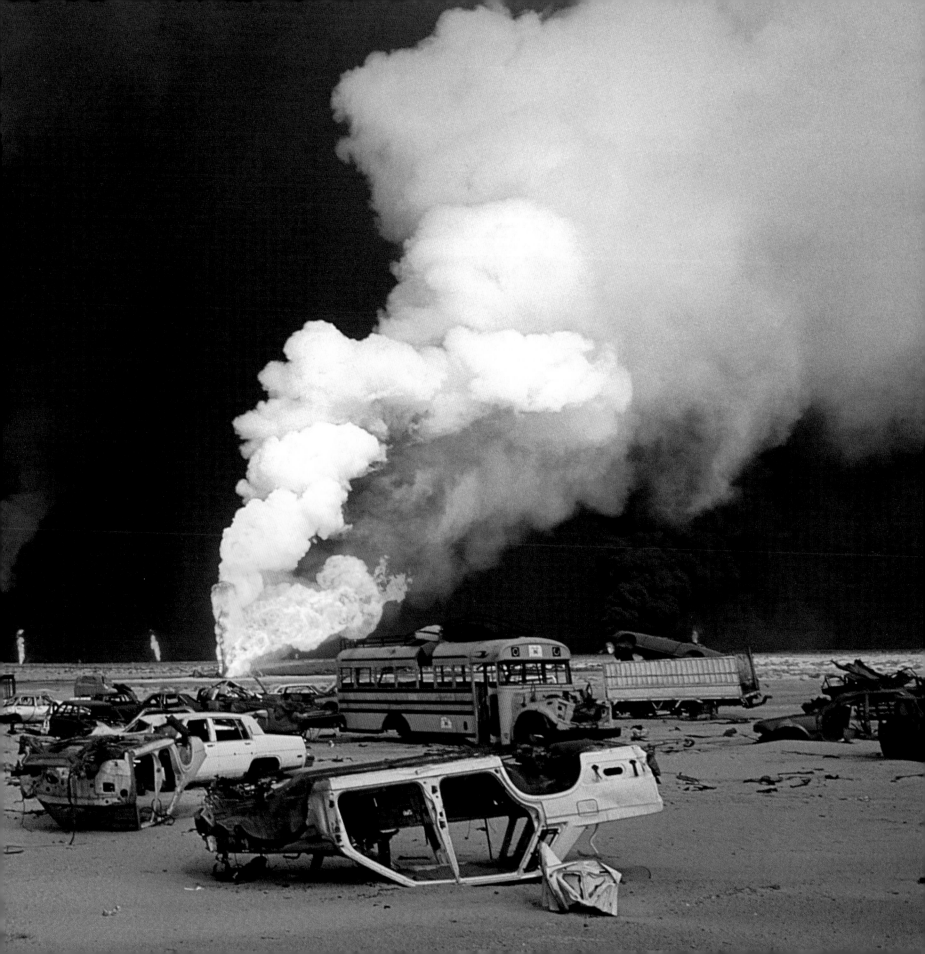

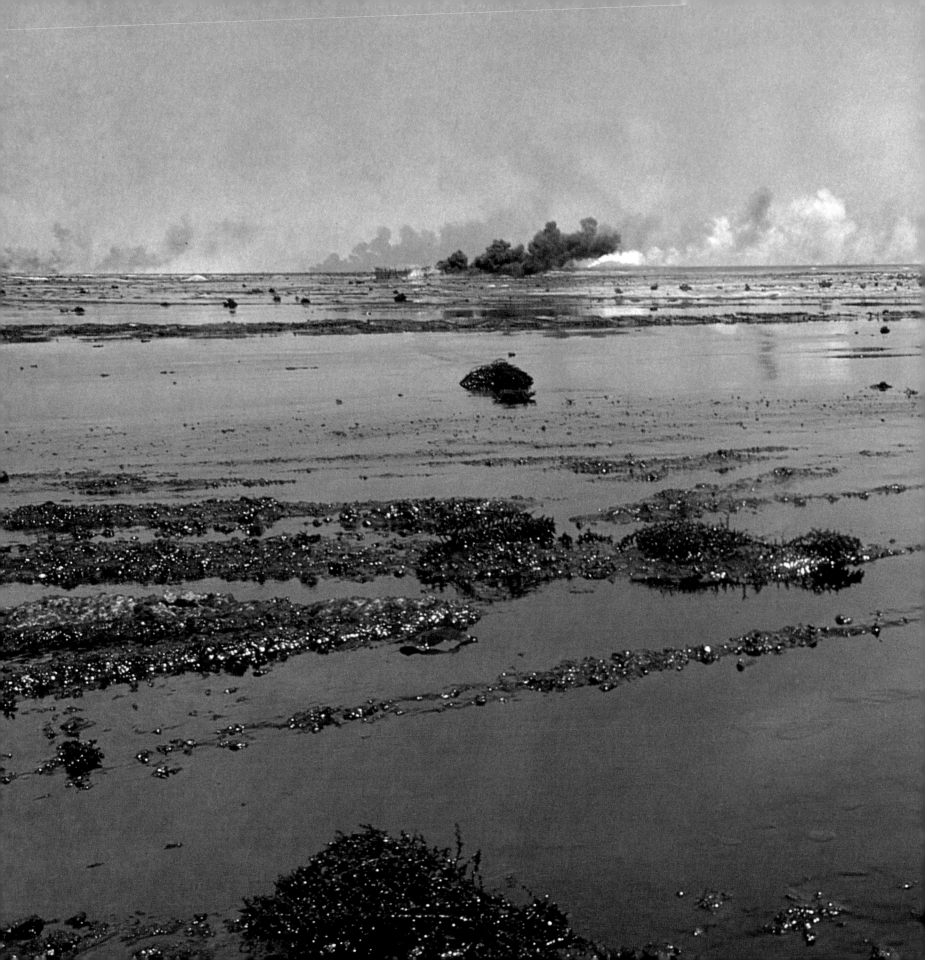

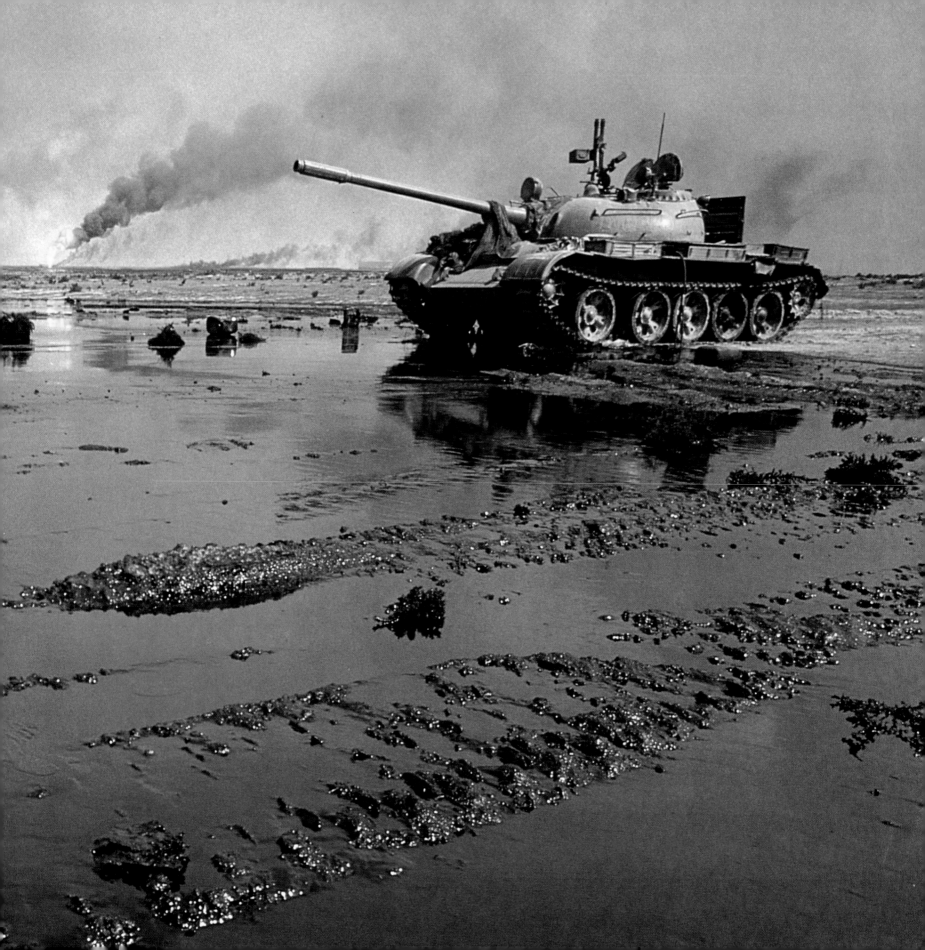

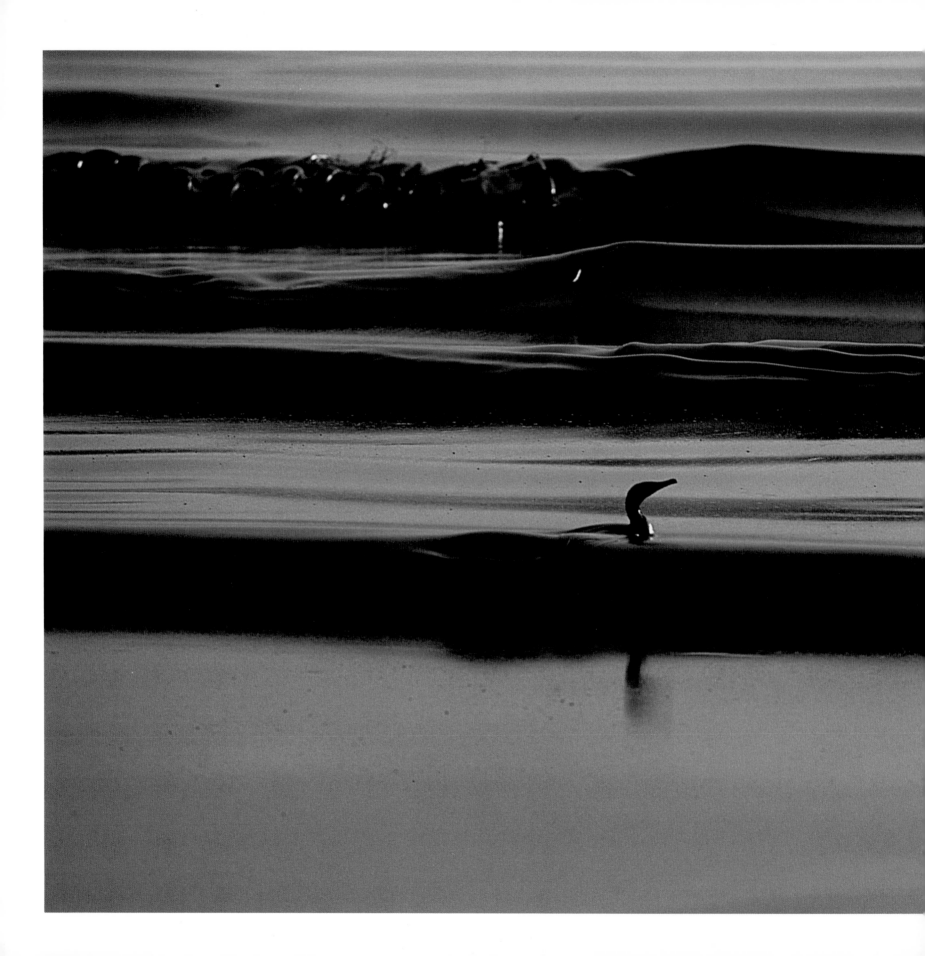

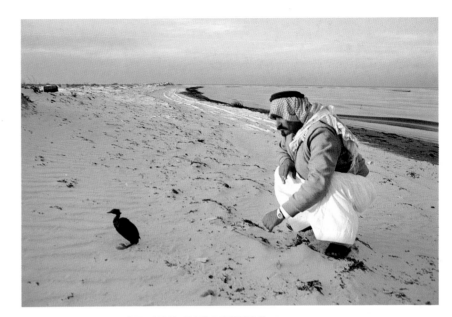

THE MOTHER OF ALL DISASTERS

When Hussein's men opened the taps of the pipeline on Kuwait's offshore oil terminal and emptied the holds of five Kuwaiti tankers, they created the largest pollution event in history. This disaster took a terrible toll on hundreds of species of marine life, including dolphins, whales, and seabirds, which died by the thousands. "I went to the beach at dawn and found dozens of birds on the rocks and sand," says Patrick Durand. "They were completely oil-soaked. Some were asleep with their heads beneath their wings. They would die this way. Unable to unstick themselves, they would suffocate. As I approached them, some attempted to return to the water. But now their natural habitat was nothing but oil. Once there, many dived and did not resurface."

LEFT

A seabird in the oil-thick surf. Khafji, Saudi Arabia. 25 January 1991. *(Patrick Durand)*

ABOVE

A Saudi man observes an oil-covered bird on the beach at Jubail, Saudi Arabia. 14 February 1991. *(Jacques Langevin)*

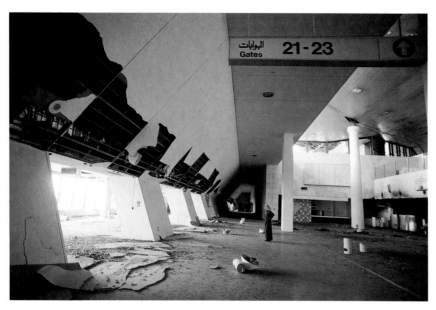

IRAQI ATTACKS

ABOVE

Iraqis ransacked and set fire to the main lobby of Kuwait City International Airport. March 1991. *(Stephane Compoint)*

RIGHT

"All that remains in the Emir of Kuwait's spectacular Bayan palace is the Kuwaiti national anthem engraved and filled in solid gold on a massive marble column. The palace is the absolute priority of the reconstruction phase orchestrated by the Kuwaiti government," says Stephane Compoint. "This has greatly angered Kuwaitis who consider it more important to restore water, power, and telephone lines." Kuwait City. March 1991. *(Stephane Compoint)*

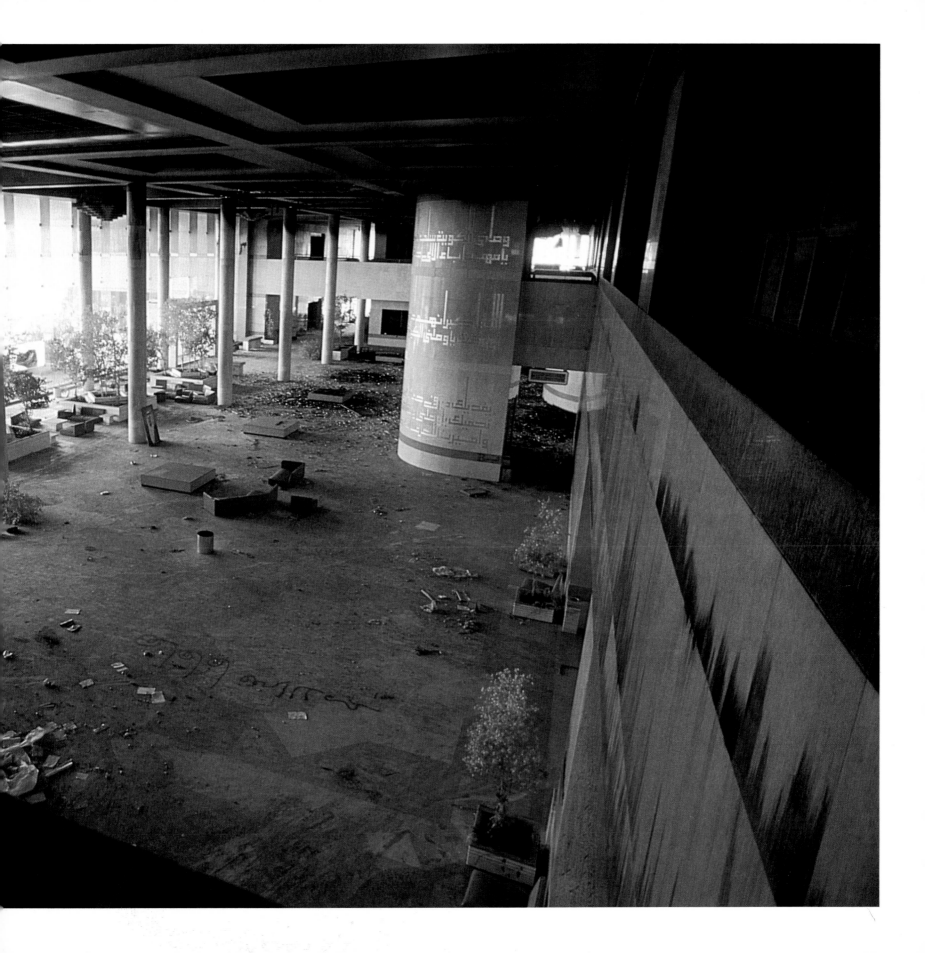

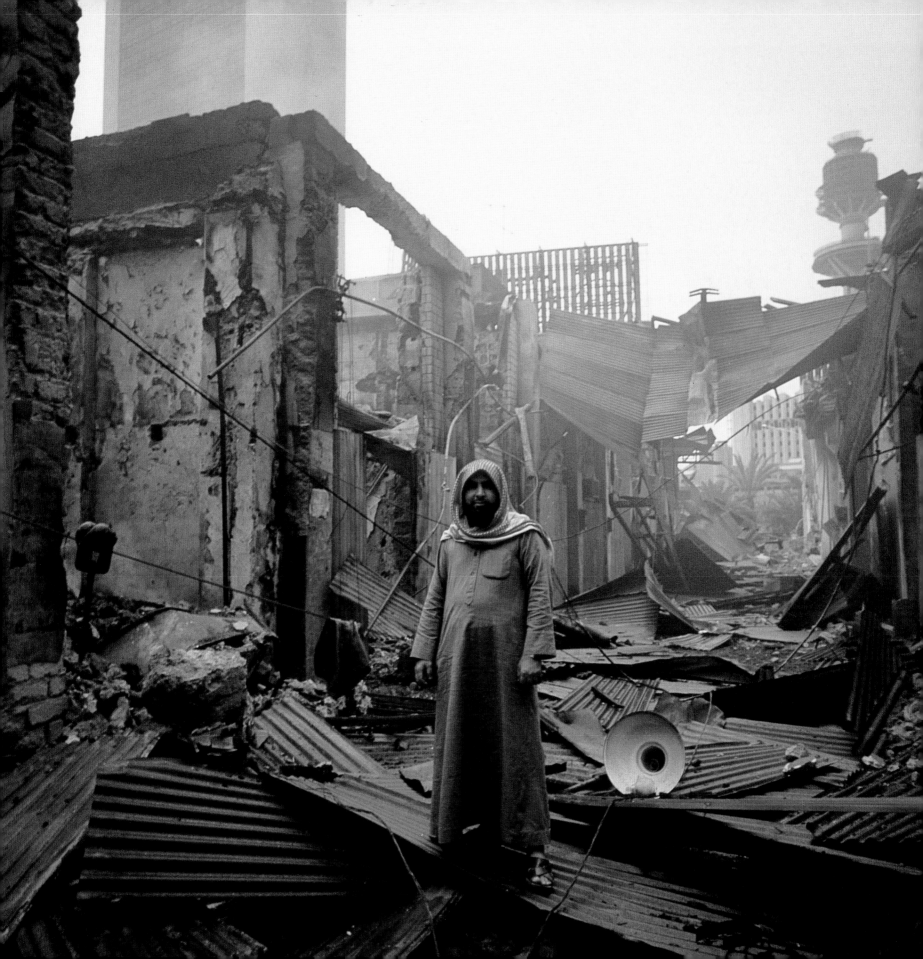

WORST CASE SCENARIO

OPPOSITE

"Unfortunately, the old sector of the city with its souks had been totally demolished by the allied bombings," notes Jacques Langevin. "In the middle of the rubble, this shop owner seemed to be in shock." Kuwait City. 26 February 1991. *(Jacques Langevin)*

TOP

"Noon looked like midnight as these neighborhood children played in a ditch caused by a bomb explosion," recalls Stephane Compoint. "The local hospital in al Ahmadi gave the kids masks to be worn when outside. This is the town closest to the burning Burgan oil field." Al Ahmadi, Kuwait. March 1991. *(Stephane Compoint)*

MIDDLE

The remains of a Mitsubishi car dealership, looted by Iraqi soldiers before they fled Kuwait City. March 1991. *(Stephane Compoint)*

BOTTOM

Kuwait City's desalination plants were completely knocked out of operation, but Saudi Arabian supertankers deliver temporary supplies of fresh water. These Kuwaitis wait with containers to collect it. Kuwait City. March 1991. *(Stephane Compoint)*

OVERLEAF

An aerial view of burning Kuwaiti oil fields from a C-130 Hercules on its approach to Kuwait City International Airport. 8 March 1991. *(F. Lee Corkran)*

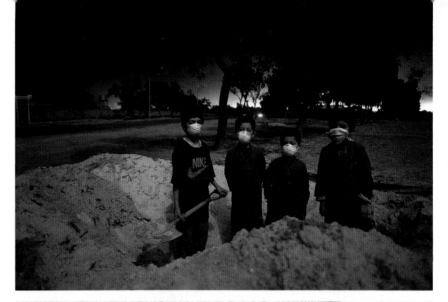

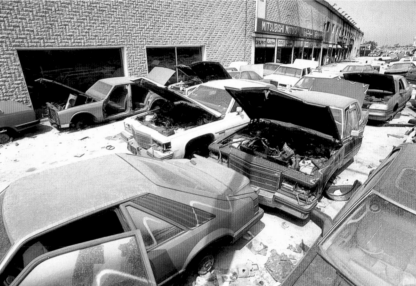

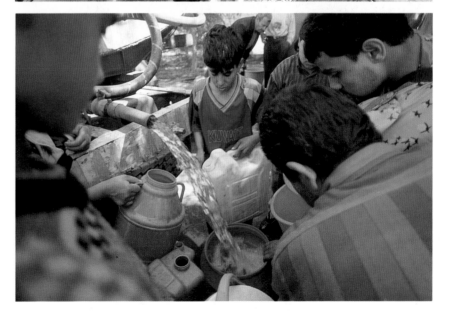

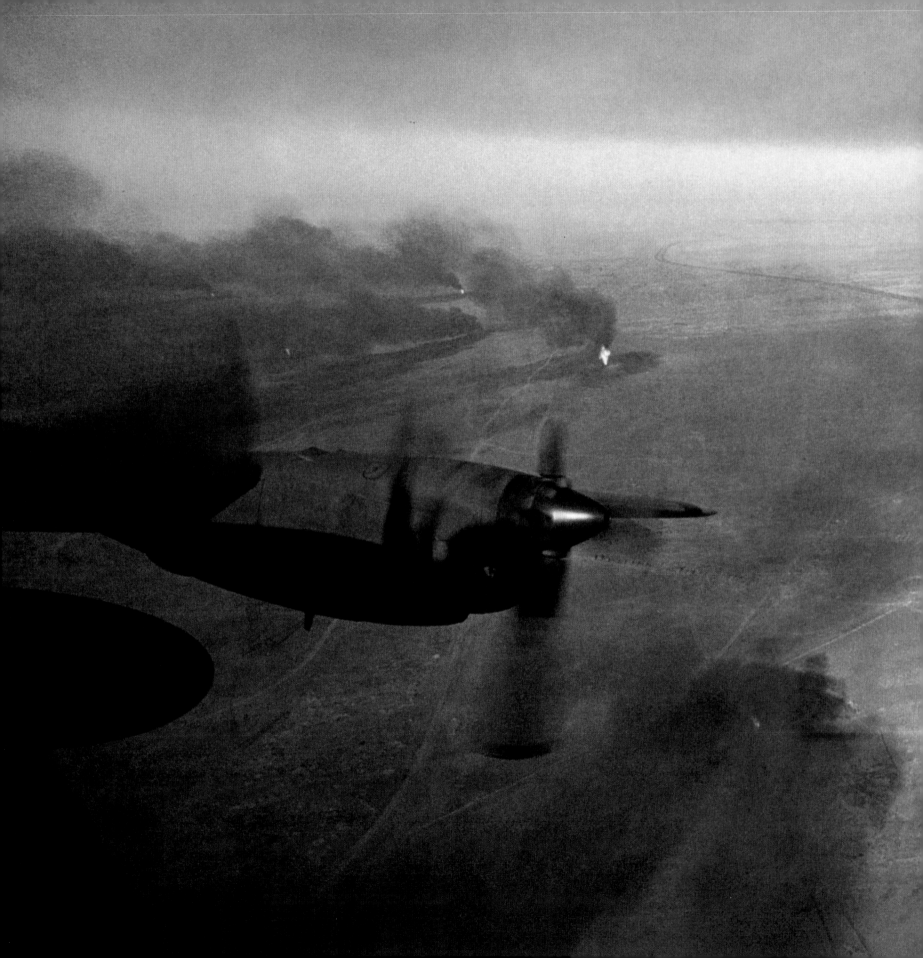

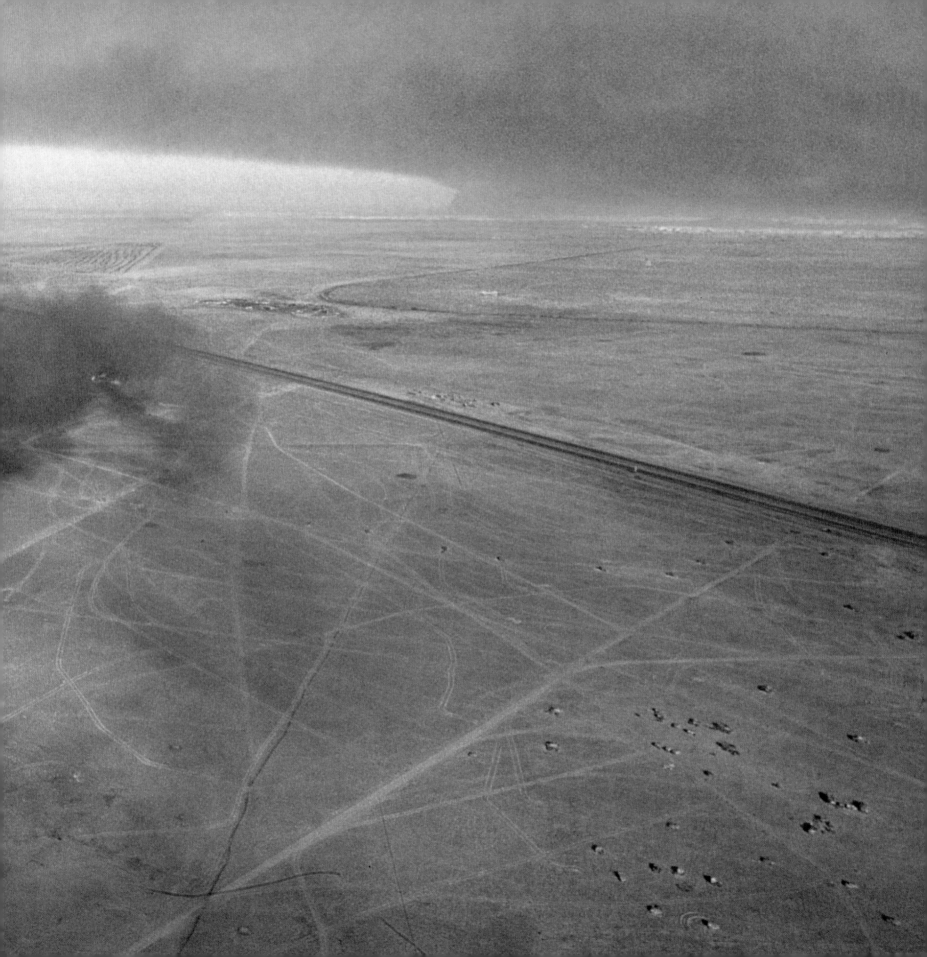

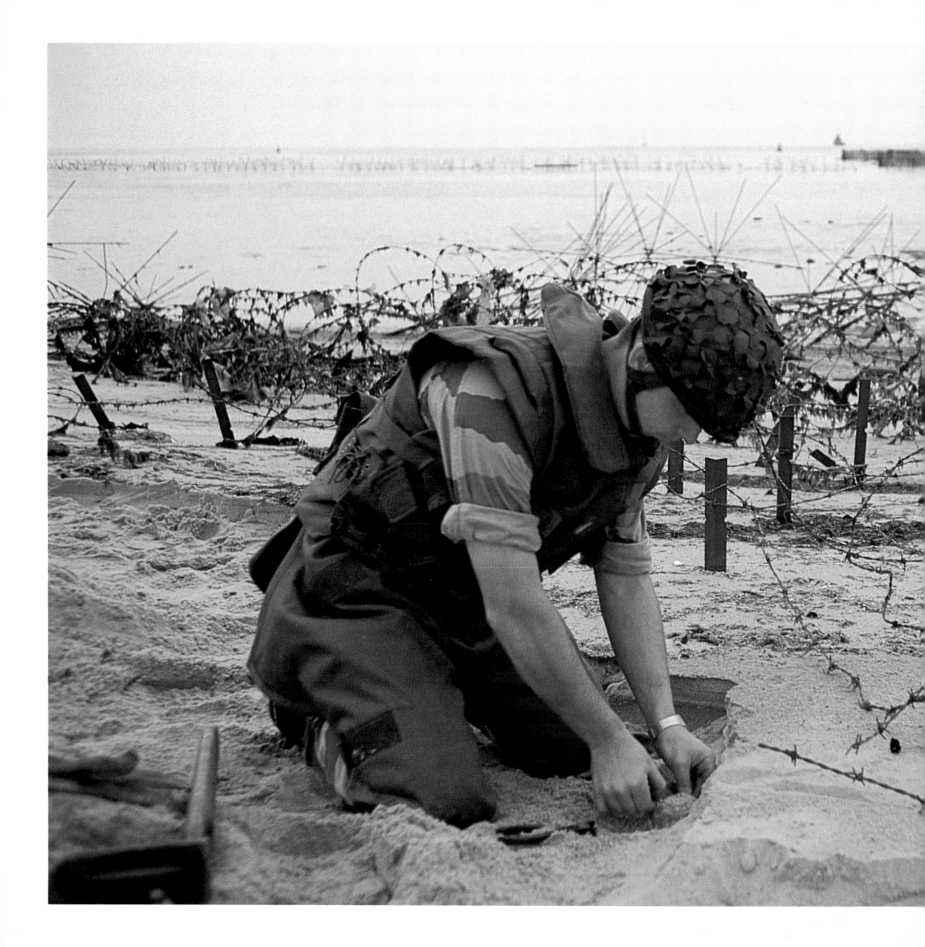

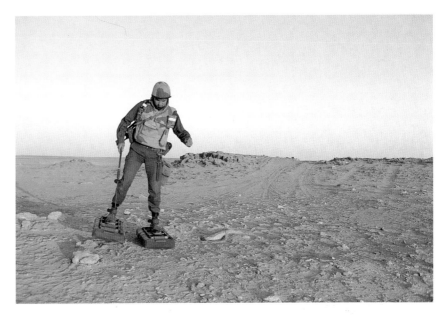

MINE FINDS

"Teams of Foreign Legionnaires gently scrape the sand with shovels to discover Iraqi mines planted along a sixteen-mile stretch of Kuwait City beachfront," says Allan Tannenbaum. "When one is found, the soldiers shout, 'mine,' and an expert removes it and unscrews the detonator. The French said that Iraqi mine planters lacked imagination, and that all were placed at predictable intervals." Kuwait City. 23 March 1991. *(Allan Tannenbaum)*

"This mine specialist of the Foreign Legion's 6th Engineering Regiment wore specially designed shoes," says Thierry Orban. "They were so lightweight that he could walk over eggs without crushing them, and of course would not detonate mines." Southern Iraq. 24 February 1991. *(Thierry Orban)*

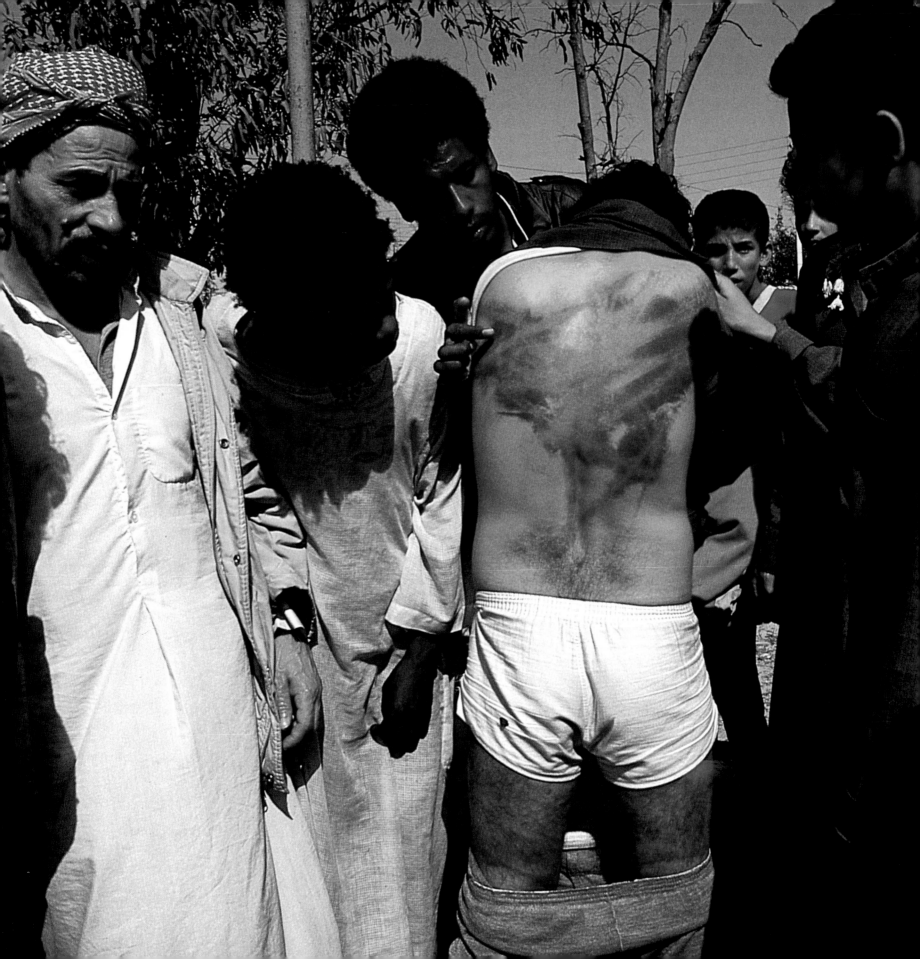

ATROCITIES

OPPOSITE

"Coming back from the last checkpoint on the road to Basra, I noticed a group of people in the nearly deserted border town of Safwan," says Allan Tannenbaum. "They were surrounding a local Iraqi vegetable vendor who claimed Kuwaiti soldiers had bound, blindfolded, and beaten him, and given him no food or water for several days — all this after the liberation of Kuwait, and only because he was Iraqi. Hatred and suspicion between Iraqis and Kuwaitis and Kuwaitis and Palestinians is extreme." Safwan, Iraq. 16 March 1991. *(Allan Tannenbaum)*

ABOVE AND BELOW

"I was looking for evidence of the Iraqis' torture victims," says Derek Hudson, "and in one of the drawers in this morgue, I found a Kuwaiti corpse with various patterns carved into his upper torso. The torturer had cut his initials into the man's left arm." Kuwait City. 28 February 1991. *(Derek Hudson)*

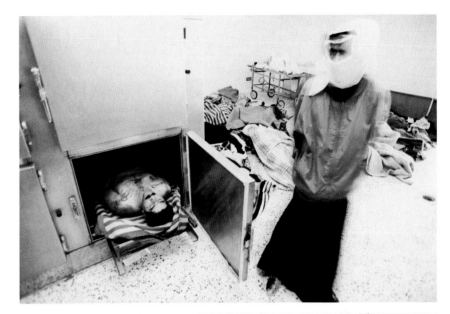

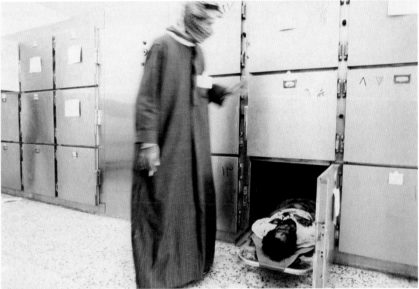

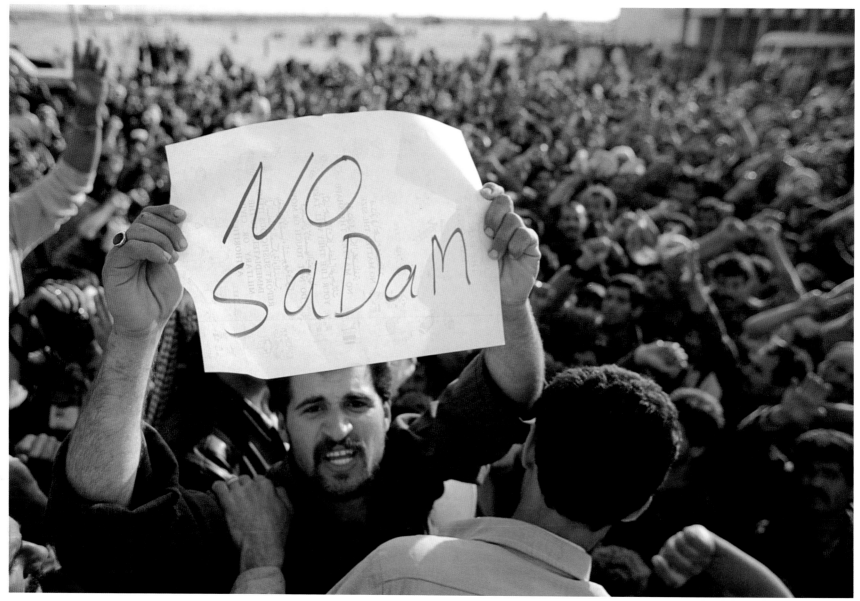

HOTEL CALCUTTA

"Iraqi refugees in Safwan were desperate to let the world know that once the allied forces pulled out, their lives would depend on Saddam Hussein's whim," says Allan Tannenbaum. "People demonstrated vocally and emotionally at this food distribution camp, formerly an Indian construction company site, now known as Hotel Calcutta because of its squalor. The refugees welcomed the Americans but complained that President Bush didn't go far enough. He left Saddam Hussein in power." Safwan, Iraq. 4 April 1991. *(Allan Tannenbaum)*

OPPOSITE

"Before Safwan became filled with refugees, who gathered at the news that the Americans were distributing food and providing medical care, people would frequently beckon passing vehicles with a gesture of hunger," says Allan Tannenbaum. "Children would run after the cars hoping to catch an MRE." Safwan, Iraq. 4 April 1991. *(Allan Tannenbaum)*

OVERLEAF

"Soldiers of the Coldstream Guards, best known for guarding Buckingham Palace, watched over this mile-square British compound which held captured Iraqi T-SS tanks, APCs, rocket launchers, trucks, artillery pieces, and small arms," says Allan Tannenbaum. "All were being shipped back to Britain to decorate bases and add to museum collections." Near Mutla, Kuwait. 27 March 1991. *(Allan Tannenbaum)*

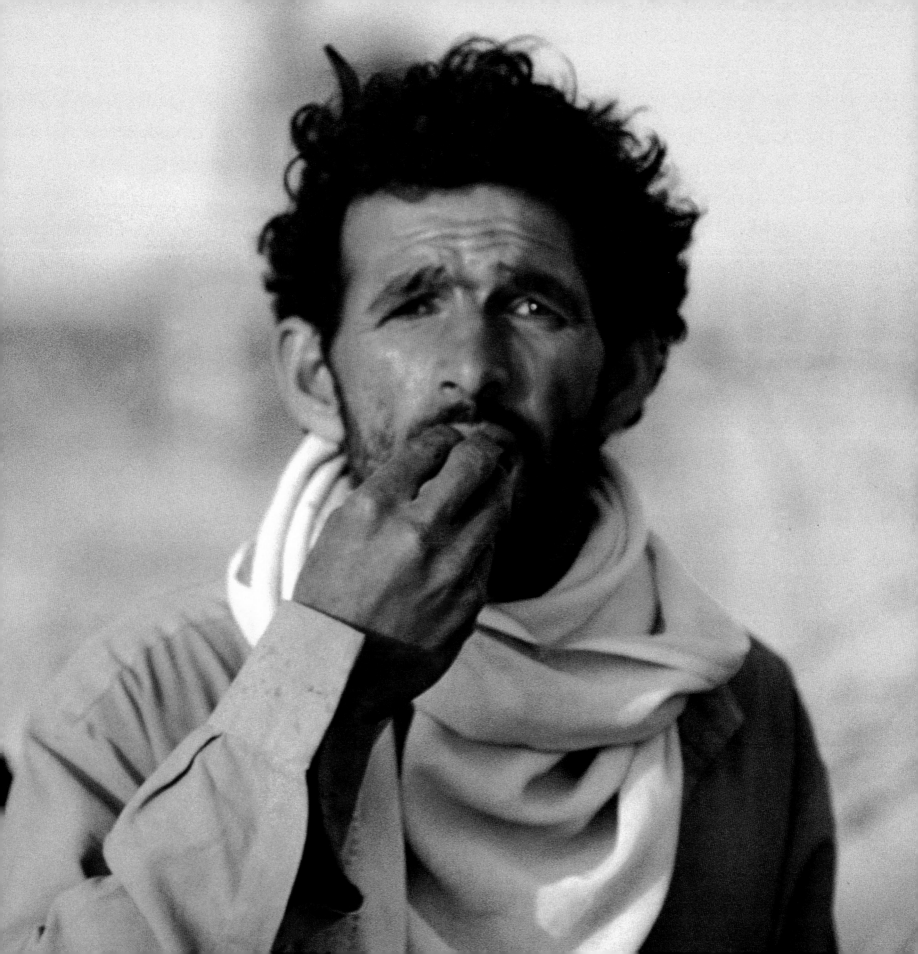

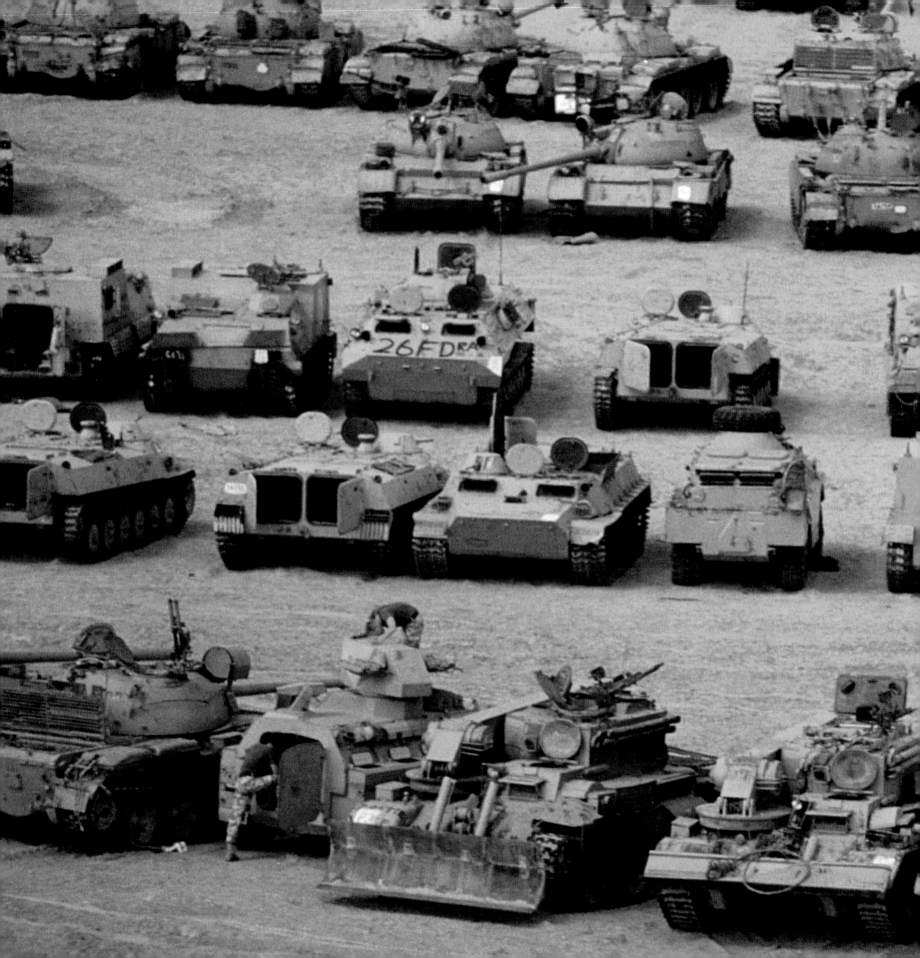

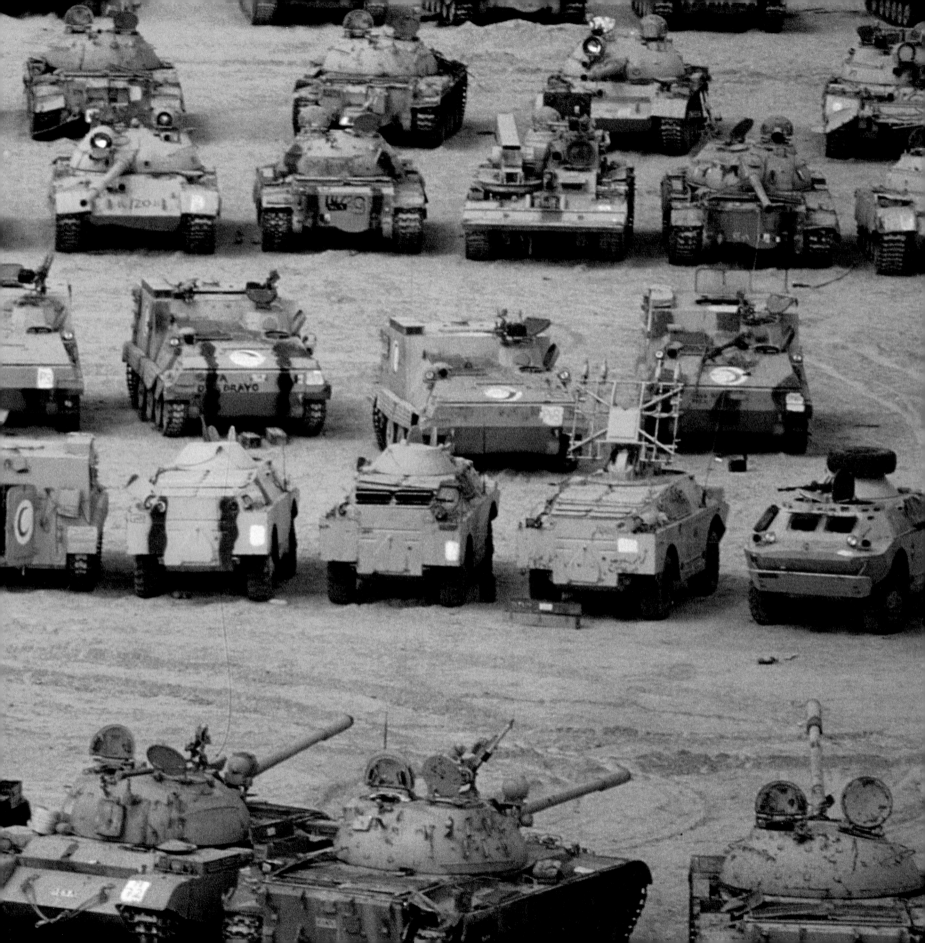

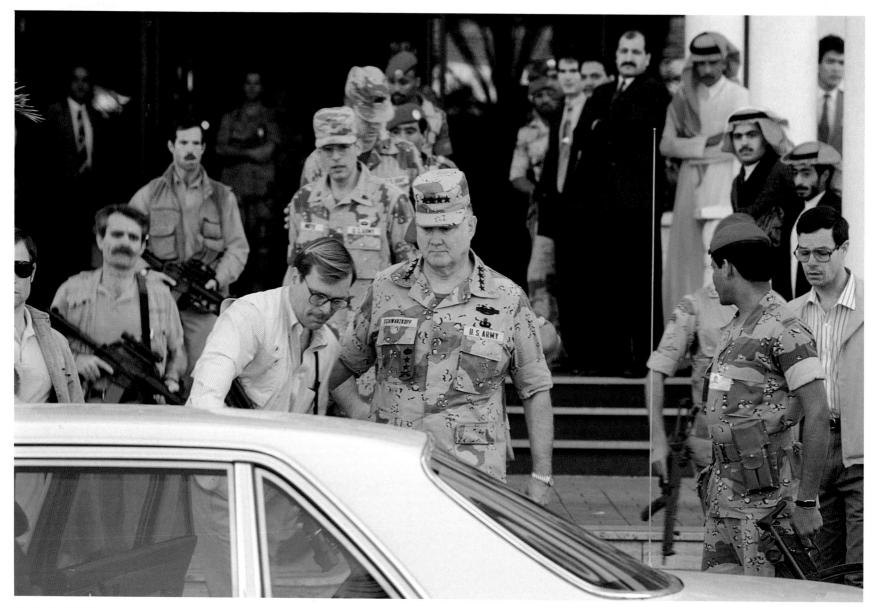

SUPER HERO

ABOVE

"Predicting which door General Schwarzkopf would leave from was like playing the shell game," recalls Thierry Orban. "For security reasons, it always involved a detailed staging, using several waiting cars." Riyadh, Saudi Arabia. 10 February 1991. *(Thierry Orban)*

OPPOSITE

General Schwarzkopf is invited to the French embassy by General Maurice Schmitt, the French Army chief of staff, where he is presented with a sword of St. Cyr (the French equivalent to West Point) and a Legionnaire's kepi. Schwarzkopf congratulates Schmitt on the efficiency of the French forces. Riyadh, Saudi Arabia. 5 March 1991. *(Patrice Habans)*

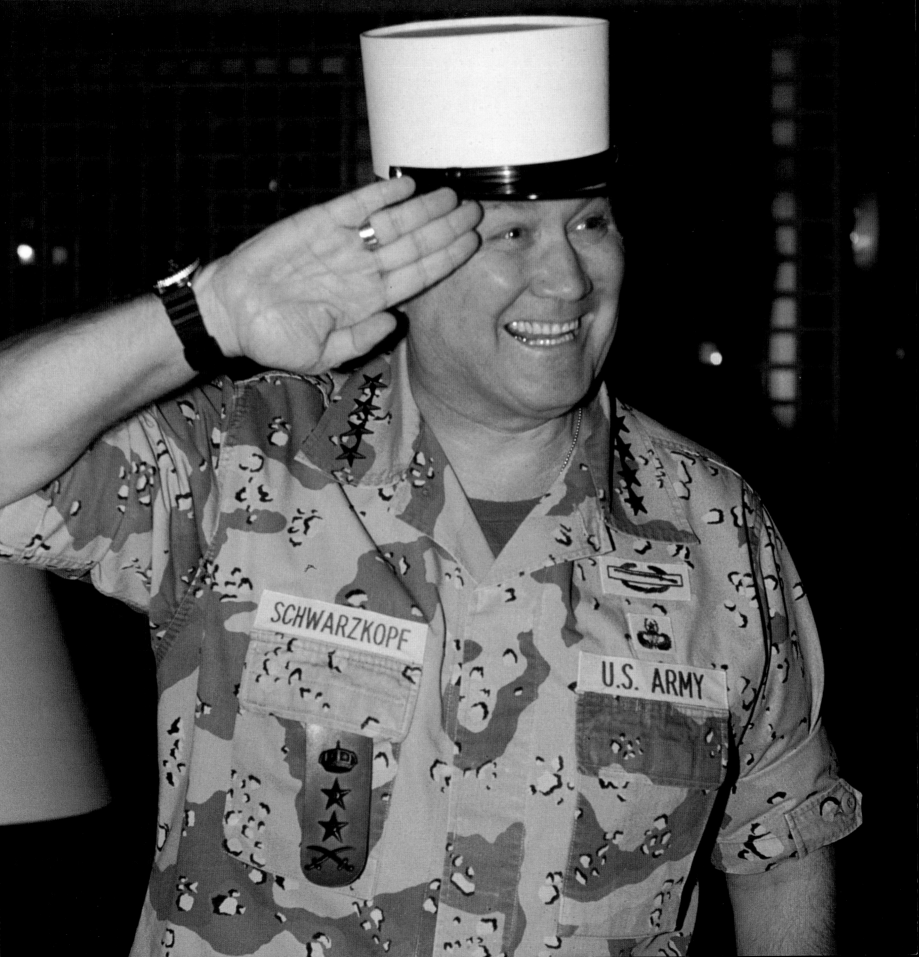

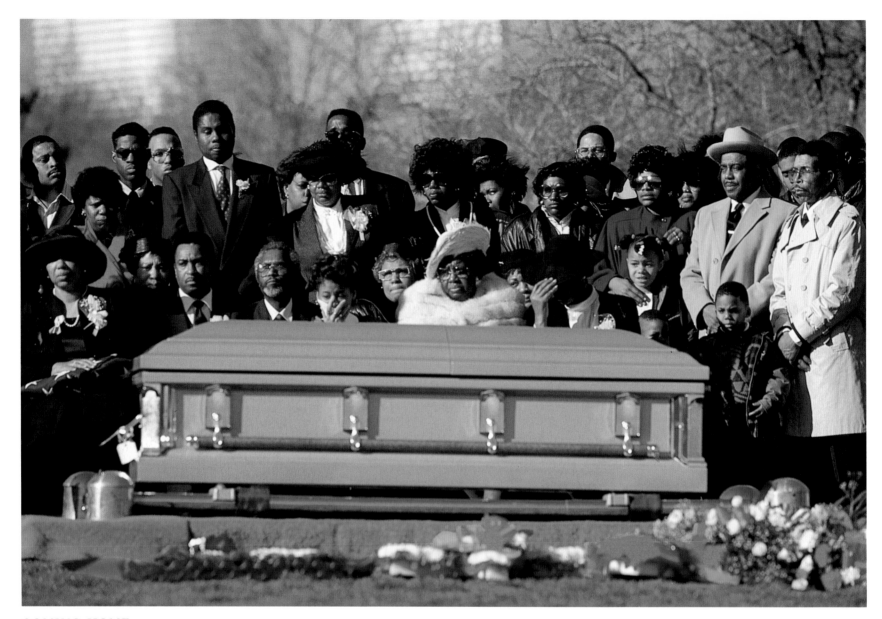

COMING HOME
Funeral of Pfc Timothy Shaw, U.S. Army. Arlington National Cemetery,
Virginia. 2 March 1991. *(Jean-Louis Atlan)*

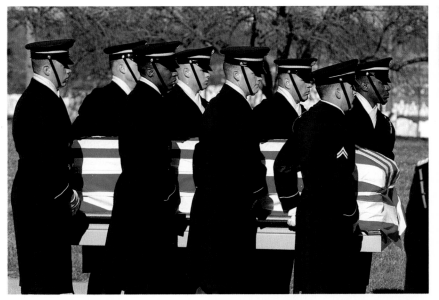

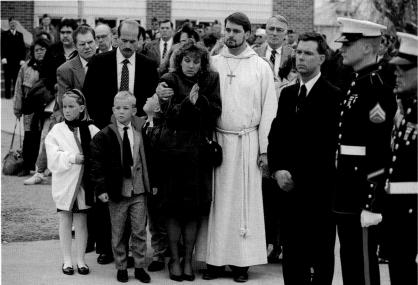

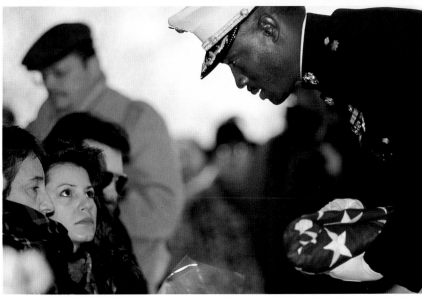

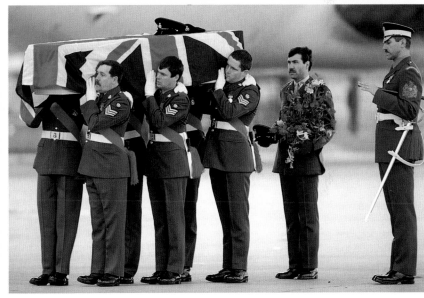

TOP LEFT
Funeral for Major Marie Rossi, a Marine helicopter pilot who became a hero for transporting troops into Iraqi combat zones. Arlington National Cemetery, Virginia. 11 March 1991. *(Jean-Louis Atlan)*

ABOVE LEFT
"The soldier's mother was paralyzed with grief," recalls Nola Tully. "A group of Marines folded the flag from her son's coffin, and one turned, stood before her, and bowed to hand her the flag. His gesture was so simple. It said what could never be spoken." Funeral of Captain Manuel Rivera, Jr., U.S. Marines. Long Island, New York. 31 January 1991. *(Nola Tully)*

TOP RIGHT
"The difficulty in photographing a situation like this was that the grief of the family is so strong that even with the separation provided by a camera, the emotions get to you," remembers Allan Tannenbaum. Funeral of Corporal Stephen Bentzlin, U.S. Marines. Wood Lake, Minnesota. 12 February 1991. *(Allan Tannenbaum)*

ABOVE RIGHT
The first of the British soldiers killed in action in the Gulf War were honored at RAF Brize Norton. Oxfordshire, England. 8 March 1991. *(Tim Graham)*

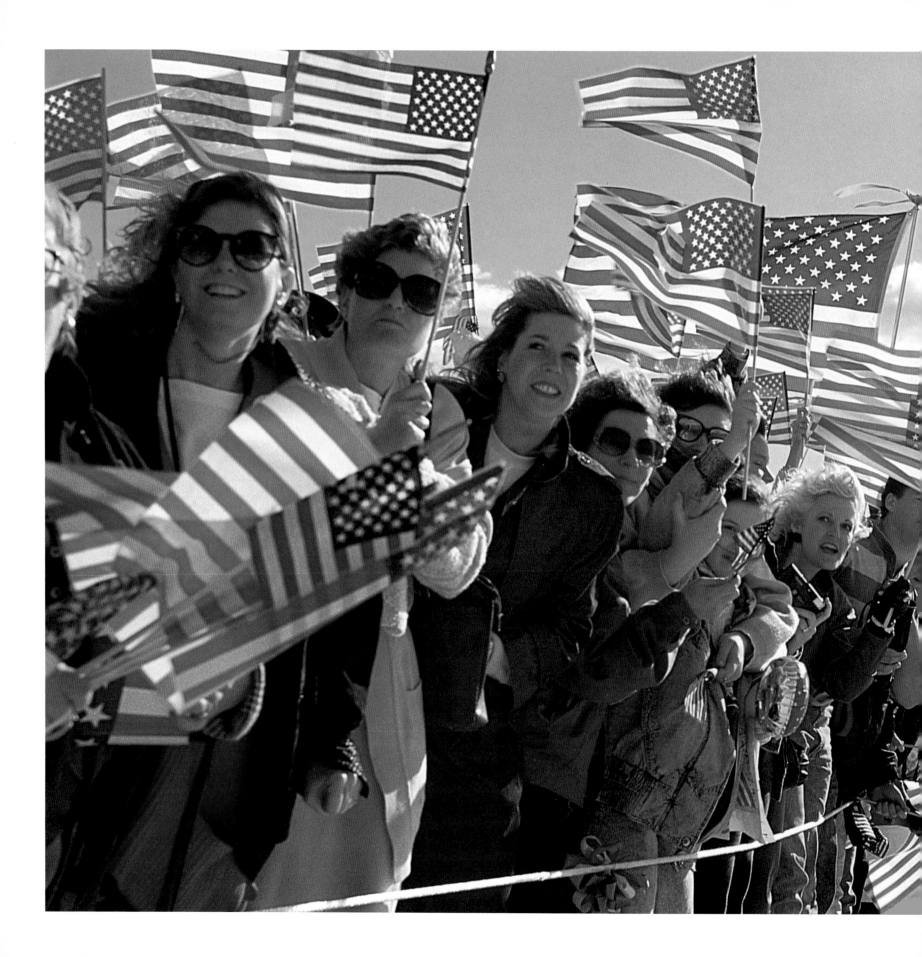

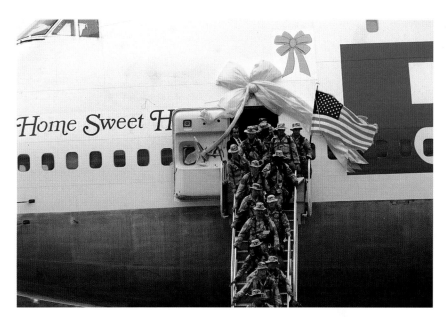

HOMECOMING

"Wind and cold weather kept people inside the hangar until a plane was announced to be approaching the base," notes Laura Sikes. "Then the families and friends would go outside to the bleachers or stand behind the ropes to watch the plane's touchdown and hope to catch a glimpse of their loved one. The cheering got louder and louder until the last soldiers made their way out of the plane and across the tarmac to the hangar where the actual reunions were held." Families greet returning soldiers of the 101st Airborne Division. Fort Campbell, Kentucky. 9 March 1991. *(Laura Sikes)*

Returning soldiers of the 24th Mechanized Infantry Division. Fort Stewart, Georgia. 9 March 1991. *(Les Stone)*

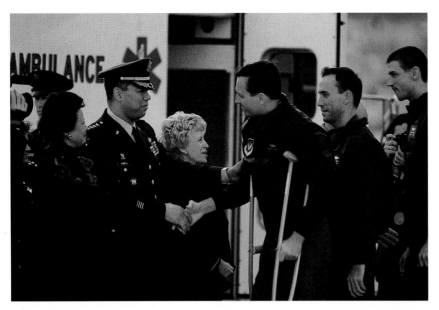

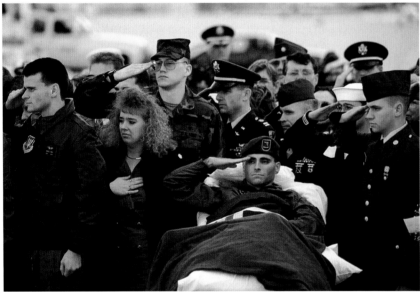

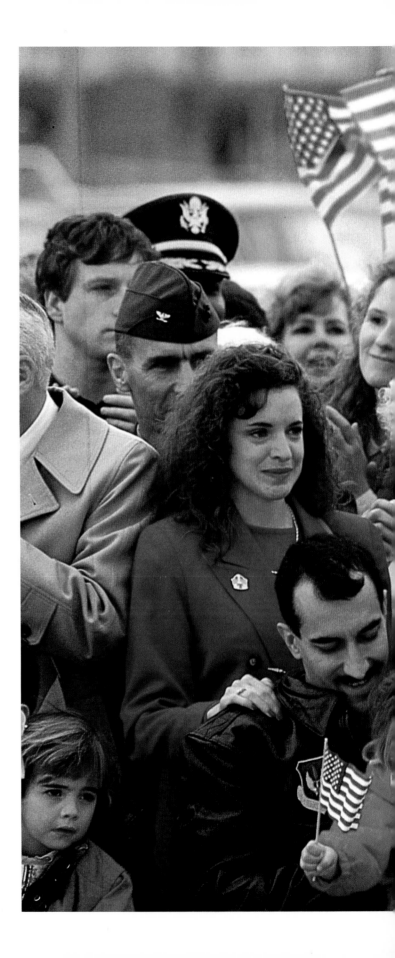

POW WOW

"All the returning POWs were celebrities in this crowd," observes Jean-Louis Atlan. "Colin Powell and Dick Cheney were out to greet them, although I hardly remember even seeing them in all of the chaos. Thousands of screaming, cheering, crying families and friends are a lot of competition when it comes to getting a camera angle. Often you look for landscape to climb, or someone's shoe to stand on. Shooting becomes a sport at these events."

RIGHT
The first female POW, Specialist 4 Melissa Rathbun-Nealy hugs her mother. Andrews Air Force Base, Maryland. 10 March 1991. *(Jean-Louis Atlan)*

TOP
General Colin Powell greets returning Air Force Captain Bill Andrews. Andrews Air Force Base, Maryland. 10 March 1991. *(Jean-Louis Atlan)*

ABOVE
Sergeant Daniel Stamaris salutes from his stretcher. Andrews Air Force Base, Maryland. 10 March 1991. *(Jean-Louis Atlan)*

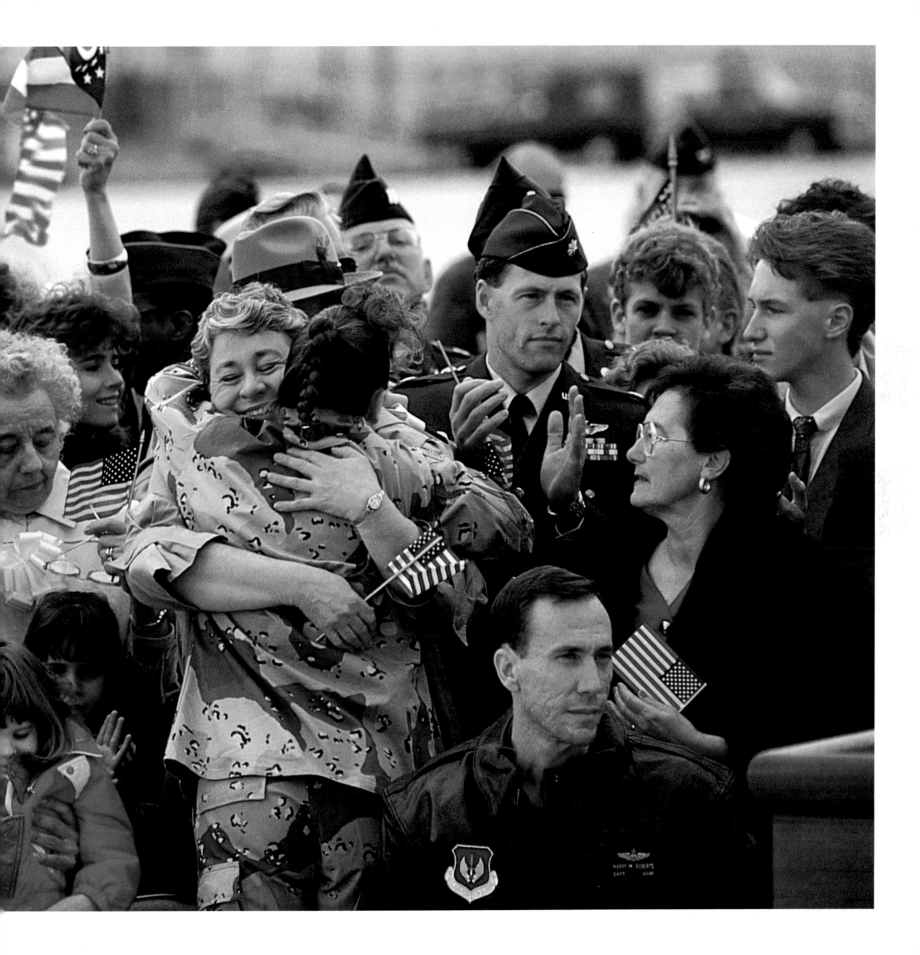

FAMILY REUNIONS

RIGHT

A B-52 crewman is met by his wife and children. Langley Air Force Base, Virginia. 8 March 1991. *(Allan Tannenbaum)*

TOP

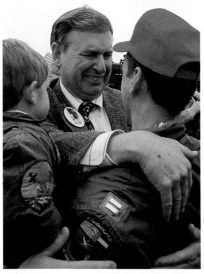

A pilot's father is overcome with emotion upon seeing his son return safely. Langley Air Force Base, Virginia. 8 March 1991. *(Allan Tannenbaum)*

MIDDLE

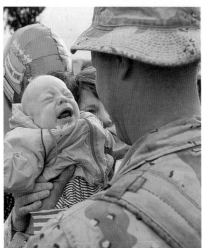

A Marine corporal returning from the Gulf holds his three-month-old baby for the first time. Camp Pendleton, California. 9 March 1991. *(Richard Perry)*

BOTTOM

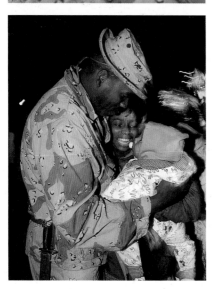

"Families had been waiting six months for their relatives to return safely, and tonight they waited another six hours," recalls Les Stone. "The tension finally broke at 3 A.M. when the troops arrived. As the soldiers approached their families, the public affairs officers tried in vain to keep some order, but within a minute it was total chaos, with families, soldiers, and media running everywhere in a frenzy of picture taking, pushing, shoving, joyous screaming, and crying." Here a soldier is greeted by his wife and their newborn. Fort Stewart, Georgia. 8 March 1991. *(Les Stone)*

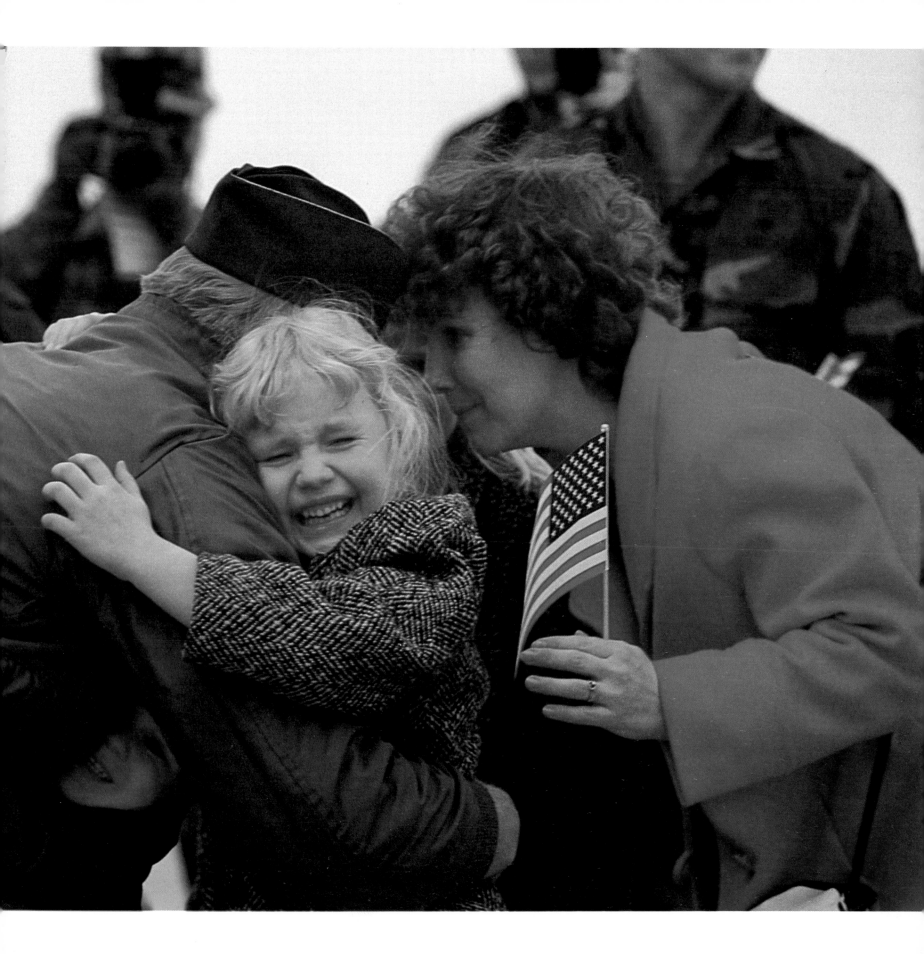

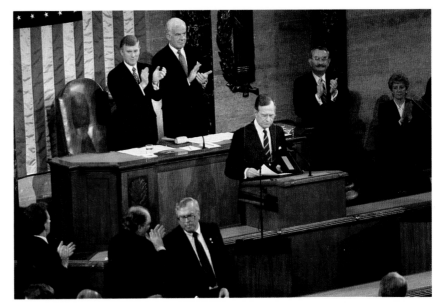

POW PILOTS

LEFT

"When the POW pilots gave their press conference at the Bethesda Naval Hospital, it was all very theatrical," recalls Jean-Louis Atlan. "The room was packed with press, but these poor guys looked so stiff. They didn't want to be there at all — Lieutenant Jeffrey Zaun, in particular. When he noticed that I was taking pictures of him, he sort of looked up nervously. I smiled at him and he smiled back. It was a very tough day for someone who never asked to be a hero. In fact, at the end of the conference, the press applauded because they sympathized with everything these guys had been through." Bethesda, Maryland. 14 March 1991. *(Jean-Louis Atlan)*

JUST SAY WHEN

ABOVE

"For days we tried to get the date the first U.S. troops would be returning," remembers Jean-Louis Atlan. "The Pentagon wouldn't give us a clue, and we realized that President Bush would dispense that crowd-pleasing information himself. At this joint session of Congress, he announced that troops would begin returning on March 8." Washington, D.C. 6 March 1991. *(Jean-Louis Atlan)*

HOME SAFE

"What you can't see in this picture are the hundreds of people behind me, screaming for their husbands, fathers, and sons," recalls Les Stone. "The pilots did a fly-over in formation before they landed, waved to their families after landing, and cried with them after this picture." Norfolk, Virginia. 28 March 1991. *(Les Stone)*

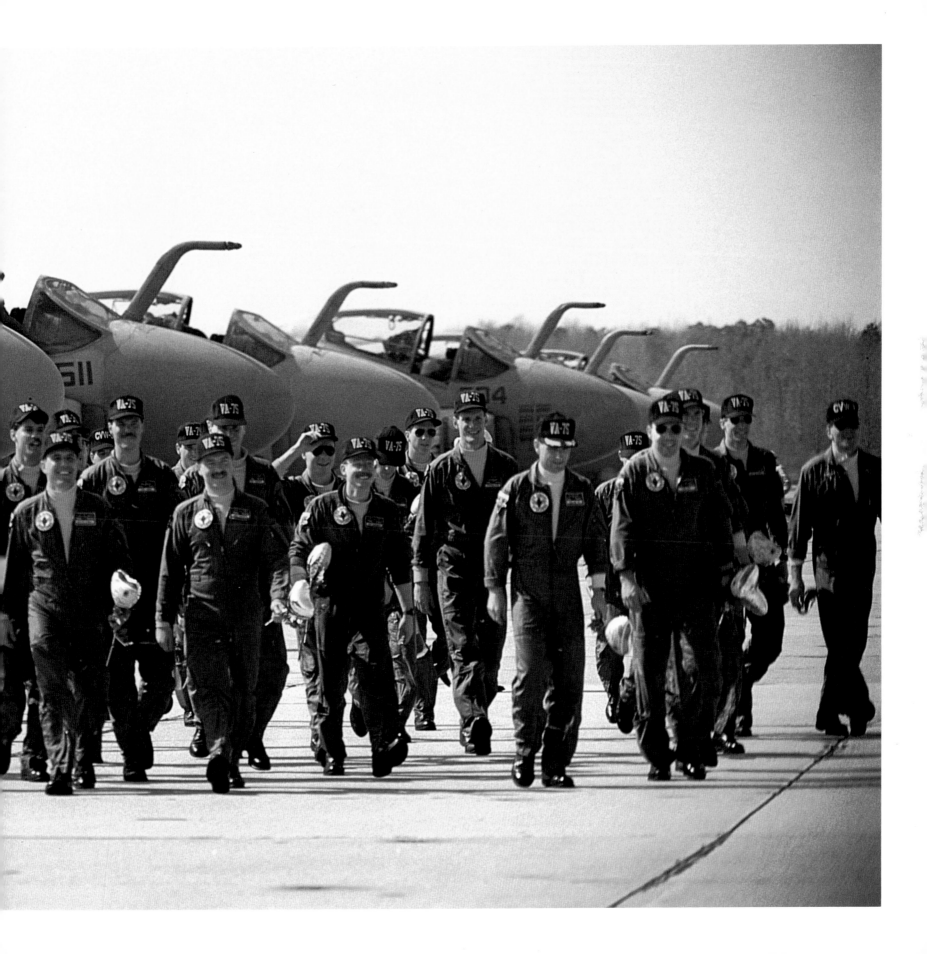

STEALTH CONSCIOUS

"Not everyone in the crowd at Fort Nellis Air Force Base was there to greet returning family and friends," recalls Richard Perry. "Many had come from nearby Las Vegas to get a glimpse of the Stealth, which has become a media event unto itself. And with eight F-117A Stealth fighters in one place at the same time, it created an even greater sensation. As the Stealths approached the field in pairs, they made one low pass over the crowd, then banked off in opposite directions and landed one at a time. The planes assembled at the far end of the field, then taxied to the crowd in a long line and parked side by side. Ground crews secured the planes. Then, in perfect synchronization, they opened their cockpit tops. The crowd was roaring. The pilots jumped from their planes and walked to greet their families. The markings on the side of the planes indicate the number of combat hits and include each pilot's name." Nellis Air Force Base, Nevada. 1 April 1991. *(Richard Perry)*

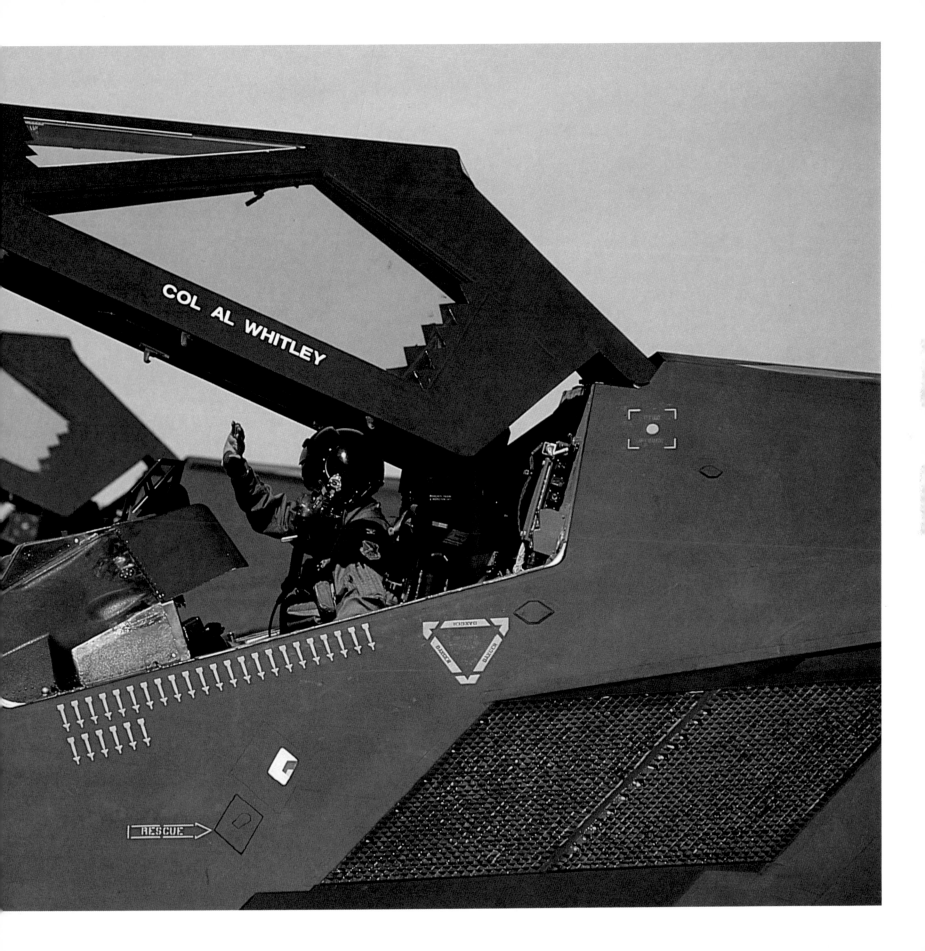

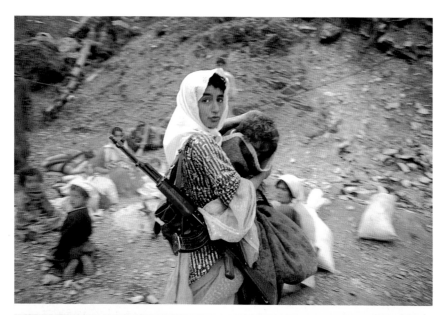

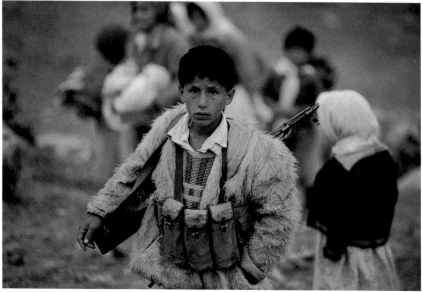

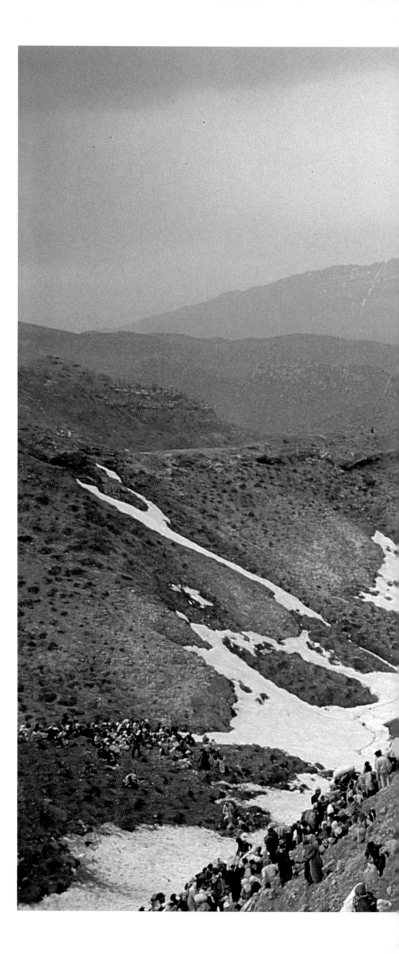

EXODUS

TOP, ABOVE, RIGHT

"When the last Kurdish cities had fallen to the Iraqi army, the population headed en masse toward Turkey," says Patrick Robert. "Four colleagues and I took the same road through the mountains as hundreds of thousands of fleeing Kurds. When we reached the border four days later, the Turkish army made it known: the Kurds were not welcome. They were stranded on a cold steep slope, still wearing the light clothes they wore in the plains. Many were barefoot. In this exodus, they had sacrificed all belongings and reminders of their past." Northern Iraq. 30 March 1991. *(Patrick Robert)*

OVERLEAF

"An eight-year-old Kurdish girl was trampled to death in the melee as the Sikorsky Super Jolly Green Giant landed to deliver relief supplies," says Les Stone. "The people were hungry, thirsty, and desperate, and this was the first U.S. aid to appear on this mountainside. What they delivered was just a drop in the bucket of what was needed." Isikveren, Turkey. 16 April 1991. *(Les Stone)*

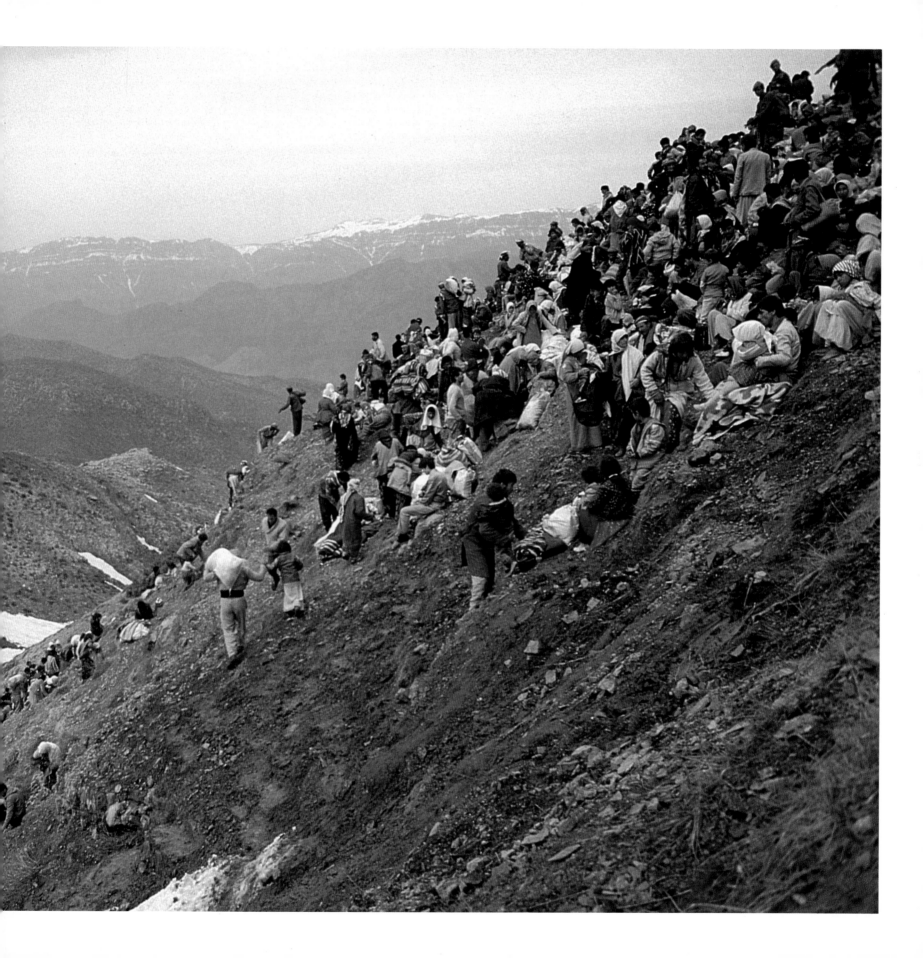

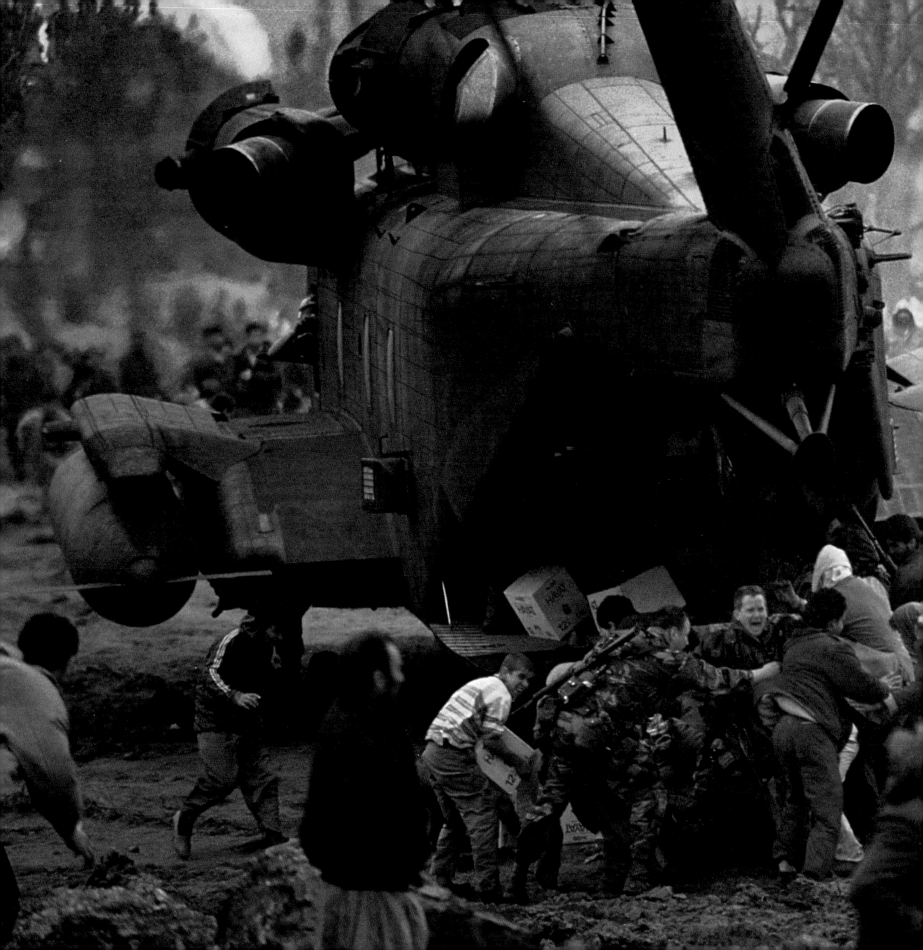

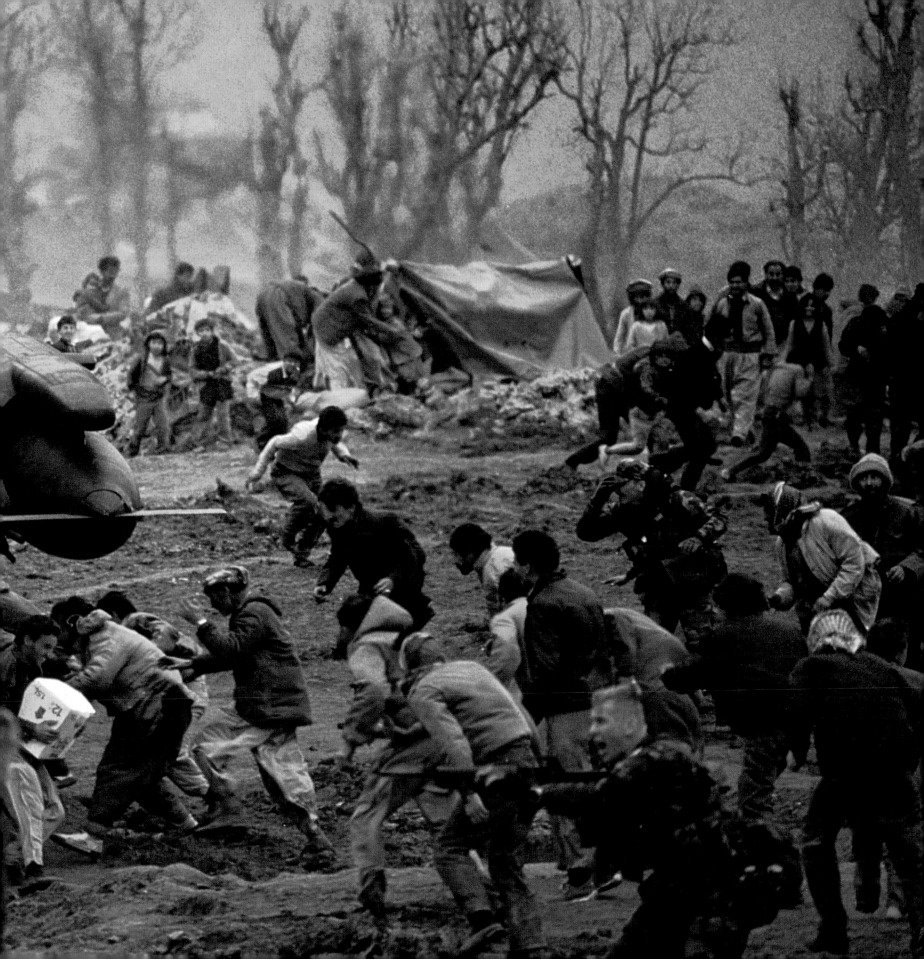

THE PHOTOGRAPHERS

JEAN-LOUIS ATLAN

Born in Tunis in 1939, Atlan began his career in Paris and was a unit photographer for the film directors Eric Rohmer, Francis Giacobetti, and Edouard Molinaro. He joined Sygma in 1977 and has covered major news in Europe and the Middle East, including the labor strikes in Poland, the Carter administration's failed hostage rescue attempt in Iran, and the Soviet invasion of Afghanistan. In 1981 Atlan relocated to Washington, D.C., and became Sygma's White House correspondent. Based in the capital, he covers events in the United States and Latin America and frequently travels with the President on both his domestic and international trips. His photographs appear regularly in NEWSWEEK, TIME, STERN, LIFE, and PARIS MATCH.

■

DOMINIQUE AUBERT

Born in the Parisian suburb of Bois-Colombes, Aubert began his career

as a photographer with the United Nations peacekeeping forces in Lebanon. In 1982 he returned to Paris where he free-lanced for several magazines, including L'EXPRESS and VSD, and for the French wire service Agence France-Press. In 1987 he joined Sygma and became a specialist in overseas news. He has covered civil wars in Afghanistan and Angola, the Romanian revolution, and the Palestinian uprising in the Israeli Occupied Territories. He is twenty-eight and based in Paris.

■

JAMES CACHERO

This thirty-one-year-old native of Honolulu got his start in photography as an assistant in a commercial studio. After several years in Los Angeles as a stringer for the wire services and several years free-lancing in Asia and Central America, he returned to Honolulu, where he has been based since 1985. He became affiliated with Sygma in 1986.

STEPHANE COMPOINT

Born in Paris in 1961 and based there, Compoint has been a general assignment photographer for Sygma since 1989. He has covered the investigation of prisoner of war camps inside France during the Second World War, international auto races, and tennis tournaments, and he produced an extensive series on the French police. Before joining Sygma, he specialized in sports photography, covering several Olympic games and the Formula 1 racing season, as well as the Paris-Dakar auto race.

■

F. LEE CORKRAN

Born in Phoenix, Arizona, Corkran began photographing at age fifteen and joined the Air Force in 1983. Based in Frankfurt until 1991, he covered Air Force and Department of Defense activities. In the Military Picture of the Year contest he won a first place in sports in 1990 and a first place in portraiture in 1989. He has received the Air Force Commendation Medal for humanitarian relief activities and was awarded the Bronze Star for his participation in combat missions during the Gulf War. In 1990, as a student at the annual Eddie Adams Workshop, Corkran won an assignment from Sygma. He left the Air Force in summer 1991 and continues his affiliation with this agency.

■

PATRICK DURAND

The thirty-nine-year-old native of

Orléans, France, first studied advertising and then, his schooling complete, headed to Southeast Asia, where he spent five years traveling and free-lancing. In 1978 he returned to Paris where he was hired by the French magazine VSD. Two years later, he moved to the United States. From 1980 until 1985, he was a U.S.-based correspondent for PARIS MATCH and LE FIGARO MAGAZINE. He moved to South Africa in 1985 and covered political unrest for two years. He has photographed many international events, such as the war in Afghanistan, the massacre of students in Tiananmen Square in Beijing, and the Romanian revolution, since he joined Sygma in 1986.

■

DENIS FINLEY

In 1985 the native Philadelphian decided to turn his photography from a hobby into a profession. That same year he was admitted to the University of Missouri School of Journalism, one of the most prestigious in the country, and after he received his master's with honors, he won an internship at the NATIONAL GEOGRAPHIC magazine. It was one of several internships, including stints at the DETROIT NEWS and the VIRGINIAN PILOT, where he has been a staff photographer since October of 1987. Now thirty-nine and based in Norfolk, Virginia, he has been contributing to Sygma since 1989. The recipient of many regional honors and of awards from the National Press

Photographers Association, he has also been honored by the University of Missouri Pictures of the Year contest for his sports photography.

■

TIM GRAHAM

Immediately following school in his hometown of Harefield, England, Graham began his career as an assistant at a Fleet Street picture agency, where he handled local assignments. In 1968 he covered a royal family tour, which sparked his interest in photographing the British aristocracy. After three years as a staff photographer for the DAILY MAIL, he began a free-lance career. His photographs appear in such magazines as VOGUE, TIME, LIFE, THE OBSERVER, PARIS MATCH, and STERN. He has published several books on the royal family and has taken the official royal family portrait several times. Based in London, now forty-three, he has been affiliated with Sygma since 1980.

■

PATRICE HABANS

Now fifty-four, this Frenchman began his career in 1955 as a photographer on the staff of JOUR DE FRANCE. In 1956 he moved to PARIS MATCH where he would remain for the next seventeen years, with the interruptions of two years for military service in Algeria and one year in New York as an assistant to Richard Avedon, from whom he learned fashion photography. In 1973 Habans became the assistant managing editor at PARIS MATCH. He moved to the Swiss magazine ILLUSTRÉ in 1979. After a year he left

ILLUSTRÉ and was made the official photographer of the Moscow Olympiad. He joined Sygma in 1980 and has been affiliated with the agency ever since. He was born in Boulogne.

■

THOMAS HARTWELL

Based in Cairo for the past nine years, the thirty-six-year-old Hartwell holds bachelor's degrees in photojournalism and Middle Eastern Studies from the University of Texas, and he studied at the University of Isfahan, Iran, in the year preceding the radical Muslim revolution in that country. His photographs have been reproduced in TIME, FORTUNE, THE NEW YORK TIMES, and THE INTERNATIONAL HERALD TRIBUNE, and his portraits of Middle Eastern political figures have appeared frequently on the covers of international news magazines. This native of Beaumont, Texas, has been affiliated with Sygma since 1987.

■

DEREK HUDSON

Born in 1953 in London, Hudson is the only child of adoptive parents. After being expelled from school at age sixteen for "misdemeanors," he decided to try for a career in photography. Within six months of obtaining a position as an apprentice with a London newspaper, he won the prestigious Lord Beaverbrook/Daily Express Young Photographer of the Year award. He was seventeen. The following year he won the same award. Hudson worked on Fleet Street as a free-lance photographer with THE TIMES, the DAILY EXPRESS,

and the DAILY TELEGRAPH, then moved to Paris where he free-lanced for THE LONDON SUNDAY TIMES and PARIS MATCH for about three years. He joined Sygma in 1986 and returned to London as its photographer for Britain. In 1988 he won second prize in the news/people category of the World Press Photo Foundation contest for his photographs of Margaret Thatcher's election campaign. He has covered numerous uprisings and wars around the world.

■

JONAS JORDAN

Born on the fourth of July, 1951, in Savannah, Georgia, Jordan has been a photographer for the Savannah District, U.S. Army Corps of Engineers since 1977. His corps assignments have included the cleanup efforts in the aftermath of Hurricane

Hugo as well as military construction projects in the Carolinas and Georgia. Apart from his normal photography duties with the army, Jordan has free-lanced for the ATLANTA CONSTITUTION, THE NEW YORK TIMES, and the CHICAGO SUN-TIMES. He has volunteered his photographic skills for the Georgia Conservancy, the Department of Family and Children Services (Chatham County, Georgia), and the Savannah Symphony Orchestra. He is the recipient of the Department of the Army Achievement Medal for Civilian Service and has won the Georgia Professional Photographers Association's Photographer of the Year award.

■

JACQUES LANGEVIN

A native of Laval, in Brittany, Langevin began his career in pho-

tography in 1972 as a lab technician in Paris. In 1976 he joined the Associated Press and subsequently covered major international news stories, such as the Iranian revolution, the Iran-Iraq war, and the winter Olympics in Sarajevo. In 1984 he joined Sygma and has since worked in Asia, Central and South America, Europe, and the United States. His photographs of the student uprising in Tiananmen Square in Beijing won the Leica Award, the International Center of Photography award for reportage, and an honorable mention in the World Press Photo Foundation contest. He is thirty-six years old and based in Paris.

■

JOE McNALLY

Born in Montclair, New Jersey, McNally began his photography career in 1978 as a studio assistant at the New York DAILY NEWS. Shortly thereafter he became a

stringer for the Associated Press and United Press International, and in 1981 he started to free-lance, working primarily for LIFE, NATIONAL GEOGRAPHIC, and SPORTS ILLUSTRATED. He joined Sygma in 1989 and continues to photograph on assignment for corporate and magazine clients. In 1988, he won first prize for magazine illustration in the Pictures of the Year contest. His photographs appear regularly in numerous major magazines worldwide, including GEO, LIFE, STERN, PARIS MATCH, and THE LONDON SUNDAY TIMES. Thirty-nine years old, he is based in New York City.

■

MOSHE MILNER

Born in Germany in 1946 to survivors of the Holocaust, Milner moved to Israel with his family in 1948. He trained as a photographer in the army, becoming Prime Minister Golda Meir's personal photographer

and the photographer for several succeeding Israeli prime ministers, including Itzhak Rabin and Menachem Begin. Since 1981, Milner has been a Sygma photographer based in Tel Aviv. He has covered most of the important events in the Middle East, including the Israeli invasion of Lebanon, the evacuation of Yamit, and the Palestinian uprising in the Israeli Occupied Territories.

■

THIERRY ORBAN

Born in Dormans in the Champagne region of France, Orban attended the Louis Lumière Photography School in 1974 and soon became a photographer with the elite paratroopers regiment of the French army. In 1978, after a year with the French National Geographic Institute as an aerial photographer, he joined the Sygma bureau in Paris, working as a lab technician during the day and shooting assignments at night, mostly photographing at concerts and plays. His first major international news story was the Lake Nyos disaster in Cameroon. Since then he has covered other international events from his base in Paris, such as the Armenian earthquake, the dissolution of East Germany, and Madonna's concert in Japan, which he says proves his continuing versatility. He is thirty-six.

■

JACQUES PAVLOVSKY

Born of Russian parents in the Basque town of St. Jean-de-Luz, this veteran of numerous overseas assignments was an advertising photographer in the 1950s and sixties before

joining Sygma at the invitation of its founding members. Since his affiliation with the agency in 1974, he has covered such international news as the end of the war in Vietnam, the plight of the boat people in the South China Sea, and the eight-year-long Iran-Iraq war. He is a specialist in North African and Middle Eastern affairs, with particular expertise in Iraq. His portraits of Saddam Hussein and his battle-scene photographs from the Iran-Iraq war have appeared on the covers of major magazines around the world. He is sixty years old and based in Paris.

■

RICHARD PERRY

Born in Seattle, Washington, thirty-five years ago, Perry has a degree in photojournalism from Ohio University and began his career with a half dozen photography internships — notably with the NATIONAL GEOGRAPHIC and the LOUISVILLE COURIER-JOURNAL. He got his first job with the SEATTLE TIMES as a photographer and editor, then went on to win the National Press Photographers Association Picture Editor of the Year award in 1980. In the 1980s he worked for several newspapers around the country and since 1989 he has been free-lancing in Los Angeles. He recently started shooting for Sygma. His photographs have appeared in NEWSWEEK and PEOPLE, among other major magazines.

■

PATRICK ROBERT

Born in Maison-Carrée in Algeria, Robert received a degree in agrono-

my and began his career in photography as an assistant in fashion and advertising. In 1980 he became a lab technician in Paris but soon graduated to full-time free-lance photography. Since 1982 he has covered virtually every war in Africa and the Middle East. He joined Sygma in 1987 and has covered the Palestinian uprising in the Israeli Occupied Territories, the war in Afghanistan, the revolution in Romania, and the civil war in Chad. His photographs of the conflict in Liberia won him an honorable mention in the 1990 World Press Awards. He is thirty-two and based in Paris.

■

AXEL SAXE
After receiving his master's degree in history in 1984, Saxe became a free-lance photographer, working primarily with the French publications L'EXPANSION, ELLE, and LIBERATION. After joining Sygma in 1989 he worked in Hungary, covered the plight of the Palestinians, and did extended features on the French Foreign Legion. His work appears regularly in major European magazines. The thirty-two-year-old is based in Paris, his native city.

■

LAURA SIKES
Born in Jacksonville, Florida, Sikes began her career shooting for a suburban newspaper. Currently, she free-lances for major U.S. magazines. Since her affiliation with Sygma in 1986, she has covered major national events, such as

Hurricane Hugo and the Democratic and Republican party conventions of 1988, and she has contributed photo essays to MISSIONS USA. Thirty-seven, she is based in Atlanta.

■

LES STONE
Born in New York City in 1959, where he is now based, Stone began his professional career as a photographer for the Metropolitan Transit Authority, shooting its subway advertising and annual reports. In 1989, as a free-lancer, he won the spot news category in the Pictures of the Year contest for his photograph of Panamanian vice presidential candidate Guillermo Ford being beaten by hoodlums of the Noriega camp. Since then, Stone has joined Sygma and covers domestic and international news stories. Stone's photographs appear regularly in TIME, NEWSWEEK, PARIS MATCH, and STERN, among other magazines.

■

ALLAN TANNENBAUM
Tannenbaum, forty-six and a native of Passaic, New Jersey, has been based in New York for his entire career. He joined Sygma in 1982, after nine years as photo editor and photographer for the SOHO WEEKLY NEWS. He has specialized in coverage of international news events, such as the Philippine revolution, the Korean elections in 1987, and the Palestinian uprising in the Israeli Occupied Territories. Among other awards, Tannenbaum won first prize for spot news in the World Press Photo Foundation contest of 1989.

His photographs appear regularly in NEWSWEEK, TIME, PARIS MATCH, LIFE, and STERN.

■

NOLA TULLY
After graduating from the Rhode Island School of Design in 1985 with a fine arts degree in photography, the twenty-nine-year-old native of Cincinnati, Ohio, moved to New York and began her career in photography as an assistant to several photographers. In 1989, after three years as a researcher in the Sygma bureau in New York, she began to cover news events for Sygma in the U.S. Her photographs have been reproduced in NEWSWEEK, TIME, LIFE, PARIS MATCH, and STERN and exhibited at Nikon House in New York. She is based in New York.

For their fine work under often dangerous and always difficult conditions during the Gulf War, I thank the twenty-four photographers of Sygma Photo News represented in this book. For their excellent editorial direction, I thank Hubert Henrotte and Claude Thierset of Sygma's Paris office. And for his enthusiasm and help, I am especially grateful to Raymond H. DeMoulin of the Professional Photography Division of Eastman Kodak Company, whose active support made this book possible.

Eliane Laffont
PRESIDENT
SYGMA PHOTO NEWS

SYGMA PHOTO NEWS
PHOTOGRAPHY EDITOR
Eliane Laffont
DESIGNER
Jean-Claude Suarès
CAPTIONS
Glenn Albin
COORDINATOR
Jean-Pierre Pappis
ASSISTANT COORDINATOR
Christopher Noble
PRODUCTION
Linda Gates and Kathleen Gates
of Gates Studio

HARRY N. ABRAMS, INC.
PROJECT DIRECTOR
Robert Morton
EDITOR
Anne Hoy

EASTMAN KODAK
COMPANY
Raymond H. DeMoulin
Charles W. Styles